```
1.51193261236120    7.43028488663780    1.10255089694625      13T18:04:00.000   3156.233767325260   -4059.087832101000    4438.394366448710    3.22137745202481    6.12026351399726    3.300557
0.24361176305556    7.64049681968696   -0.51339151238874      13T18:08:00.000   3805.272918489990   -2460.553408340...                                                             644    1.840743
-1.04219409251836   7.29588186165597   -2.09166127832784      13T18:12:00.000   4177.851576198980    -683.251214051...                                                             014    0.247705
-2.25243015654566   6.42147337952814   -3.51773638468958      13T18:16:00.000   4247.039124537560    1143.673597098...                                                             480   -1.362871
-3.29934238091530   5.08049985248207   -4.68793768194687      13T18:20:00.000   4007.860842943600    2887.568937811160   -4665.046926985340   -1.62253809753825    6.91331516004228   -2.874219
-4.10675699690360   3.37025667377060   -5.51684704199098      13T18:24:00.000   3477.650615396710    4421.788170694470    3813.756281351010   -2.76898401171628    5.79385065454469   -4.176549
-4.61580098523232   1.41543682560155   -5.94382951285331      13T18:28:00.000   2694.861390300980    5634.847290369400    2684.679654445320   -3.71450785681705    4.25329691967827   -5.174915
-4.78951454689600  -0.64111723631555   -5.93788711296409      13T18:32:00.000   1716.322356235680    6438.589014353410    1360.025861710900   -4.39024850589507    2.40374728410374   -5.796348
-4.61572887494835  -2.64923289301615   -5.50008458204542      13T18:36:00.000    613.126332252936    6774.695466612120     -63.699536083601   -4.74697955522917    0.38024975054000   -5.995481
-4.10783239779162  -4.46298131740483   -4.66329394322520      13T18:40:00.000   -534.582704989848    6619.019388757570   -1482.805858306900   -4.75900306490706   -1.66932109643425   -5.758205
-3.30342844136734  -5.95152524962673   -3.48928264652774      13T18:44:00.000  -1643.530614389310    5983.309608361950   -2794.092308465700   -4.42607369056826   -3.59561363805197   -5.102641
-2.26116724184972  -7.00839842503145   -2.06366011178371      13T18:48:00.000  -2633.442343757240    4914.203141052030   -3902.438837875800   -3.77321451027333   -5.25910379496880   -4.077525
-1.05620423535215  -7.55848470748619   -0.48940118196277      13T18:52:00.000  -3432.863612217430    3489.595149202930   -4727.698521014820   -2.84837171587625   -6.54034988829756   -2.758025
0.22513134519797   -7.56265789991204    1.12037414744007      13T18:56:00.000  -3984.225832069740    1812.808741641580   -5210.360510498060   -1.71856408311940   -7.34806662919926   -1.239847
1.49113443699806   -7.02021626809730    2.65012232801201      13T19:00:00.000  -4247.845484602680       5.093862140979   -5315.656614357430   -0.46493340703349   -7.62490941376095    0.367734
2.65084533604640   -5.96898724264707    3.98950842669796      13T19:04:00.000  -4204.656497580750   -1802.982229932990   -5035.928638939250    0.82282789826350   -7.35097973734576    1.949360
3.62024964571883   -4.48340933456149    5.04102322101512      13T19:08:00.000  -3857.549768597550   -3480.716021403330   -4391.165164038170    2.05243492722657   -6.54507247404843    3.391273
4.32835865039283   -2.66993998977401    5.72717974383470      13T19:12:00.000  -3231.262553708120   -4906.501762231410   -3427.698522961670    3.13518724268564   -5.26388762656155    4.588981
4.72271156145691   -0.66004926613857    5.99669235612583      13T19:16:00.000  -2370.755741590550   -5976.587041272680   -2215.071291790660    3.99226654794874   -3.59873071712376    5.454762
4.77379585814690    1.39946468419442    5.82893111430573      13T19:20:00.000  -1338.133749851030   -6612.723778989110    -841.183220240632    4.56055853282048   -1.66965440870072    5.924380
4.47748504963697    3.35762322742349    5.23575552046167      13T19:24:00.000   -208.240431033664   -6768.115063120910     594.016555969733    4.79775961092701    0.38291062638499    5.962388
3.85551117894689    5.07096145823724    4.26076029617628      13T19:28:00.000    936.799506494547   -6431.076970864890    1985.868151519470    4.68594100625548    2.40865103531902    5.565299
2.95359799676580    6.41456544840866    2.97565047910964      13T19:32:00.000   2013.665572909650   -5626.030164494480    3232.792435952050    4.23314794692202    4.25899883124172    4.762122
1.83768355935199    7.29119851063894    1.47458831629661      13T19:36:00.000   2944.035131466780   -4411.670502053000    4243.861662182470    3.47266787116056    5.79872306624180    3.611979
0.58889530568162    7.63789657943350   -0.13309760122180      13T19:40:00.000   3660.343772489520   -2876.526834543160    4945.487592823710    2.46026449585156    6.91594849673234    2.199281
-0.70236858894658   7.42995723617147   -1.73075611861497      13T19:44:00.000   4110.681484200300   -1132.361932062470    5286.740880975740    1.26977065270076    7.53007396417427    0.627250
-1.94268269784901   6.68246943395386   -3.20244697718702      13T19:48:00.000   4262.477551950190     694.041434242152    5242.955408501650   -0.01245856602218    7.59718027518818   -0.989831
-3.04214336006456   5.44953072740204   -4.44118309273733      13T19:52:00.000   4104.783659142530    2470.051200114900    4817.413744174780   -1.29365930709041    7.11269819790477   -2.534685
-3.92085032286542   3.82053640118026   -5.35665684891894      13T19:56:00.000   3649.037137674230    4066.713062297570    4041.087875829290   -2.48113069880176    6.11167106849188   -3.895207
-4.51475019652109   1.91409234687950   -5.88191917244246      13T20:00:00.000   2928.268561788060    5368.031574273560    2970.439269746340   -3.48868386495281    4.66647160845907   -4.972348
-4.78061953047373  -0.13052340049352   -5.97869836663036      13T20:04:00.000   1994.785928859950    6279.420687383220    1683.400523993040   -4.24289547075987    2.88213174226369   -5.687320
-4.69946531889258  -2.16393102855623   -5.64045491785379      13T20:08:00.000    916.406000083843    6734.699164411640     273.728049159044   -4.68878396296515    0.88886731975208   -5.988044
-4.27790635253951  -4.03813419697589   -4.89277499093456      13T20:12:00.000   -228.515234142188    6701.006765793610   -1155.891459735020   -4.79408240798064   -1.16762835838828   -5.852675
-3.54735201083472  -5.61768809659533   -3.79102310525966      13T20:16:00.000  -1356.870829689720    6181.201504484630   -2501.438779805890   -4.55170565910981   -3.13731810283648   -5.291891
-2.56124373406620  -6.78939241301157   -2.41574747743826      13T20:20:00.000  -2386.928704805380    5213.517197686530   -3665.239647055220   -3.98006068008203   -4.87731452535233   -4.347539
-1.39085705073794  -7.46987397341163   -0.86648126662432      13T20:24:00.000  -3244.275615444080    3868.556797735190   -4563.069832199240   -3.12129597986713   -6.26237584230665   -3.089078
-0.12013265248067  -7.61081354908066    0.74539594847745      13T20:28:00.000  -3867.135429804110    2243.967192889600   -5130.148354551330   -2.03785568620434   -7.19365650913949   -1.608015
1.16002172825819   -7.20182889679992    2.30418336666472      13T20:32:00.000  -4210.680051597140     457.292438977303   -5325.628139989180   -0.80767674588045   -7.60503733260691   -0.011101
2.35775620909071   -6.27134319368314    3.69761735900891      13T20:36:00.000  -4250.114246653120   -1362.404599040950   -5135.377922380100    0.48118385566155   -7.46713746158967    1.587042
3.38652523573800   -4.88498572682307    4.82453891051029      13T20:40:00.000  -3982.405047704630   -3083.626939200560   -4572.957011444390    1.73644308307067   -6.78918730751774    3.071572
4.17117850234163   -3.14183809935085    5.60215544251241      13T20:44:00.000  -3426.559416924300   -4581.714412248060   -3678.738612884460    2.86775211995748   -5.61868259584617    4.335163
4.65376632905441   -1.16791446843354    5.97256295061293      13T20:48:00.000  -2622.415171126620   -5747.756804305810   -2517.195215862380    3.79289875965812   -4.03873875160368    5.285324
4.79825948690259    0.89281519819475    5.90761611859873      13T20:52:00.000  -1627.949624526920   -6496.587541367610   -1172.449010505650    4.44393693501386   -2.16303785473353    5.852204
```

00.000	1739.102840687240	−5863.851232524870	2958.655469851300	4.38987853798857	3.82413886296183	4.98410793512033	14T00:04:00.000	20.720350921552	−6720.577794020150	10
00.000	2716.609639417270	−4743.913253841870	4032.335326075520	3.70632950482609	5.45153390145668	3.90853050565558	14T00:08:00.000	1162.091968640690	−6259.758853703210	23
00.000	3496.567809102410	−3278.982724386860	4811.953507099170	2.75376646104421	6.68157671303000	2.54868215622335	14T00:12:00.000	2218.902637155390	−5343.456168014070	35
00.000	4022.423946752600	−1575.750152926070	5240.882153249820	1.60175721550605	7.42538884296718	1.00401154162826	14T00:16:00.000	3114.329947239980	−4038.487509438670	44
00.000	4256.126929694410	241.933694002595	5288.074384281590	0.33396366625419	7.62962924069930	−0.61305508382644	14T00:20:00.000	3783.384656549880	−2439.935411203930	50
00.000	4180.799526220130	2042.046555234350	4950.218929138900	−0.95785903527230	7.27988896430819	−2.18519194554180	14T00:24:00.000	4177.589539186540	−664.111125184458	53
00.000	3801.923195410820	3693.888748512340	4251.929489441150	−2.18023518926272	6.40153736722450	−3.59836346600053	14T00:28:00.000	4268.430565456080	1159.942689647770	51
00.000	3146.959771408230	5077.484178457250	3243.992535021160	−3.24456582120177	5.05807507971920	−4.74979848179611	14T00:32:00.000	4049.356218072420	2899.772562632020	46
00.000	2263.416553488090	6092.285029124990	1999.759694288930	−4.07341210298192	3.34702171091429	−5.55541579597710	14T00:36:00.000	3536.240093264760	4429.023992595770	37
00.000	1215.453967306600	6664.571971710370	609.849025370248	−4.60633515144166	1.39304970135708	−5.95632959357511	14T00:40:00.000	2766.283161805670	5636.575331240110	26
00.000	79.217488423291	6752.922578697630	−824.483121200688	−4.80457798201423	−0.66101183641454	−5.92339189667873	14T00:44:00.000	1795.383363949810	6434.672190101700	12
00.000	−1062.785962105060	6351.290772238990	−2198.832632559340	−4.65421115753454	−2.66516136310748	−5.45968398621634	14T00:48:00.000	694.086644076776	6765.425968995480	−
00.000	−2127.784941383180	5489.328681685190	−3413.374265412120	−4.16692635079426	−4.47378224052130	−4.59997380873052	14T00:52:00.000	−457.604332874894	6605.094910664400	−15
00.000	−3038.788371880040	4230.017888049850	−4380.150238114700	−3.37883496722430	−5.95644675319970	−3.40767914037543	14T00:56:00.000	−1576.129947825360	5965.771182381920	−26
00.000	−3730.112475498090	2664.876718401010	−5029.357955479760	−2.34739804976319	−7.00712851463149	−1.96967750381438	14T01:00:00.000	−2580.518511668590	4894.351428689770	−39
00.000	−4151.991463098340	907.226230794056	−5314.222086199110	−1.14699462428602	−7.55114490063837	−0.38982467658136	14T01:04:00.000	−3398.264308566950	3468.892700521600	−47
00.000	−4274.014801338120	−915.940825347258	−5214.196625028890	0.13639892870988	−7.54979814066770	1.21842255446595	14T01:08:00.000	−3970.471617460340	1792.768294024200	−53
00.000	−4087.228715995750	−2672.912773882440	−4736.361161898150	1.41094019238518	−7.00269243305857	2.73958519772542	14T01:12:00.000	−4255.951605153570	−12.827696400399	−53
00.000	−3604.817180888110	−4236.527997398690	−3914.980777092010	2.58502948591123	−5.94799764979721	4.06388147226164	14T01:16:00.000	−4234.061483534600	−1817.487181218070	−50
00.000	−2861.290569357390	−5493.233215629040	−2809.219485835920	3.57359433418608	−4.46039966155797	5.09484424370357	14T01:20:00.000	−3906.150187792700	−3490.760550667700	−43
00.000	−1910.173266359620	−6351.354725927970	−1499.076215595340	4.30425782769403	−2.64657220950416	5.75644352445734	14T01:24:00.000	−3295.552339908830	−4911.370692457460	−33
00.000	−820.270342012682	−6747.965957472270	−79.719884905081	4.72289402169181	−0.63800243074787	5.99916910391353	14T01:28:00.000	−2446.083353126970	−5975.942772720320	−2
00.000	329.280450140400	−6653.754963982760	1345.432652637670	4.79819477039783	1.41844477810146	5.80434144975748	14T01:32:00.000	−1419.040522479060	−6606.636234263400	−
00.000	1454.866104935630	−6075.363847968100	2672.394220411490	4.52439771168946	3.37201653318164	5.18594167203770	14T01:36:00.000	−288.855421132134	−6757.064377345350	
00.000	2474.602320514010	−5054.904056654880	3804.357952236930	3.92155306742945	5.07974929222854	4.18939565371528	14T01:40:00.000	862.340178820549	−6415.924639609430	2
00.000	3314.371969813090	−3666.785208178410	4658.853482816510	3.03390780484892	6.41714915385568	2.88795874724207	14T01:44:00.000	1950.791921180790	−5607.937393274740	3
00.000	3913.247141332090	−2012.139992665730	5173.772832512930	1.92639647534473	7.28736389469072	1.37694700261518	14T01:48:00.000	2897.341039589230	−4392.007291581010	4
00.000	4227.870500299810	−211.328241103597	5311.807858216310	0.67956429946864	7.62789138307027	−0.23358707651046	14T01:52:00.000	3633.253319385430	−2856.758790575120	4
00.000	4235.505218755260	1604.827170151450	5063.045354025450	−0.61631067604741	7.41449542992081	−1.82673835809081	14T01:56:00.000	4105.187745496590	−1113.923505507050	5
00.000	3935.626297146890	3304.455846060100	4445.635521105060	−1.86748146383050	6.66273266026056	−3.28693237642800	14T02:00:00.000	4278.978390445480	709.827595730459	5
00.000	3349.966944060040	4764.122993288810	3504.488762133920	−2.98331370351458	5.42695272885317	−4.50805474071274	14T02:04:00.000	4142.057536346060	2482.035949806410	4
00.000	2520.995517927550	5877.761990431550	2308.088914079920	−3.88267449740428	3.79676557222310	−5.40099226593920	14T02:08:00.000	3704.344447084250	4073.994817753870	3
00.000	1508.900319860890	6564.463738247010	943.563864898830	−4.50001316991727	1.89093020343349	−5.90051089964201	14T02:12:00.000	2997.566009622990	5370.029514476470	2
00.000	387.208658761402	6774.460497596920	−489.687366920555	−4.79041788977168	−0.15140793998901	−5.97023436794238	14T02:16:00.000	2073.020635123950	6275.934072664760	1
00.000	−762.610672600456	6492.812371602870	−1887.309339807360	−4.73307084672017	−2.18099627155279	−5.60555723648395	14T02:20:00.000	997.887422479916	6725.933741659720	
00.000	−1857.169925855650	5740.452251700360	−3147.729140178150	−4.33286589827023	−4.05013107747782	−4.83404644079155	14T02:24:00.000	−149.702963309973	6687.578637084590	−1
00.000	−2817.287125092160	4572.450118345300	−4179.605149757240	−3.61966944412042	−5.62376744073230	−3.71278540130184	14T02:28:00.000	−1286.441712655190	6164.081734069710	−2
00.000	−3573.696397698710	3073.782483140140	−4908.388960703660	−2.64565221662453	−6.78917136577530	−2.32368558273536	14T02:32:00.000	−2329.981136415620	5193.952794786600	−3
00.000	−4071.931923353490	1353.035844493540	−5281.555728717540	−1.48121950164554	−7.46339943124633	−0.76723324389069	14T02:36:00.000	−3204.932283984660	3847.977448543590	−4
00.000	−4276.111439954640	−465.421384076150	−5272.214893513890	−0.20990051255017	−7.59855560972961	0.84467301216931	14T02:40:00.000	−3848.247361401200	2223.873890026120	−5
00.000	−4171.402617802930	−2250.244525415540	−4880.941414676880	1.07738681048189	−7.18468155901499	2.39634700624624	14T02:44:00.000	−4213.628123994740	439.147865703552	−5
00.000	−3765.090811647710	−3872.342594604430	−4135.761326296890	2.28827315039039	−6.25048203292560	3.77599589302279	14T02:48:00.000	−4274.711621653060	−1377.287377695700	−5
00.000	−3086.175828143580	−5214.035277150530	−3090.294348173680	3.33522743786955	−4.86189593817837	4.88338980418482	14T02:52:00.000	−4026.903667874520	−3094.181193431780	

THE INFINITE

THE INFINITE

●

HIRMER | Infinity
Experiences

Dedicated to the explorers—in space and on the Earth— who are willing to push the boundaries of the unknown.

This project was created with the participation of the following astronauts and cosmonauts:

NASA
National Aeronautics and Space Administration

Anne McClain
Christina Hammock Koch
Nick Hague
Jessica Meir
Andrew R. Morgan
Victor J. Glover
Christopher Cassidy
Douglas Gerald Hurley
Robert Louis Behnken
Kathleen Rubins
Shannon Walker
Michael S. Hopkins

Canadian Space Agency
David Saint-Jacques

European Space Agency
Luca Parmitano

Japan Aerospace Exploration Agency
Soichi Noguchi

Mohammed bin Rashid Space Centre
Hazzaa Al Mansoori

Roscosmos State Corporation for Space Activities

Oleg Dmitriyevich Kononenko
Aleksey Nikolayevich Ovchinin
Aleksandr Aleksandrovich Skvortsov
Oleg Ivanovich Skripochka
Sergey Nikolayevich Ryzhikov
Sergey Vladimirovich Kud-Sverchkov
Anatoli Alekseyevich Ivanishin
Ivan Viktorovich Vagner

	Title	Author

ISS Living Area

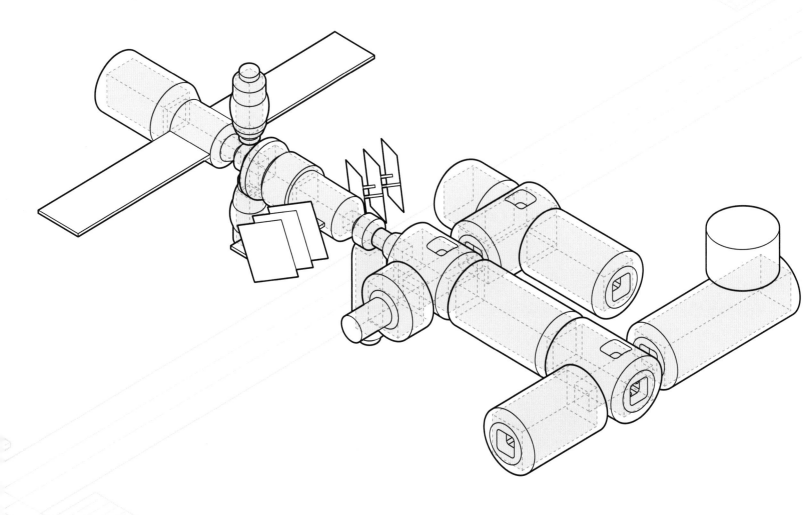

Zarya
Functional Cargo Block

Diameter: 13.5 ft
Length: 41.2 ft
Launch: November 1998

Unity
Node 1

Diameter: 15.0 ft
Length: 17.9 ft
Launch: December 1998

Zvezda
Service Module

Diameter: 14.3 ft
Length: 43.0 ft
Launch: July 2000
Windows: 14
Sleep stations: 2
Toilet: 1

"On the day of the launch, as I got closer to the launch rocket, it was like I shed off different parts of my life. I said goodbye to all my friends and then my family. I said goodbye to all of them. Then you get closer, and you change your clothes, you change into your launch suit, and you strip off the last clothes that you picked out and now you're wearing clothes that have been picked out *for you*. You're stripping away everything that is invented by humans until right before you're launching. It is the most rawly human that I've ever felt."

—Anne McClain

"After the main engine cut off and we went to microgravity, I could peek out and make out, for the first time, the crescent of the Earth. It's amazing... I mean, it is the complete absence of light. It's black. The blackness is so rich and the blue so distinct, and the crescent—it wasn't a sunrise or a sunset. It was this perfect emptiness. And then the blue of the Earth. We were at this point over an ocean, which, most of the time when you look out the window, that's what you see because there's just so much more of it. And I could see clouds and you could see the shadow of the clouds on the surface of the ocean, and that space between them was so tiny. It was unbelievable to imagine how high we were relative to those clouds, and how high clouds seem to you when you're on the ground and you look up. This just makes us feel so infinitesimally small."

—Andrew Morgan

"I will never forget the first time I looked down on the Earth. It was actually from the Soyuz vehicle, after we had gotten into zero gravity. We got busy with some things, and were following our procedures and, obviously, working with the systems. And then, during the next kind of quiet moment, I remembered: oh, I have a window. The copilot and pilot of the vehicle were monitoring some parameters and I was sort of on my own over there, in my seat. I opened the window and out there—just almost everywhere—was the Earth. It was so bright and so beautiful, and it was just such a perfect sphere. And I said: 'Oh, my gosh!' And I just said that out loud into the comm system. Then I realized, oh no, everything's fine—it's just Earth. And so I said that, so that all would know nothing was wrong. I was just in awe of Earth and couldn't help myself from exclaiming about how amazing it looked."

—Christina Koch

"It was a very visceral, very physically jarring, and very clear experience. When the engines cut off, we knew we were safely in orbit and that's when I experienced my first moment of microgravity. And it was just a very exciting time. We had our zero-g indicator: the child from the show meets the Mandalorian, and Baby Yoda comes out and is floating around. And it was just a nice moment when we could say: *Hey, we made it!* And then, when we came into the Space Station, I remember seeing these giant smiles. I just wanted to hug everybody. I wanted to celebrate that moment. It was such a long journey getting to this point! But also, I knew my family was watching, because there were cameras on and they could see all of us, all their family members, float through the hatch into the Space Station. And they could at least exhale and know that we were safe."

—Victor Glover

9

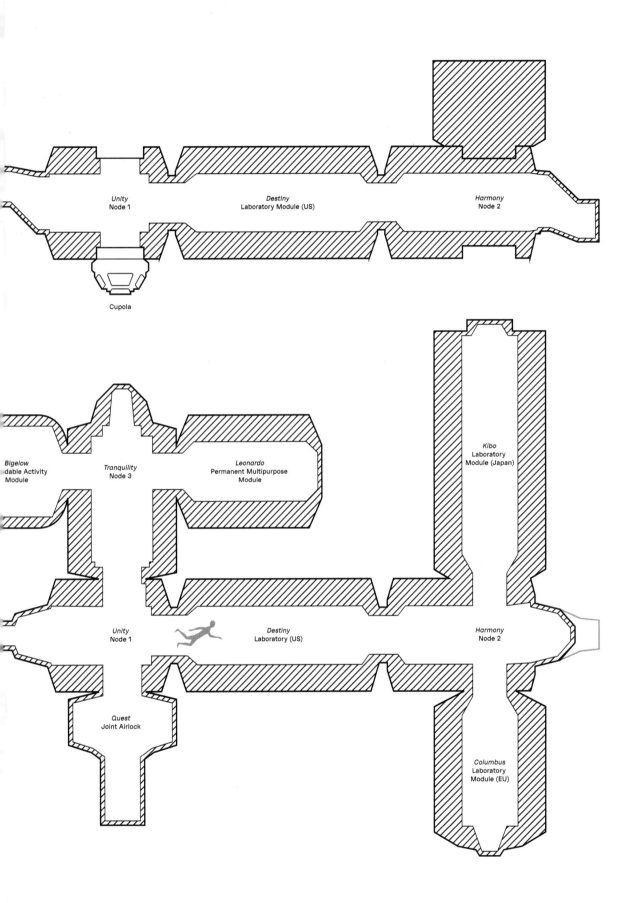

Unity
Node 1

Destiny
Laboratory Module (US)

Harmony
Node 2

Cupola

Bigelow
dable Activity
Module

Tranquility
Node 3

Leonardo
Permanent Multipurpose
Module

Kibo
Laboratory
Module (Japan)

Unity
Node 1

Destiny
Laboratory (US)

Harmony
Node 2

Quest
Joint Airlock

Columbus
Laboratory
Module (EU)

Poisk
Mini-Research Module

Diameter: 8.4 ft
Length: 16.0 ft
Launch: November 2009

Tranquility
Node 3

Diameter: 14.7 ft
Length: 22.0 ft
Launch: February 2010
Toilet: 1

Cupola

Diameter: 9.7 ft
Height: 4.9 ft
Launch: February 2010
Windows: 7

Rassvet
Mini-Research Module

Diameter: 7.7 ft
Length: 19.7 ft
Launch: May 2010

Leonardo
**Permanent Multipurpose
Module**

Diameter: 15.0 ft
Length: 22.0 ft
Launch: February 2011

Bigelow
**Expandable Activity
Module**

Diameter: 10.6 ft
Length: 13.2 ft
Launch: April 2016

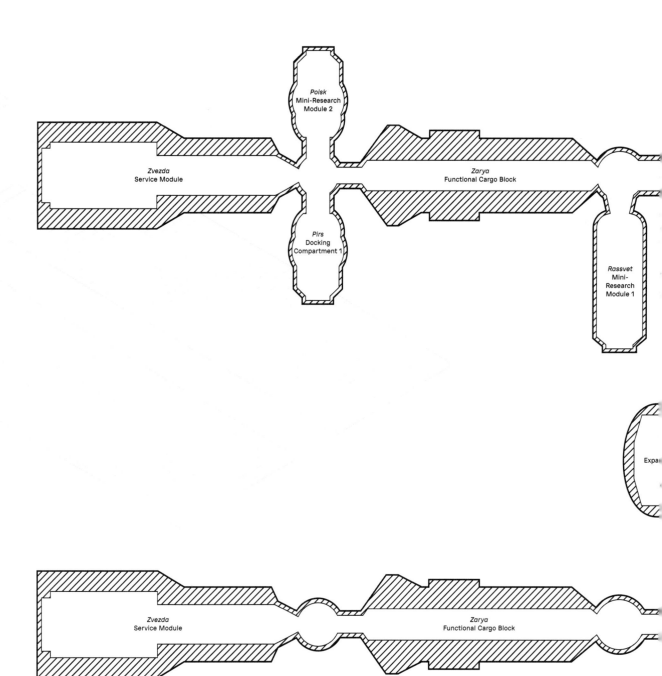

Destiny
Laboratory Module (US)

Diameter: 14.0 ft
Length: 28.0 ft
Launch: February 2001
Window: 1 (20 in)

Quest
Joint Airlock

Diameter: 13.0 ft
Length: 18.0 ft
Launch: July 2001

Pirs
Docking Compartment 1

Diameter: 8.4 ft
Length: 16.1 ft
Launch: September 2001

Harmony
Node 2

Diameter: 14.0 ft
Length: 24.0 ft
Launch: October 2007
Sleep stations: 4

Columbus
Laboratory Module (EU)

Diameter: 15.0 ft
Length: 23.0 ft
Launch: February 2008

Kibo
Laboratory Module (Japan)

Diameter: 14.4 ft
Length: 36.7 ft
(Pressurized Module) /
12 ft (Experimental
Logistics Module
Pressurized Section)
Launch: July 2009
Windows: 2

In 2016, Felix & Paul Studios began a collaboration with NASA to document the training of a new generation of astronauts through the medium of cinematic virtual reality (VR). The resulting production, a two-part series titled *Space Explorers: The Journey Begins*, was shown all over the world and brought audiences closer than ever before to the world of human spaceflight.

A few years later, Felix & Paul Studios forged a partnership with *Time*, the International Space Station US National Laboratory, and NASA, to send VR camera systems to the ISS for the production of a multi-part series titled *Space Explorers: The ISS Experience*. Over a period of almost three years, Felix & Paul Studios was granted unprecedented access to capture various aspects of the mission, including the daily lives of astronauts living and working aboard the Space Station. Together with the crew members of six different ISS expeditions, the team filmed hundreds of hours of fully immersive footage, including the first-ever spacewalk by ISS astronauts and extravehicular imagery captured in a 3D, 360-degree cinematic VR format.

As part of the global, cross-platform distribution for *Space Explorers: The ISS Experience*, Felix & Paul Studios and PHI Studio joined forces to create a large-scale immersive, interactive exhibition based on the virtual reality content captured on board the International Space Station. *The Infinite* is the result of their combined creative and technological vision.

—Stéphane Rituit
 Co-Founder/CEO, Felix & Paul Studios

—Eric Albert
 CEO, PHI

*I am working to bring
celestial objects like
the Sun and the Moon
into the spaces that
we inhabit.*

— James Turrell

The great vastness above us has long been a giant canvas
for our imagination. Since the moment humanity looked
up at the stars, we've been captivated by the cosmos. Our
fascination can be traced as far back as cave paintings,
with images of the constellations depicted along the walls.
We have come to learn that space is mostly empty and
so the significance that we give to the cosmos is largely
an extension of our imagination, our wonder, our ability to
dream beyond what we understand. This impulse to dream
the unknown has, time and time again, pushed us as a
civilization, influencing artistic developments, scientific inno-
vations, and human consciousness.

Interest in outer space has been quietly returning to the
public consciousness and today enjoys a popularity unseen
since the space race decades ago. We are living in one of the
most exciting time periods for space technology. Alongside
these developments, we are seeing a rapid acceleration in our
ability to capture and share these moments via new media.
NASA has long recognized the importance of artists—their
ability to capture the emotional and cultural significance of
past and future space initiatives, and their capacity to inter-
pret the impact of the space program.

Culturally and socially, space has always been defined
as the area beyond what we are capable of reaching. With

recent advancements—not only the entry of private entre-
preneurs into the aerospace industry, but also innovations
in VR technology—maybe it's time to redefine what space
means to us as a society. Mirroring the technological progress
that has facilitated the orbital Space Station are advance-
ments in how art integrates technology.

PHI has always been dedicated to the intersection of art
and technology, and we see ourselves at the vanguard, push-
ing the boundaries of what is possible. With *The Infinite*, we
designed an experience with the collaboration of Felix & Paul
Studios that would reconsider how we approach themes of
space exploration. In this collaboration, we wanted not only to
cast the International Space Station (ISS) in a new light but to
do it in a way that places the visitor's experience at the center.

We're discovering that our audiences are making a tran-
sition toward becoming digital citizens. We're seeing people
pivot toward and adapt to new information technologies to
participate in social activities and influence, in turn, how they
experience art and culture. The pandemic has only acceler-
ated this process, as a result positioning virtual reality (VR)
technology at the forefront of the future of storytelling—and
that is inspiring.

*Scientists have many
of the same issues when
they look for hidden
things as artists do.*

— Laurie Anderson

Crucial to *The Infinite* was the development of an artistic
language that places visitors at the center of the journey and
accords them the agency to engage freely with the content,

11

explore the architecture of the exhibition scenography, and glean a unique understanding of the science. To achieve this, we expanded upon the immersive qualities of VR by designing and embedding the content within a physical architecture that incorporates mixed media, lighting, and acoustics. The effect situates the audience within an immersive experience even before they touch any equipment and well after they complete the VR component.

The software and interface that we have developed with our collaborators incorporate free-roaming technology into the experience, not only to allow visitors to share their collective experience but also to underscore the liberty they feel in creating their own, unique journey.

Much of our content was made possible by new developments in new media technologies but also through the willingness of the ISS astronauts to share their daily lives aboard the station. They are present on the Space Station as scientists, but their intimate documentation speaks to the human aspect of this massive undertaking. The ever-evolving body of content captured in space is made possible by Felix & Paul Studios in collaboration with TIME Studios. This immersive experience is anchored within an imaginative and scientifically accurate exhibition, while the astronauts' testimonies to daily life in outer space paint a portrait of the work being done above our planet, setting the stage for future exploration.

Rather than simply reproduce images for the viewer to gaze at in wonderment at our capacity as a species to push beyond our limits, we focus instead on immersing the spectator in that experience. It is our hope that this may render the sensation of space more accessible. Making this documentation accessible brings these moments back down to Earth and gives visitors an opportunity to bear witness firsthand to the developments being made on the station. In so doing, *The Infinite* provides an avenue for visitors to reflect on humanity's place among the stars, and to live in this moment together.

As humanity develops the tools to create sharper images of the cosmos, so, too, do these tools and technologies affect artists and their techniques. Our progress is thus not limited to improving the fidelity of our representations; for the tools that we create shape our relationship to space and our ability to imagine the vastness beyond our planet.

It's simply a manipulation of numbers and relationships, like a musical composition. It's very different from the sort of visual art where you're looking through the surface of the painting or the sculpture to see what it represents.

— Ryoji Ikeda

We are honored to have renowned artist Ryoji Ikeda create a site-specific work that visualizes and sonifies a different dimension of the space program, one that reframes the microscopic to the human, to the macroscopic. By orchestrating sound, images, physics, and mathematics, Ikeda reconceptualizes the notion of the infinite by challenging the limits of human perception using data-driven research and digital

technology. Image formation is a fundamental tool in humanity's attempt to bring the cosmos within reach. Ikeda anchors his work in science as well as art, as a means of understanding the world.

In 1969, more than 600 million people watched as networks broadcast the Apollo 11 lunar expedition live over the space of 31 hours. Satellites beamed images back to Earth in real time, and the Earth watched along, captivated, as we as a species took our first steps toward the stars.

Now, more than fifty years later, the balance of power between nations and corporations continues to frame and shape how we as a civilization expand beyond our planet; yet despite such limitations, the International Space Station stands as a symbol of what an international community may achieve when we work together. *The Infinite* aims to recapture an appreciation similar to that which the Apollo 11 mission instilled in humanity: to inspire optimism because of what we as a species are capable of accomplishing and to celebrate our ability to come together, once again, behind a common dream.

—Phoebe Greenberg

Long ago, in their yearning to understand the properties of light and vision, the Greeks theorized that our eyes emitted luminous beams—that, like lanterns, they diffused light generated by an inner flame, allowing us to discern objects, landscapes, and living beings. This lovely metaphor suggested that a fire burning within the body gave human beings the ability to see, study, and understand the world in which they live.

Only much later, in the eleventh century, did the Arab physicist, astronomer, and mathematician Ibn al-Haytham arrive at a crucial insight. While being held captive in Egypt, al-Haytham was inspired by a beam of light filtering into his dark room and realized that if we are able to see, it is because the thing we gaze at is lit by a beam of light from elsewhere, reflecting off its surface before reaching our eyes. This light, then, is independent of us: it comes not from inside the body but from without, and its source is far above us, in the fire of the Sun, well beyond what is perceptible by the human gaze.

In dedicating his life to studying the trajectory of light, the optical phenomena of refraction and reflection, and the mechanics of the eye, lenses, and mirrors, this thinker made discoveries that later inspired countless theories and inventions, and yielded repercussions for both art and science.

We can imagine, by extension, that al-Haytham's novel perspective on the mechanics of vision and its connection to the Sun helped spark human curiosity about the light of the sky, and amplified the voice of a silent appeal from the heavens and the stars.

Where do we come from? What are we? Where are we going? The title of this work by the nineteenth-century painter Paul Gauguin clearly evokes the burning desire to understand, sustained by that flame kindled in the hearts of people of all backgrounds and beliefs.

To this day, this metaphorical inner fire that lights our eyes continues to ignite us. Our view of the universe has been steadily focused, refined, and clarified thanks to advances in space science and the boundless courage of the men and women who explore the cosmos. We have walked on the Moon, floated free in space. Yet our understanding of the universe is still incomplete, and the field of potential exploration still as vast. The realm of things unknown to us seems to extend to infinity, and this perpetual appeal to our curiosity informs the beauty, mystery, and richness of our existence.

For decades now, first through television and the print media, and later the democratized access to information afforded by the Internet, we have been able to witness—at a great distance but in real time—those space explorers' adventures. Their exploits and voyages have nurtured our collective imagination and fired the dreams of millions of children all over the planet, lured by the fantasy of interplanetary and interstellar odysseys. The literary and filmed works inspired by those quests have also played their part in enriching the spectrum of hypotheses and possible (hi)stories.

Children of the digital age, Félix Lajeunesse and Paul Raphaël are explorers of another kind of space, rendered with the aid of light. Their shared passion for cinema and its more immersive formats brings us closer to the source, or sources, of that light, whose eternal attraction continues to encourage us to explore and to excel. Using the tool that they have created—Felix & Paul Studios—they have undertaken an astounding cinematic odyssey together with NASA and its astronauts. This adventure, *Space Explorers: The ISS Experience*, dazzles and impresses on myriad levels.

The filmmakers cast an admiring gaze on these intrepid space travelers, which we, too, may share, thanks to their mastery of the science of image-making and their documentary perspective on the International Space Station and the life experiences of its crew members.

As with cinema, it is through our eyes that we are able to appreciate this world. But thanks to advances in virtual reality, which have expanded the horizons of cinema, it is as though our bodies have made the journey to the ISS as well—a consequence of the three-dimensional rendition of reality in which we find ourselves.

We are physically engaged with this environment, free of gravity's pull, as the men and women of science who inhabit it busy themselves and move around us like so many floating sea creatures. We are privileged witnesses to their day-to-day activities, and their confidants as they sensitively reflect on their adventures. The astronauts' openness and generosity in lending themselves to this entertainment venture, whether in operating the camera inside the station or sharing their personal perspectives on their experiences, enhances the welcoming nature of the enterprise and underlines its uniqueness. This feeling of being so close to them, when in fact we are so far, is mind-blowing and unsettling. We can make the trip to be by their side at lightning speed simply by slipping on a VR helmet, and then return to our earthbound reality the minute we take it off, still permeated by the fantastic—yet very real—traces and impressions left by this abstract romp.

This immersive installation experience, a tribute to light and space which we have titled *The Infinite*, was developed on the initiative of Phoebe Greenberg and Studio PHI, in association with Felix & Paul Studios, as a showcase for the filmmakers' one-of-a-kind collaboration with NASA. It is the fruit of an adventure that demanded more than two years of research, exchange, and international collaboration. The spectacle of the ISS floating hundreds of kilometers distant from any visible border, its narrow confines sheltering allied explorers of diverse backgrounds, can only awaken the best in us and quicken our desire for peace.

Besides creating a showcase for the work of Felix & Paul Studios, the impetus behind *The Infinite* was to reinvest in a close dialogue between science and art—for the former is a source of inspiration for the latter—and convey the poetic and spiritual magnitude of this adventure and the reflections it arouses in us.

The team's aim is that the touring version of the installation will be in a format accessible to all, so that as many people as possible can share in this experience of body and space as explored from a singular, innovative perspective of moving freely through an open expanse.

Visitors to the exhibition can also admire a new piece by the internationally acclaimed sound and visual artist Ryoji Ikeda, whose works, predicated on humanity's relationship to science and the cosmos, consistently captivate and astonish by their beauty, complexity, and intelligence.

A team of artists, researchers, and technicians had to be assembled to make this enterprise possible. This experience is the outcome of their collaboration. I have the honor of being part of that team. As I write these lines, the most exciting moments of the project, which will form the crescendo of this exhibition, are about to be captured. For the first time ever, an EVA (extravehicular activity) will be documented in virtual reality thanks to the teamwork of Felix & Paul Studios, NASA, and the ISS astronauts. The images will enable visitors to *The Infinite* to virtually accompany, in starkly realistic fashion, a pair of ISS astronauts on a spacewalk. Transported into orbit, with only their own bodies floating in space as conveyance, spectators will be able not only to witness the outside of the station, a giant insectoid drifting in microgravity, but also gain some sense of what spacefarers call "the overview effect." This expression was coined to describe the powerful shift in mindset experienced by those fortunate enough to look down on our planet from above. Astronauts will tell you that the emotion stirred by the sight of Earth—beautiful, floating amid the unfathomable vastness of space, protected by its gossamer atmosphere—is unlike any other. It is a feeling prompted by an ineffable moment of clarity and awareness: how incredible it is that we should have sprung into existence in the heart of this infinite cosmos, so dismal, so hostile to the development of life! This profound apprehension of the miracle of the evolution on Earth of living species imparts a compelling, staggering feeling of compassion and empathy for all living things.

Through the images captured via this experience, the camera eyes focused upon us from this magical vantage point

on high recall the light source that inspired our ancestors, the great seekers and artists of our distant collective past. Light, at once inspiration and raw material, is the source of all ideas. That inner flame by which we see, as the ancients believed, and the light of stars shining in infinite space, remarkable in its shapes, movement, and colors: these sources of light reflect and echo each other. Sustained by that warmth, our thirst for knowledge—universal, unavoidable, forever unquenchable— now impels us to search further still, beyond brightness and into a darkness of unimaginable depth, for clues and answers to the mystery of why we are here.

We hope that this book provides a way for all those who journeyed on the odyssey of *The Infinite* to relive and extend the experience. And that for everyone, its contents, its tracery of images and thoughts, conversations and fictions, will inspire you, feed your dreams, and help you embrace the awe that you feel as your gaze traverses the vast, boundless realms of the unknown, of all that remains to be discovered.

Above all, may it help us all to reflect on the miracle of our human existence, by turns limned in light and sheltered by shadow.

—Marie Brassard

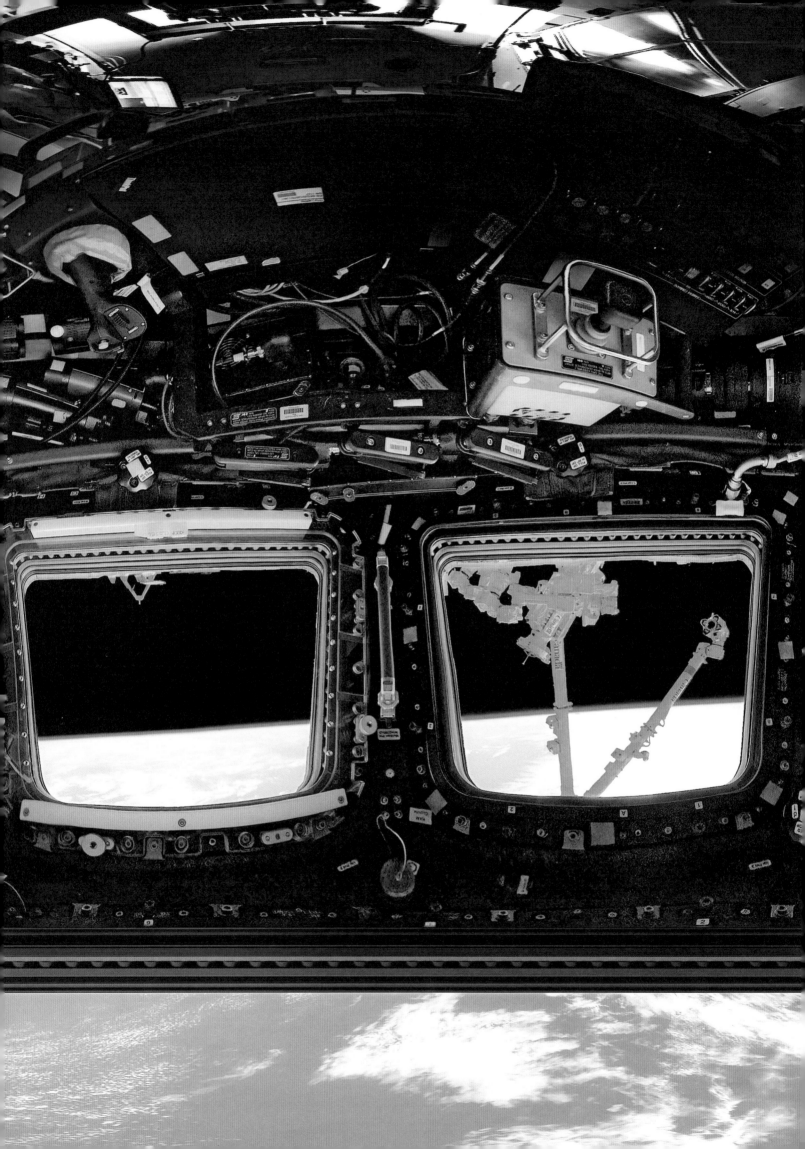

"I remember the first time I looked outside: it was just almost too much to take in. There were so many nuances and so many colors and so many things happening at the same time. It was overwhelming. It's just so new and so different. And the deserts that I am used to seeing as brown and terra-cotta and ocher. Some of them are now white because they get covered in snow. It just fills me with wonder. And my mind wonders, thinking about the people that live there, the animals, the nature—what would it look like from down there? How, what would it feel like to walk in those deserts, to climb those mountains? What is the weather like right now?

—Luca Parmitano

"I didn't go straight to the cupola window when I arrived. I wanted to save that experience. I wanted to have music in my ears, and I really wanted it to be a special moment."

—Andrew Morgan

"We were down at one of the southernmost points of our orbit and ... and we could see the southern lights. They were lighting up in these ghostly hues of green that just kept wandering and moving ever so slowly —with the naked eye there—these faint, ghostly little apparitions were dancing on the horizon."

—Nick Hague

"One of the views I had from the cupola was flying over Africa. It was the east coast of Africa that we were passing over at that moment, and the colors, all of the different colors of the sand and of the Earth melding together. It was really this breathtaking vision, and then, coming out into the water, the colors and the different clarity—that we can see things from up above—is really astounding. One of the things that really struck me about the view from the cupola is that I instantly felt much closer to the Earth than I'd ever seen or felt from any picture that I've seen taken from the Space Station."

—Jessica Meir

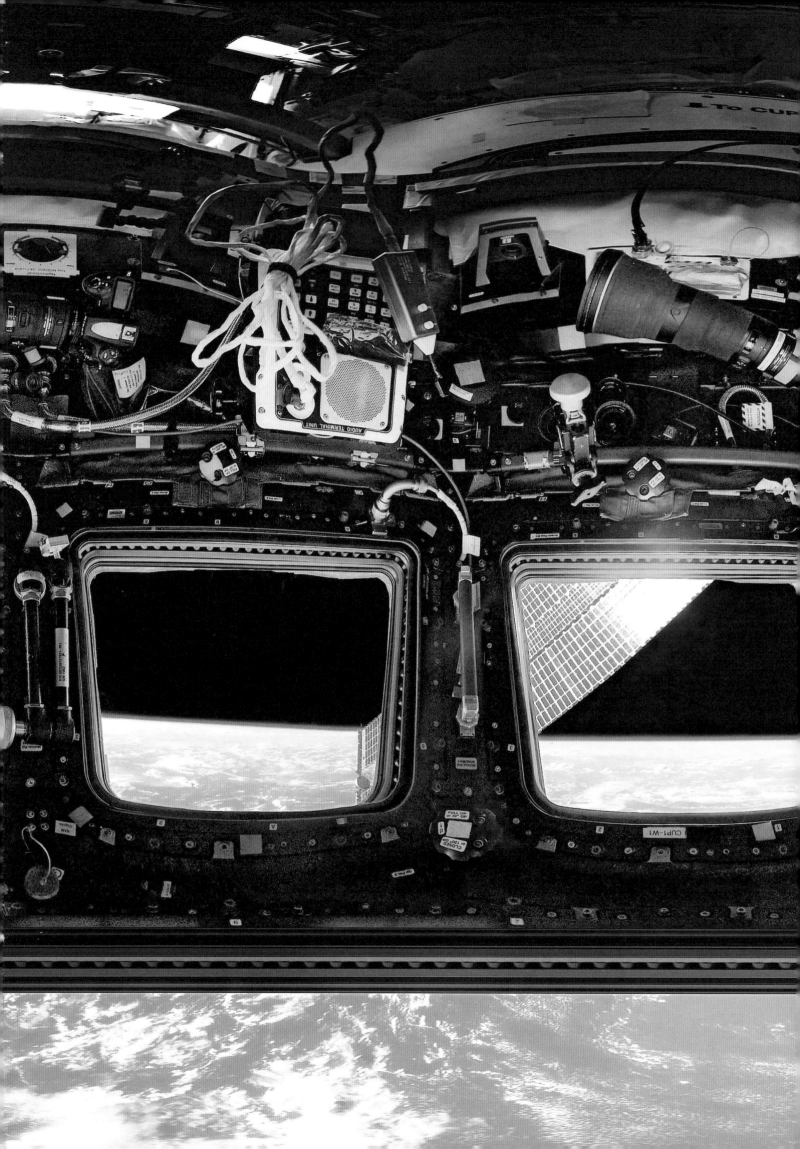

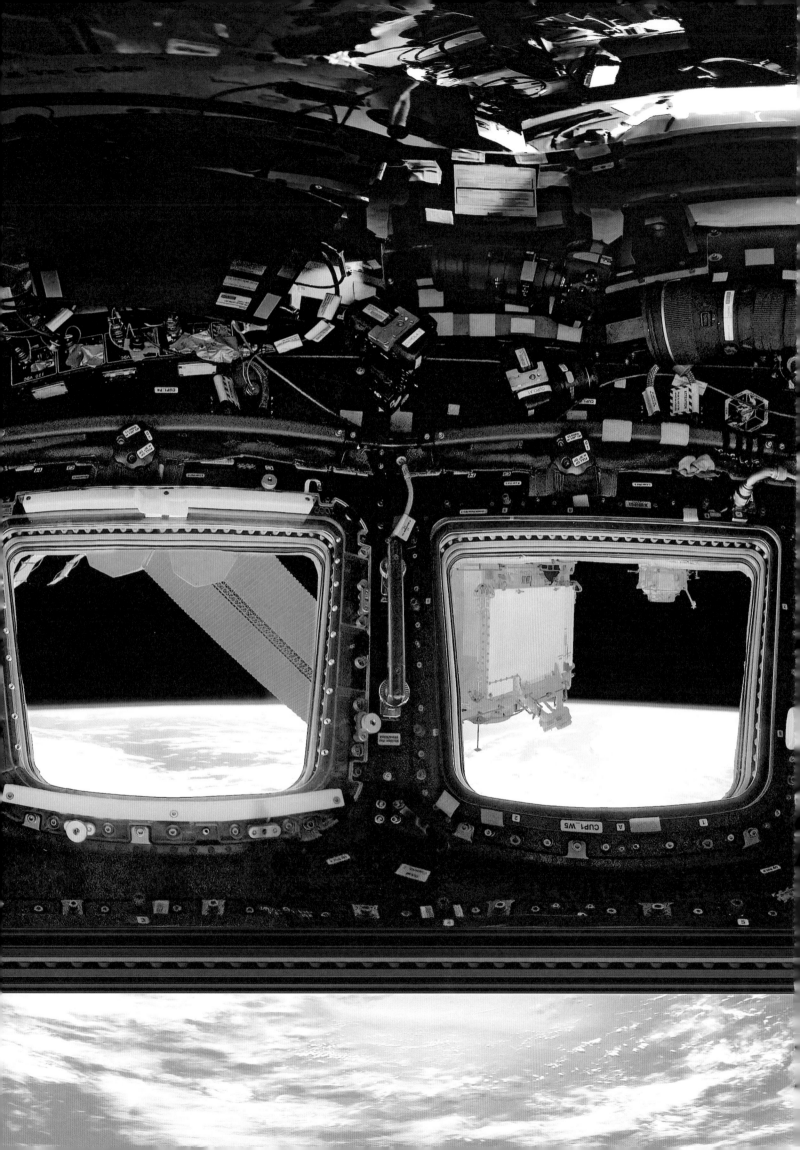

Earthrise, taken on
December 24, 1968 at 16:00 UTC
by Apollo 8 astronaut
William Anders.

Modified Hasselblad 500 EL
with a Zeiss Sonnar 250mm f/5.6 lens.

The Blue Marble, taken on
December 7, 1972 at 10:39 UTC
by Apollo 17 crew: Gene Cernan,
Ronald Evans, and Harrison Schmitt.

Modified Hasselblad 500 EL
with a Zeiss Planar 80mm f/2.8 lens.

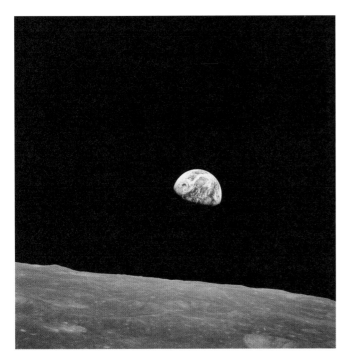

Earthrise, taken on
December 24, 1968 at 16:00 UTC
by Apollo 8 astronaut
William Anders.

Modified Hasselblad 500 EL
with a Zeiss Sonnar 250mm f/5.6 lens.

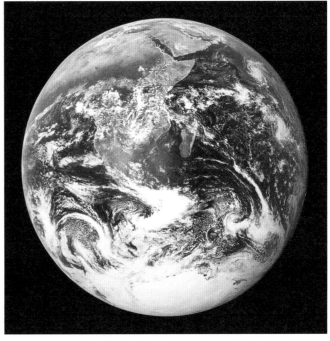

The Blue Marble, taken on
December 7, 1972 at 10:39 UTC
by Apollo 17 crew: Gene Cernan,
Ronald Evans, and Harrison Schmitt.

Modified Hasselblad 500 EL
with a Zeiss Planar 80mm f/2.8 lens.

Immersed in the Overview: An Interview with by
Presencing Oneself Félix Lajeunesse Tracy Valcourt
in *The Infinite* and Paul Raphaël

It has been argued that the most enduring legacy of the NASA space program comes in the form of images, notably *Earthrise* (Apollo 8, 1968) and *The Blue Marble* (Apollo 17, 1972). These photographs were invested with a sense of universalism that harnessed the awe of the astronauts, who were rare witnesses to the Earth from afar and who attested to its regal fragility being set in, not against, a backdrop of pure space. Both images were poetic in their flawless simplicity. *Earthrise*'s magic is in its uncanny resemblance to a terrestrial landscape, whose tension rides along the "horizon line" of the Moon's irregular surface as an airless proxy for a pastoral setting. In the place of the Sun is Planet Earth. As in a more traditional, earthbound landscape, the horizon line serves as the viewers' anchor point, which orients them to the space displayed before them. Spectacularly curated in this frame is a constellation of spatial orientations between Earth, Moon, and spacecraft. It is a relationship between bodies: celestial, human, and technological. Meanwhile, the impact of *The Blue Marble* is in seeing Earth untethered, a body unmarked by artificial lines, which on Earth manifest as borders, and upon a globe as a graticule.

In both cases, as in all images, there are of course other bodies in proximal or distant relationships with the things being represented and the materials forming that representation, which is that of the viewer(s). To visually engage with an image, as it is to engage with living subjects, inert objects, or environments natural or built, is an operation of presencing that asserts: "I am here." It is an orientational conclusion: I am here because that other body is there; I am here, you are there, held by physics, proximate to other bodies, in relationship to architectures and atmospheres. When looking at images, consensus holds that we are outside of the document and at a distance, both temporally and spatially, to the worlds held within it.

Up until now, the vast majority of humans have understood "home" as a planetary conception through image and imagination. What might happen if "whole Earth" knowledge could extend past the ocular to a more haptic experience of place that manifests itself not just at, but around, a human scale that emplaces the body so convincingly that the "overview effect," the profound acknowledgment of the interconnectivity of life systems that astronauts experience, could be felt by an earthbound individual? What reimagining of experience, reordering of knowledge, reorientation of faith or philosophy—what kind of world re-picturing might occur if invited into spaces so novel that they cause one to intensify observations and more precisely calibrate movements to honor those environments? Virtual reality gives entry into such potential and responds to curiosity by intensifying it. At the heart of *The Infinite*, and in the minds of its co-creators at Felix & Paul Studios, exists an authentic desire to immerse, to share, to include, to activate, in the belief that experience should not be reserved to singular realms

or exclusive individuals. By inviting us aboard the International Space Station, they present a multisensorial exercise in wayfinding and coexistence that encourages both expansive views without and profound seeking within.

This interview is the culmination of a series of conversations with Félix Lajeunesse and Paul Raphaël, co-founders and creative directors of Felix & Paul Studios, which took place via Zoom in March 2021.

T. Valcourt

To set the foundation for the discussion, perhaps you could talk about the progression of your filmmaking careers in which you sought to create increasingly immersive experiences.

F. Lajeunesse

When we got started in immersive media, the thing that we were trying to go for was emulating or creating a sense of presence through a media experience. Prior to doing virtual reality, we spent years exploring how to create a sense of total immersion, or presence, by using other technologies such as holography and stereoscopy projections—projecting inside of environments and making audiences a part of those environments. We were aiming for presence without really knowing where that would lead us. Films are an evocation of experience with the physical world, but it's not a direct representation of experience. It's an interpretation. There's a limit to the depth of how much you can actually feel present inside of a film. We felt that for a very long time. The films that we loved the most were those that had very strong experiential qualities, such as the cinema of Yasujirō Ozu, the Japanese filmmaker who was creating immersive arts from our perspective in the 1950s, and *2001: A Space Odyssey*, and work by the Chinese filmmaker Jia Zhangke.

T. Valcourt Ozu was known both for the technicality of his film work and for his treatment of narrative. He had an eye-level manner of filming in which the gaze of the viewer met that of the actor, causing the viewer to feel more directly implicated in a scene. I can see obvious linkages to your thinking around virtual reality.

F. Lajeunesse Between 2010 and 2013 was when we started our shift and began creating stereoscopic films that were rather slow and contemplative. During this period, we began exploring a more immersive approach to cinema. We did a lot of in-depth research, exchanged many references, watched a lot of films, and looked at a lot of art in an attempt to define what we were attempting. There was no established language to describe what we wanted to do. We felt a need to anchor our work to some tradition, yet we didn't know where to find that tradition. We looked in different eras of cinema and went all the way back to the '50s and '60s, with Ozu. What struck us about his celebrated *Tokyo Story*, for example, is the simplicity of the storytelling itself. I think it is the experiential quality of the film that makes it great, even though the narrative is very light. The way it is filmed is so deep—the execution of it and the process by which it was created—and if we were to qualify that depth, it's all in the quality of the observation that created this perfect synergy between the form of cinema that he was practicing and what you see on the screen.

T. Valcourt It is as though Ozu treated the camera as if it were a person and filmed with this sense of relationship that imposed presence.

F. Lajeunesse When you look at what is known as the "tatami shot" that he used in *Tokyo Story*, and in other of his films, which necessitated his team

30

to design a tripod that would allow a big 35 mm camera to be at the same eye level as someone sitting down or kneeling down on the tatami mat—it was a technical problem that they had to solve. The whole point was to make you feel like you're not just watching people around the table, but you're around the table with them and experiencing a meal with them. At this level of immersion there is a kind of erasure of the camera, so that you feel like it's you who is there. You can feel that, and there's such a profound and hypnotic and emotional quality about that transparent approach to cinema, which is one of the reasons why his work holds such enduring fascination for us.

T. Valcourt

There is a scene in *Space Explorers: The ISS Experience* (the VR film work included in *The Infinite*) where you experience this kind of intimacy, as you rub shoulders in virtual space with one of the astronauts at a mealtime gathering. It is a split-second moment, but it is remarkable. It plays with spatial orientation while leveraging the Space Station's sense of confinement.

P. Raphaël

The ISS is actually quite small. It's huge in terms of orbital objects, but it's cramped by normal Earth standards—especially if you're going to be there for so long. Some astronauts have been up there for as long as a year. The claustrophobia and the repetitiveness of the few modules you can actually be in is an overwhelming aspect of this project, you could say. In terms of environment, it is more difficult for a virtual reality camera to capture proximity than it is distance. The project offers significant technical and logistical challenges, as every shot that we shoot from Earth implicates dozens of NASA employees who are validating the position of the camera.

Modified Hasselblad
data camera

Felix & Paul Studios' camera
used on ISS expeditions 58 to 65.

This means that we only have partial control over what's going to happen while we're shooting. For artistic, technical, and safety reasons, the camera can't just be anywhere, and ideally you don't want to be stuck against the wall or anywhere too close to things. The Space Station provides an interesting challenge, because there are only so many ways you can film people in such an environment. You have a corridor, and you don't want to be too close to any walls, so you usually end up in the middle of the corridor as much as you can, and then you usually have this *point de fuite*, or vanishing point.

T. Valcourt

In painting, for example, this was foundational for establishing a sense of spatial regression, while here you seem to use it as a strategy to invite us deeper into the experience of the Space Station.

P. Raphaël

This vanishing point is almost always behind the astronaut, and consistently frames him or her in a certain way. And that is just inherent to the combination of many factors, which produces an interesting effect—a sense of navigation through the space. It takes weeks for astronauts to develop a kind of 3D map of where they are and how to get around, and we were not sure how that would reflect for someone entering into a virtual experience of this environment, which is, in a sense, chaotic. There's stuff everywhere, but if we can offer a logic, then people can navigate themselves through it, which helps to metabolize the space in a way that simply looking at it cannot. Just looking at it could be very overwhelming. This order, this sort of symmetry partially provided by the vanishing point, helps keep the chaos under control. It gives the visuals a Kubrickian sense of order or symmetry, as in *A Space Odyssey*, which serves as a counterpoint to the chaos, the proximity, and the claustrophobia.

34

T. Valcourt

There was a convincing sense of claustrophobia in certain instances, for example, when the astronauts were preparing to depart Earth in the capsule destined for the ISS. Invited into those spaces through VR, you do sense your body pressing in on you. I don't think that in regular cinema you get that.

F. Lajeunesse

In cinema, you can fake it. That's what the whole language of tele-photo lenses and things like that is mainly designed for, but you cannot really, completely, live it in cinema. You can allude to it, you can evoke it, but you can't viscerally *live* it. Maybe after a while, if you create a whole film captured with telephoto lenses inside of a small environment, after a couple of scenes, you will start to feel a sense of claustrophobia, for sure—but it's something that you will really have to build because it's an artificial recreation of the real thing. Inside of virtual reality you can, from second zero-one, you can feel it viscerally, which is very different.

T. Valcourt

In emphasizing a sense of presence, the focus is on the human *being* rather than as a character developed, given particular motivations, and pushed toward certain ends. The narrative arc is replaced by a kind of reassuring, measured cadence.

P. Raphaël

Traditionally, even when a story is about a character, or characters, it's more about the story than the characters themselves. They're just there to attach all the story points together, more than anything else. By focusing on the people and being attentive to their quotidian gestures of being there, of *being*, we hope to convey the experience of the astronaut aboard the Space Station as one described both by profound solitude and an extreme sense of intimacy or community.

We felt that centering on the human experience would be the best way for the viewer to actually feel and experience what's happening, rather than absorbing it as plotline that contributes to an internal dramatic curve of where the story is going. I don't think anyone at any point, when watching this series or roaming through the exhibit and experiencing these moments on the ISS, is wondering, "I can't wait to see what happens next." They might be looking forward to the spacewalk because they know there's a spacewalk involved, or a view of Earth from the cupola, but it really isn't about what's coming next; it's about what's happening now and that's the core presence. By leaning away from story and more into character, you create less of a sense of "I want this to be over so that I can know what comes next," which is how most stories make you feel. That's the antithesis of presence. We very consciously took this approach, and it's an approach we take in almost all immersive storytelling that we've done since before VR, as Félix mentioned earlier.

T. Valcourt

I like this idea of a narrative that's not pushing toward conclusion. You really do get so immersed in the storytelling that you're not craving development, you're not reading action in terms of introduction, climax, denouement. This seems an accurate evocation of presence as a condition that attenuates to the "now."

F. Lajeunesse

I would like to add something to that, because that's exactly right, what Paul said—but I also want to put that in a different context. When we started the process of editing, we were in front of hundreds of hours of material. We were going through it all, and it was so rich and so dense and there was so much to it, that we quickly realized we could do twenty different takes or twenty different versions of

this whole series. There was a point, I remember, we were in the editing room when it occurred to me that we needed to approach the project as anthropologists in the year 2500 who are tasked with its analysis. I was thinking what we would find in there is the inception of the expansion of humanity into space, the first community of settlers who have lived for a long time outside of the confines of Earth. Anthropologists from the future would not be interested in cliffhangers and what happens at the end of episode one as a driver toward serial development of drama. It would be the nature of each moment that they're observing. With this in mind, we sought to capture the purity of experience at an important moment in time and place. It's not to add to the noise, to the ambient noise, of our cultural moment. The world doesn't need us to do that, but we said, let's try to capture this critical moment in time and let's try to make that something worthwhile and worth it for the present, but also to future audiences.

T. Valcourt

This focus on capturing the authentic moment seems to reinstate some faith in the documentary status of images, which is certainly dwindling in a contemporary visual culture invaded by cheap fakes and synthetic media.

F. Lajeunesse

We knew that we wanted this production to be 100 percent made in space, and that was not to find a marketing angle that was cool for the project. It was about honoring authenticity—that everything that you see and hear in this production was captured in that particular environment at that particular time.

T. Valcourt

Something essential about *The Infinite* is that people will have the opportunity to experience it in groups, to share the experience with

others. In this sense, avatars become vehicles to experience. What kinds of considerations went into the development of this aspect of the project?

P. Raphaël

We have to balance quite a few things when thinking about the avatars. First of all, we knew we needed avatars because we'd have many people in a physical space. Whether or not COVID is around, they don't want people to bump into each other, but even more so these days. We knew we needed a representation of the user. We've talked a lot about presence and how important that is to us, and your body is a large part of what makes you feel present. We came up with this star beam that is translucent. It's visible, but also you could see through it; it doesn't block your vision of the ISS. If you're surrounded by people, it's in the theme, it's in the style, it's androgynous, so that everyone can embody it regardless of gender. It doesn't have legs, because we're not tracking your legs, as the body kind of dissolves in particles as it reaches the floor. These are all different considerations we had to go through, and had to work through, to get to where we ended up.

F. Lajeunesse

Yes, and on the far less superficial level, it's fun.

T. Valcourt

Yes, *fun*! Let's say that out loud. It needs to be said. [laughter]

F. Lajeunesse

Yes, because actually this is an essential concept. We are proposing an experience and inviting people on a journey. They are going to be experiencing cinematic virtual reality content that we captured in space, but also walking from one hotspot to another hotspot. That in itself needs to be physically engaging, needs to be fun. This needs

to be an experience that you wouldn't necessarily have inside of your home. You're with other avatars inside of a space, and you're interacting with things. When a scene begins, there is nothing else for you to do other than experience the scene; but in between the scenes, it gives you a certain pleasure to grab objects, to throw things around, to walk around, to go in and out of the Space Station. For me, the avatar is like a vehicle, and it's actually fun and engaging to be inside of that vehicle, and to use that vehicle to explore. There are also all of the levels that Paul talked about that I think are very interesting in terms of the embodiment and all that, but there's also just the simplicity of a convention that allows you to be inside of that environment and to feel the environment through that convention, through that avatar. It's going to be very interesting to see the collective experience of having ninety people, at the same time, embodying this avatar and interacting with one another. It's going to be the first time that something like that is made. I'm very much looking forward to seeing how people respond to it, and how they feel about the nature of that experience. I think we'll learn a lot from that.

"Sharing the experience of living in orbit is truly the aspect that I'm going to miss the most. It's life. We're living up here. It's not a short mission. The times that I've shared, the quiet moments, looking out the window with someone, talking about places on the ground and what it reminds us of, floating around the dinner table and sharing a meal and telling some stories, or asking how each other's families are doing and talking about what they're going through. Those are the special times that I'm going to remember most. The interactions with my crewmates, the shared experience of living in space."

—Nick Hague

"I had really become so accustomed to living in space, and even to things like floating and just kind of the physicality of being in microgravity, that I forgot that I was even in microgravity and that it was something unique. I joke that until I saw Jessica arrive at the Space Station and enjoy so much the floating around, and all the craziness of how that feels, I actually had forgot that I was floating. Seeing her giddy to be there and so excited by all the little things, how things look when they float around, how things pop out of your hand, really reminded me that I was in a unique environment. To see it all through her eyes again made it new for me again. It reinvigorated my time on board the Space Station."

—Christina Koch

"I'm a little bit worried that when I come back down, this is going to quickly fade and just seem like a dream. Like it never happened. Like these seven months (it will have been) that I spent in space aren't going to feel real anymore because I'll quickly return to that feeling that I have gotten used to, of being back in gravity. So that's why I'm really trying to hold onto these memories—to get videos, to get pictures, to remember. And to try to put it into words, try to put down on paper what this feeling is like. But it's so difficult, because I don't know how to describe it to anybody."

—Jessica Meir

"As a crew, we are a little microcosm of humanity here. And our psychological well-being depends on the company of others. So, these are way more than colleagues. They are even more than friends. Our fellow crew members become our brothers and sisters. And that's the kind of level of relationship that we develop, of complete mutual trust and openness."

—David Saint-Jacques

41

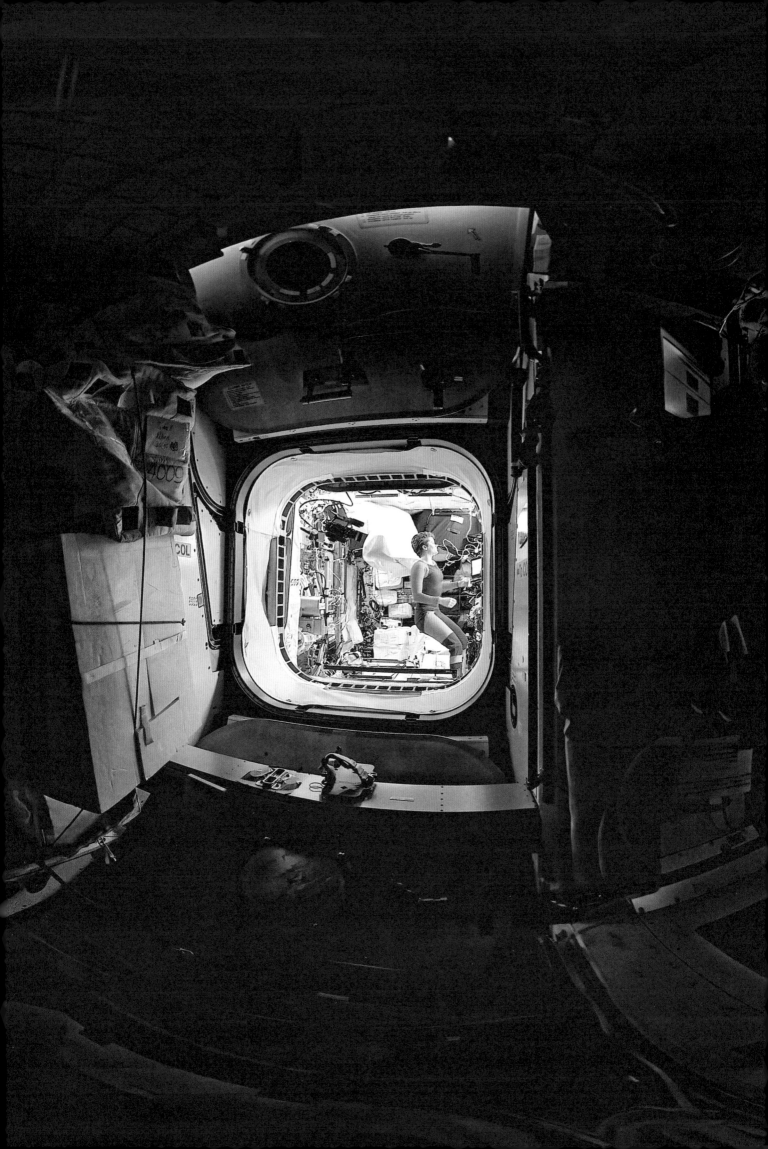

Anne McClain

(Lieutenant Colonel, US Army) NASA Astronaut
First Spaceflight

Anne C. McClain was selected by NASA in 2013.
The Spokane, Washington native earned a bach-
elor of science degree in mechanical/aeronautical
engineering from West Point. A 2002 Marshall
Scholar, McClain took a master's degree in aero-
space engineering from the University of Bath,
and a second master's in international relations from
the University of Bristol. A US Army lieutenant
colonel and a senior army aviator, McClain has more
than 2,000 flight hours in 20 different aircraft.
She is an OH-58D Kiowa Warrior pilot and instructor
pilot, and a rated pilot in the C-12 Huron (King Air),
UH-60 Blackhawk, and UH-72 Lakota. Most recently,
McClain launched on Dec. 3, 2018, and served as
a flight engineer on the International Space Station
for Expeditions 58 and 59.

**Expedition 58
Summary**
Flight Engineer

Soyuz MS-11
Mission dates:
Dec. 20, 2018–Mar. 15, 2019

The crew
· Oleg Kononenko
 Commander
· David Saint-Jacques
 Flight Engineer

Spacewalks
—

**Expedition 59
Summary**
Flight Engineer

Soyuz MS-12
Mission dates:
Mar. 15–June 24, 2019

The crew
· Oleg Kononenko
 Commander
· David Saint-Jacques
 Flight Engineer
· Nick Hague
 Flight Engineer
· Christina Koch
 Flight Engineer
· Alexey Ovchinin
 Flight Engineer

Spacewalks
· 03.22.19 (6:39)*
· 03.29.19 (6:45)
· 04.08.19 (6:30)*
· 05.29.19 (6:01)

Total Days in Space
204

McClain conducted two
spacewalks totaling 13 hours
and 8 minutes.

* Spacewalk(s) conducted by
 Anne McClain

David Saint-Jacques

(PhD, MD) CSA Astronaut
First Spaceflight

David Saint-Jacques was selected to be an astronaut by the Canadian Space Agency (CSA) in 2009, and subsequently took part in the 20th NASA astronaut class. He holds a PhD in astrophysics from Cambridge University and an MD from Université Laval in Quebec City, Canada. Prior to becoming an astronaut, Saint-Jacques served as a family doctor in Nunavik, in northern Quebec, and taught family medicine at McGill University in Montreal. He was awarded the Royal Canadian Geographical Society Gold Medal in 2014. Saint-Jacques launched on December 3, 2018, and served as a flight engineer aboard the International Space Station during Expeditions 58 and 59 for a total of 204 days—the longest Canadian space mission to date. In this course of that mission, Saint-Jacques circled the globe 3,264 times, covering a distance of 139,096,495 kilometers and returning to Earth on June 24, 2019.

**Expedition 58
Summary**
Flight Engineer

Soyuz MS-11
Mission dates:
Dec. 20, 2018–Mar. 15, 2019

The crew
· Oleg Kononenko
 Commander
· Anne McClain
 Flight Engineer

Spacewalks
—

**Expedition 59
Summary**
Flight Engineer

Soyuz MS-12
Mission dates:
Mar. 15–June 24, 2019

The crew
· Oleg Kononenko
 Commander
· Anne McClain
 Flight Engineer
· Nick Hague
 Flight Engineer
· Christina Koch
 Flight Engineer
· Alexey Ovchinin
 Flight Engineer

Spacewalks
· 03.22.19 (6:39)
· 03.29.19 (6:45)
· 04.08.19 (6:30)*
· 05.29.19 (6:01)

Total Days in Space

204

Saint-Jacques became the fourth CSA astronaut to conduct a spacewalk and the first CSA astronaut to use Canadarm2 to engage a visiting spacecraft.

* Spacewalk(s) conducted by
 David Saint-Jacques

Nick Hague

(Colonel, US Space Force) NASA Astronaut
Second Spaceflight

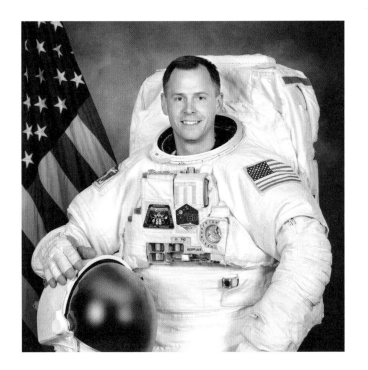

Tyler N. Hague was selected by NASA as an astronaut in 2013. The Kansas native earned a bachelor's degree in astronautical engineering from the United States Air Force Academy in 1998, and a master's in aeronautical and astronautical engineering from the Massachusetts Institute of Technology in 2000. In 2009, Hague was selected for the Air Force Fellows program in Washington, DC, and was a staff member in the United States Senate. Following his fellowship, he served in the Pentagon as a congressional appropriations liaison for United States Central Command. Hague completed astronaut candidate training in July 2015 and soon afterward was selected for a mission to the International Space Station which launched on October 11, 2018. Unfortunately, he and crewmate Alexey Ovchinin, of the Russian space agency Roscosmos, were forced to abort the mission when a rocket booster experienced a malfunction shortly after the launch of their Soyuz MS-10. The aborted spacecraft landed safely. Most recently, Hague served as a flight engineer on the International Space Station for Expeditions 59 and 60.

Expedition 59 Summary
Flight Engineer

Soyuz MS-12

Mission dates:
Mar. 15–June 24, 2019

The crew:
· Oleg Kononenko
 Commander
· Anne McClain
 Flight Engineer
· David Saint-Jacques
 Flight Engineer
· Christina Koch
 Flight Engineer
· Alexey Ovchinin
 Flight Engineer

Spacewalks
· 03.22.19 (6:39)*
· 03.29.19 (6:45)*
· 04.08.19 (6:30)
· 05.29.19 (6:01)

Expedition 60 Summary
Flight Engineer

Soyuz MS-13
Mission dates:
June 24–Oct. 3, 2019

The crew:
· Alexey Ovchinin
 Commander
· Christina Koch
 Flight Engineer
· Andrew Morgan
 Flight Engineer
· Luca Parmitano
 Flight Engineer
· Aleksandr Skvortsov
 Flight Engineer

Spacewalks
· 08.21.19 (6:32)*

Total Days in Space
203

On his most recent mission, Hague conducted three spacewalks totaling 19 hours and 56 minutes.

* Spacewalk(s) conducted by
 Nick Hague

Christina Hammock Koch

NASA Astronaut
First Spaceflight

Christina Hammock Koch was selected as an astronaut by NASA in 2013. She completed astronaut candidate training in 2015. Koch graduated from North Carolina State University with a bachelor's degree in electrical engineering and physics, and a master's in electrical engineering. On March 14, 2019, she launched for the International Space Station, serving as a flight engineer for Expeditions 59, 60, and 61. Koch set a record for the longest single spaceflight by a woman, with a total of 328 days in space.

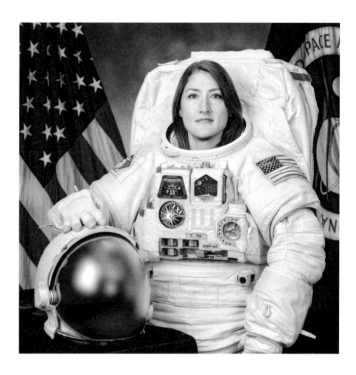

Expedition 59 Summary
Flight Engineer

Soyuz MS-12

Mission dates:
Mar. 15–June 24, 2019

The crew:
· Oleg Kononenko
 Commander
· Anne McClain
 Flight Engineer
· David Saint-Jacques
 Flight Engineer
· Nick Hague
 Flight Engineer
· Alexey Ovchinin
 Flight Engineer

Spacewalks
· 03.22.19 (6:39)
· 03.29.19 (6:45)*
· 04.08.19 (6:30)
· 05.29.19 (6:01)

Expedition 60 Summary
Flight Engineer

Soyuz MS-13
Mission dates:
June 24–Oct. 3, 2019

The crew:
· Alexey Ovchinin
 Commander
· Nick Hague
 Flight Engineer
· Andrew Morgan
 Flight Engineer
· Luca Parmitano
 Flight Engineer
· Aleksandr Skvortsov
 Flight Engineer

Spacewalks
· 08.21.19 (6:32)

Expedition 61 Summary
Flight Engineer

—

Mission dates:
Oct. 3, 2019–Feb. 6, 2020

The crew:
· Luca Parmitano
 Commander
· Andrew Morgan
 Flight Engineer
· Aleksandr Skvortsov
 Flight Engineer
· Jessica Meir
 Flight Engineer
· Oleg Skripochka
 Flight Engineer

Spacewalks
· 10.06.19 (7:01)*
· 10.11.19 (6:45)*
· 10.18.19 (7:17)* | **
· 11.15.19 (6:39)
· 11.22.19 (6:33)
· 12.02.19 (6:02)
· 01.15.20 (7:29)*
· 01.20.20 (6:58)*
· 01.25.20 (6:16)

Total Days in Space
328

Koch has conducted six spacewalks, including the first three all-woman spacewalks, for a total of 42 hours and 15 minutes.

* Spacewalk(s) conducted by Christina Koch

** First all-woman spacewalk in history

45

Luca Parmitano

(Colonel, Italian Air Force) ASI/ESA Astronaut
Second Spaceflight

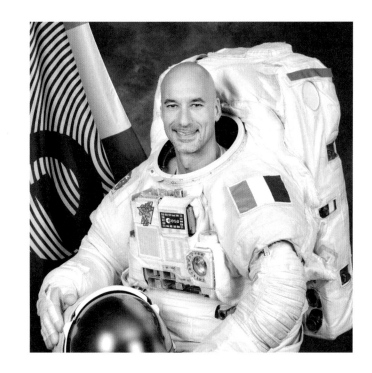

Luca Parmitano was selected as a European Space Agency (ESA) astronaut in 2009. He graduated from the Italian Air Force Academy in Pozzuoli, Italy, in 2000, and completed a master's degree in experimental flight test engineering at the Institut Supérieure de l'Aéronautique et de l'Espace in Toulouse, France, in 2009. He has served in the Italian Air Force in various roles, including as a trainer, a test pilot, and an electronic warfare officer, and has logged more than 2,000 hours flying time on more than 40 types of aircraft. He was promoted to the rank of colonel in 2019. In 2011, Parmitano served as flight engineer for the Italian Space Agency (ASI) on its first long-duration mission aboard the International Space Station. He launched on July 20, 2019, to join Expedition 60 as a flight engineer, and thereafter took on the job of Space Station commander for Expedition 61, the first Italian astronaut to assume the role.

Expedition 60 Summary
Flight Engineer

Soyuz MS-13
Mission dates:
June 24–Oct. 3, 2019

The crew:
· Alexey Ovchinin
 Commander
· Nick Hague
 Flight Engineer
· Christina Koch
 Flight Engineer
· Andrew Morgan
 Flight Engineer
· Aleksandr Skvortsov
 Flight Engineer

Spacewalks
· 08.21.19 (6:32)

Expedition 61 Summary
Commander

—

Mission dates:
Oct. 3, 2019–Feb. 6, 2020

The crew:
· Andrew Morgan
 Flight Engineer
· Christina Koch
 Flight Engineer
· Aleksandr Skvortsov
 Flight Engineer
· Jessica Meir
 Flight Engineer
· Oleg Skripochka
 Flight Engineer

Spacewalks
· 10.06.19 (7:01)
· 10.11.19 (6:45)
· 10.18.19 (7:17)**
· 11.15.19 (6:39)*
· 11.22.19 (6:33)*
· 12.02.19 (6:02)*
· 01.15.20 (7:29)
· 01.20.20 (6:58)
· 01.25.20 (6:16)*

Total Days in Space
366

Parmitano has taken part in six spacewalks totaling 33 hours and 9 minutes, including one, during Expedition 61, to repair the cosmic-particle-hunting Alpha Magnetic Spectrometer instrument, AMS-02.

* Spacewalk(s) conducted by
 Luca Parmitano

** First all-woman spacewalk
 in history

Andrew R. Morgan

(MD) (Colonel, US Army) NASA Astronaut
First Spaceflight

Dr. Andrew "Drew" Morgan was selected by
NASA in 2013. Morgan is an emergency physician
in the US Army with sub-specialty certification
in primary care sports medicine. He is a graduate
of the US Military Academy at West Point, and
of the Uniformed Services University of the Health
Sciences in Bethesda, MD. Prior to his selection
for NASA's 21st group of astronauts, Morgan served
in elite special operations units worldwide. He is
married with four children and makes New Castle, PA,
his home. On July 20, 2019, Morgan launched for
the International Space Station, serving as a flight
engineer on Expeditions 60, 61, and 62.

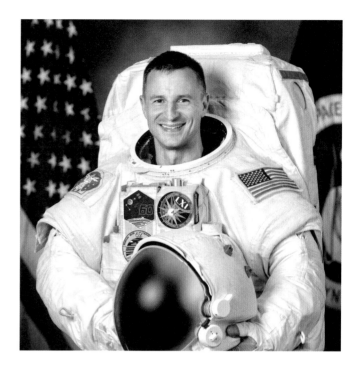

**Expedition 60
Summary**
Flight Engineer

Soyuz MS-13
Mission dates:
June 24–Oct. 3, 2019

The crew:
· Alexey Ovchinin
 Commander
· Nick Hague
 Flight Engineer
· Christina Koch
 Flight Engineer
· Luca Parmitano
 Flight Engineer
· Aleksandr Skvortsov
 Flight Engineer

Spacewalks
· 08.21.19 (6:32)*

**Expedition 61
Summary**
Flight Engineer

—

Mission dates:
Oct. 3, 2019–Feb. 6, 2020

The crew:
· Luca Parmitano
 Commander
· Christina Koch
 Flight Engineer
· Aleksandr Skvortsov
 Flight Engineer
· Jessica Meir
 Flight Engineer
· Oleg Skripochka
 Flight Engineer

Spacewalks
· 10.06.19 (7:01)*
· 10.11.19 (6:45)*
· 10.18.19 (7:17)**
· 11.15.19 (6:39)*
· 11.22.19 (6:33)*
· 12.02.19 (6:02)*
· 01.15.20 (7:29)
· 01.20.20 (6:58)
· 01.25.20 (6:16)*

**Expedition 62
Summary**
Flight Engineer

—

Mission dates:
Feb. 6–Apr. 17, 2020

The crew:
· Oleg Skripochka
 Commander
· Jessica Meir
 Flight Engineer
· Chris Cassidy
 Flight Engineer
· Anatoly Ivanishin
 Flight Engineer
· Ivan Vagner
 Flight Engineer

Total Days in Space
272

Morgan conducted seven
spacewalks totaling 45 hours
and 48 minutes during
a single spaceflight, an
American record.

* Spacewalk(s) conducted by
 Andrew Morgan

** First all-woman spacewalk
 in history

47

Jessica Meir

(PhD) NASA Astronaut
First Spaceflight

Jessica U. Meir was selected by NASA in 2013.
She holds a bachelor's degree in biology from Brown
University, a master's in space studies from the
International Space University, and a PhD in marine
biology from the Scripps Institution of Oceanography,
University of California San Diego. From 2000 to
2003, Dr. Meir worked for Lockheed Martin Space
Operations, supporting human physiology research
at the Human Research Facility at NASA's Johnson
Space Center in Houston. During this time, she also
participated in research flights on NASA's reduced-
gravity aircraft and served as an aquanaut in an
underwater habitat for NASA Extreme Environment
Mission Operations (NEEMO). Prior to becoming
an astronaut, her career as a scientist focused
on the physiology of animals in extreme environ-
ments. Meir most recently served as a flight
engineer aboard the International Space Station
for Expeditions 61 and 62.

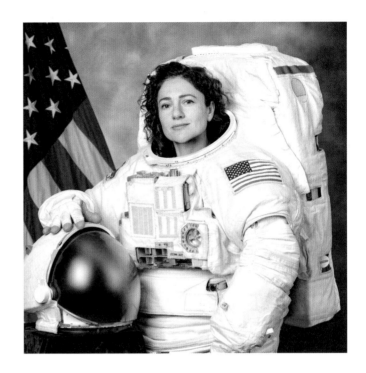

**Expedition 61
Summary**
Flight Engineer

Mission dates:
Oct. 3, 2019–Feb. 6, 2020

The crew:
· Luca Parmitano
 Commander
· Christina Koch
 Flight Engineer
· Andrew Morgan
 Flight Engineer
· Aleksandr Skvortsov
 Flight Engineer
· Oleg Skripochka
 Flight Engineer

Spacewalks
· 10.06.19 (7:01)*
· 10.11.19 (6:45)*
· 10.18.19 (7:17)**
· 11.15.19 (6:39)*
· 11.22.19 (6:33)*
· 12.02.19 (6:02)*
· 01.15.20 (7:29)
· 01.20.20 (6:58)
· 01.25.20 (6:16)*

**Expedition 62
Summary**
Flight Engineer

Mission dates:
Feb. 6–Apr. 17, 2020

The crew:
· Oleg Skripochka
 Commander
· Andrew Morgan
 Flight Engineer
· Chris Cassidy
 Flight Engineer
· Anatoly Ivanishin
 Flight Engineer
· Ivan Vagner
 Flight Engineer

Spacewalks
—

Total Days in Space
205

Meir participated in the
first three all-woman
spacewalks together with
crewmate Christina Koch
(NASA), totaling 21 hours
and 44 minutes.

* Spacewalk(s) conducted by
 Jessica Meir

** First all-woman spacewalk
 in history

Victor J. Glover

(Commander, US Navy) NASA Astronaut
First Spaceflight

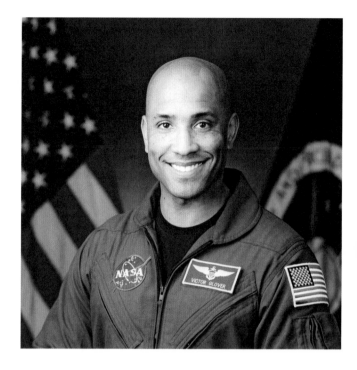

Victor J. Glover, Jr. was selected as an astronaut in 2013 while serving as a legislative fellow in the United States Senate. Most recently, Glover served as pilot and second-in-command of the SpaceX Crew-1 mission aboard the SpaceX spacecraft *Resilience*, which returned to Earth on May 2, 2021. It was the first post-certification mission of a Crew Dragon-class spacecraft and the second crewed flight for that vehicle, as well as a long-duration mission aboard the International Space Station. Glover also served as a flight engineer on the International Space Station for Expedition 64. The California native holds a bachelor's degree in general engineering, a master's degree in flight test engineering, a second master's in systems engineering, and a third in military operational art and science. A commander in the US Navy, Glover is a naval aviator and was a test pilot for F/A-18 Hornet, Super Hornet, and EA-18G Growler aircraft. He and his family have been stationed in many locations in the United States and Japan, and he has deployed in combat and peacetime.

**Expedition 64
Summary**
Flight Engineer

Mission dates:
Oct. 21, 2020–Apr. 16, 2021

The crew:
· Sergey Ryzhikov
 Commander
· Kate Rubins
 Flight Engineer
· Sergey Kud-Sverchkov
 Flight Engineer
· Mike Hopkins
 Flight Engineer
· Shannon Walker
 Flight Engineer
· Soichi Noguchi
 Flight Engineer

Spacewalks
· 11.18.20 (6:48)
· 01.27.21 (6:56)*
· 02.01.21 (5:20)*
· 02.28.21 (7:04)*
· 03.05.21 (6:56)
· 03.13.21 (6:47)*

Total Days in Space
168

Glover conducted four spacewalks totaling 26 hours and 7 minutes.

* Spacewalk(s) conducted by
 Victor J. Glover

One Day Aboard the International Space Station

06:00	Rise and shine! Freshen up with a zero-grav "shower" using wet cloths and dry shampoo. Brush teeth with foamless, ingestible toothpaste.
07:00	Breakfast, alone or with crewmates. Coffee and tea are available. Long gone are the days of astronaut foods packaged in tubes and cubes. Breakfast offerings are extensive, ranging from cornflakes to Mexican scrambled eggs to a breakfast sandwich patty. Bread and buns, however, have been off-limits since Gemini 3, in 1965, when crumbs from a pastrami sandwich smuggled on board played havoc with the machinery.
07:30	Morning conference, with live links to participating countries' ground stations in the US, Russia, Europe, and Japan. The day's tasks are reviewed and discussed.
07:55	Prep for the day's work and review of procedures.
08:15	Work time. Each day, astronauts have a full schedule of tasks. The majority are science experiments covering a wide range of disciplines: human health research, Earth and space science, biology and biotechnology, physical sciences, and systems and materials testing.
	On Saturdays, work time is for cleaning and other household chores. Molds and microbes reproduce quickly in space, so crew members must clean the station top to bottom using specialized wipes and a zero-grav vacuum cleaner. Otherwise, the weekend is free time.

13:00	Lunchtime. Menus can vary culturally, depending on what each nation's astronauts bring with them. Italian astronauts have brought along lasagna, for example, while the Russians often enjoy an excellent fish selection.
14:00	Work time. More science experiments, plus much-needed physical exercise using equipment such as treadmills and ergometers. Without exercise, muscles and bones quickly become weaker in the absence of gravity.
18:15	Work prep and review procedures for tomorrow.
19:00	Evening conference, with live links to ground control station. Astronauts report briefly on mission tasks performed and problems arising.
19:30	Free time! Astronauts catch up on their reading, write e-mails to family and friends, watch a movie, or contemplate the Earth from the windows of the station's Cupola module.
20:00	Dinner with crewmates. Once again, options are many and vary greatly by mission, and have ranged from samosas to Slovenian sausages to fluffernutter sandwiches (using tortillas instead of bread). Japanese astronauts have even been known to host sushi parties for their crewmates.
22:15	Bedtime. Some astronauts choose to stay up a bit later. Personnel sleep in sleeping bags, loosely strapped into small compartments. Due to the air conditioning and other ambient station noise, some astronauts sleep with earplugs.

Astronaut Task Planner

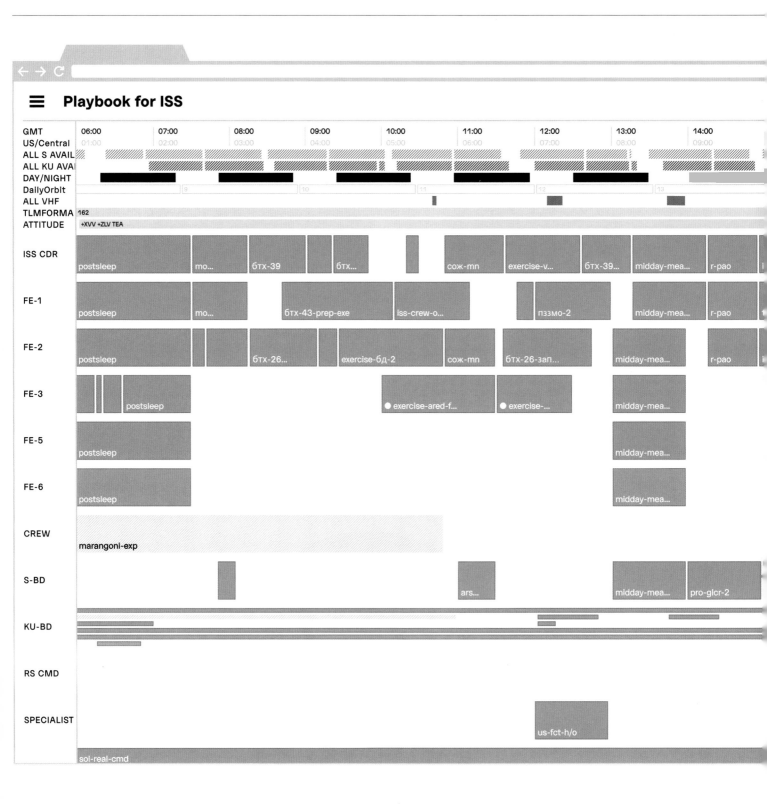

If you are accustomed to planning your day in five-minute increments, you just might have a future as an astronaut. From work and exercise, to meals and personal hygiene, to recreation and sleep, International Space Station astronauts' lives are probably the most regimented of anyone on—or off—Planet Earth.

Mission plans and schedules are laid out months in advance of launch. Once aboard the station, however,

astronauts and mission controllers adjust the schedule week by week or even daily, as required.

While the majority of astronauts' work time is spent running or monitoring scientific experiments, scheduling certain other tasks involves careful consideration. Everybody thinks of a spacewalk, for example, as an exhilarating experience, or even a spiritual one. Each spacewalk, however, is delineated by particular, practical considerations

including several hours of careful prep time prior to the walk, followed by more time afterward, for recompression.

Astronauts are expected to eat three meals a day, with carefully set calorie requirements. Time is also set aside for conferences with mission control, maintaining computers, keeping the station clean, physical exercise, and discretionary activities.

But even pastimes entail complications. Astronauts must exercise

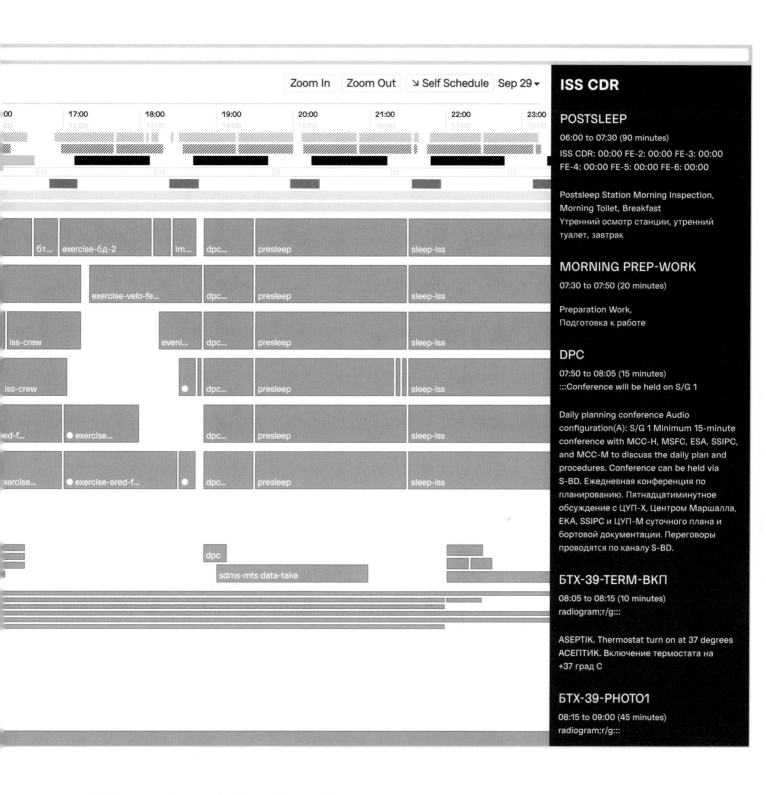

ISS CDR

POSTSLEEP

06:00 to 07:30 (90 minutes)
ISS CDR: 00:00 FE-2: 00:00 FE-3: 00:00
FE-4: 00:00 FE-5: 00:00 FE-6: 00:00

Postsleep Station Morning Inspection,
Morning Toilet, Breakfast
Утренний осмотр станции, утренний
туалет, завтрак

MORNING PREP-WORK

07:30 to 07:50 (20 minutes)

Preparation Work,
Подготовка к работе

DPC

07:50 to 08:05 (15 minutes)
:::Conference will be held on S/G 1

Daily planning conference Audio
configuration(A): S/G 1 Minimum 15-minute
conference with MCC-H, MSFC, ESA, SSIPC,
and MCC-M to discuss the daily plan and
procedures. Conference can be held via
S-BD. Ежедневная конференция по
планированию. Пятнадцатиминутное
обсуждение с ЦУП-Х, Центром Маршалла,
ЕКА, SSIPC и ЦУП-М суточного плана и
бортовой документации. Переговоры
проводятся по каналу S-BD.

БТХ-39-TERM-ВКП

08:05 to 08:15 (10 minutes)
radiogram;r/g:::

ASEPTIK. Thermostat turn on at 37 degrees
АСЕПТИК. Включение термостата на
+37 град С

БТХ-39-PHOTO1

08:15 to 09:00 (45 minutes)
radiogram;r/g:::

2.5 hours per day to maintain overall fitness and prevent muscle loss, but may not exercise immediately before or after meals.

External factors, too, contribute to scheduling difficulties, such as the ISS's current time zone or whether the station is in light or darkness.

Differing approaches among the participating space agencies only add to the complexity. Russia's space program is decades old and its personnel follow long-standing practices and procedures. Japan, a more recent spacefaring nation, brings new perspectives to the process. For operations planners at the various mission controls, scheduling represents an intricate operation demanding cooperation, openness, and tact.

After a hard day's work, the astronaut is scheduled for eight hours' sleep. There is some wiggle room, though. Astronauts who have trouble sleeping may read a book or chat online for a while instead. Of course, when sleep does come, dreaming is completely discretionary.

ISS Daily Menu Food List

REFRIGERATED

Dairy
- Cheese
- Cheese slices
- Cream cheese
- Sour cream
- Yogurt

Fruits
- Apple
- Grapefruit
- Kiwi
- Orange
- Plum

FROZEN

Meat and Eggs

BEEF
- Beef brisket, BBQ
- Beef enchilada w/Spanish rice
- Beef fajita
- Beef patty
- Beef sirloin tips w/mushrooms
- Beefsteak, bourbon
- Beefsteak, teriyaki
- Beef, stir-fried w/onion
- Beef stroganoff w/noodles
- Luncheon meat
- Meat loaf w/mashed potatoes and gravy

LAMB
- Lamb, broiled

POULTRY
- Chicken, baked
- Chicken, enchilada w/Spanish rice
- Chicken, fajita
- Chicken, grilled
- Chicken, oven-fried
- Chicken, pot pie
- Chicken, stir-fried w/diced red pepper
- Chicken, teriyaki w/spring vegetables
- Duck, roasted
- Meatball, porcupine (turkey)

PORK
- Bacon
- Bacon, Canadian
- Ham, baked w/candied yams
- Pork, chop, baked w/potatoes au gratin
- Pork, sausage, patties
- Pork, sweet and sour w/rice

SEAFOOD
- Fish, baked
- Fish, grilled
- Fish, sautéed
- Lobster, broiled tails
- Scallops, baked
- Seafood, gumbo w/rice
- Shrimp, cocktail
- Tuna, noodle casserole

EGGS
- Egg, omelet, cheese
- Egg, omelet, vegetable
- Egg, omelet, ham
- Egg, omelet, sausage
- Egg, omelet, vegetable and ham
- Egg, omelet, vegetable and sausage
- Eggs, scrambled w/bacon, hash browns, sausage
- Quiche, vegetable
- Quiche, lorraine

PASTA MIXTURES
- Lasagna, vegetable w/tomato sauce
- Noodles, stir-fry
- Spaghetti w/meat sauce
- Spaghetti w/tomato sauce
- Tortellini w/tomato sauce, cheese

OTHER
- Egg rolls
- Enchilada, cheese w/Spanish rice
- Pizza, cheese
- Pizza, meat
- Pizza, vegetable
- Pizza, supreme

Fruit
- Apples, escalloped
- Peaches, sliced w/bananas, blueberries
- Peaches w/bananas, grapes, strawberries
- Strawberries, sliced

Soups
- Beef, stew
- Broccoli, cream of
- Chicken, cream of
- Chicken noodle
- Mushroom, cream of
- Wonton

Grains
- Biscuits
- Bread
- Cornbread
- Dinner roll
- Garlic bread
- Sandwich bun, wheat/white
- Toast, wheat/white
- Tortilla

BREAKFAST ITEMS
- Cinnamon roll
- French toast
- Pancakes, buttermilk
- Pancakes, apple cinnamon
- Waffles

PASTA
- Fettuccine Alfredo
- Macaroni and cheese
- Spaghetti

RICE
- Fried
- Mexican/Spanish
- White

Starchy Vegetables
- Corn, whole kernel
- Potato, baked
- Potatoes, escalloped
- Potatoes, oven-fried
- Potatoes, mashed
- Yams, candied
- Succotash
- Squash corn casserole

Vegetables
- Asparagus tips
- Beans, green
- Beans, green w/mushrooms
- Broccoli au gratin
- Broccoli
- Carrot coins
- Cauliflower au gratin
- Chinese vegetables, stir-fry
- Mushrooms, fried
- Okra, fried
- Peas
- Peas w/carrots
- Squash, acorn w/apple sauce and cinnamon
- Zucchini, spears, fried

Desserts

CAKES
- Angel food cake
- Brownie, chocolate
- Chocolate fudge
- Shortcake
- Yellow cake w/chocolate frosting

DAIRY
- Ice cream, chocolate
- Ice cream, strawberry
- Ice cream, vanilla
- Yogurt, frozen

PIES AND PASTRY
- Cheesecake, chocolate
- Cheesecake, plain
- Cobbler, peach
- Pie, apple
- Pie, coconut cream
- Pie, pecan
- Pie, pumpkin

Beverages
- Apple juice
- Grape juice
- Grapefruit juice
- Lemonade
- Orange

Condiments
- Margarine
- Grated cheese

Cereals
- Hot cereal
- Oatmeal
- Cream of Wheat
- Grits

THERMOSTABILIZED

Fruit
- Applesauce
- Fruit cocktail
- Peaches
- Pears
- Pineapple

Salads
- Chicken salad
- Tuna salad
- Turkey salad

VEGETABLE
- Bean salad, three
- Pasta salad
- Potato salad, German
- Sauerkraut

Soups
- Chili
- Clam chowder
- Egg drop
- Miso, Japanese
- Vegetable

Desserts
- Pudding, butterscotch
- Pudding, chocolate
- Pudding, lemon
- Pudding, tapioca
- Pudding, vanilla

Condiments
- Barbecue sauce
- Catsup
- Chili con queso

ISS Daily Menu Food List

- Cocktail sauce
- Cranberry sauce
- Dill pickle chips
- Dips, bean
- Dips, onion
- Dips, ranch
- Honey
- Horseradish sauce
- Jelly, assorted
- Lemon juice
- Mayonnaise
- Mustard
- Mustard, hot Chinese
- Orange marmalade
- Peanut butter (chunky, creamy, whipped)
- Picante sauce
- Sweet and sour sauce
- Syrup, maple
- Taco sauce
- Tartar sauce

Beverages

FRUIT JUICES
- Cranberry
- Cranberry apple
- Cranberry raspberry
- Gatorade, assorted

- Pineapple
- Pineapple grapefruit
- Tomato
- V-8

MILK
- Skim
- Low-fat
- Chocolate (low-fat or skim)
- Whole

NATURAL FORM

Fruit
- Apples, dried
- Apricots, dried
- Peach, dried
- Pear, dried
- Prunes
- RaisinTrail mix

Grains
- Animal crackers
- Cereal, cold
- Chex mix
- Crackers, assorted
- Baked chips, tortillas
- Baked chips, potato

- Pretzels
- Goldfish
- Tortilla chips
- Potato chips
- Rye krisp, seasoned

Desserts

COOKIES
- Butter
- Chocolate chip
- Fortune
- Rice Krispies treat
- Shortbread

Snacks
- Beef jerky

NUTS
- Almonds
- Cashews
- Macadamia
- Peanuts

CANDY
- Candy-coated chocolates
- Candy-coated peanuts
- Life Savers
- Gum (sugar-free)

EVA FOOD
- In-suit fruit bar

REHYDRATABLE

Beverages
- Apple cider
- Cherry drink
- Cocoa
- Coffee (assorted)
- Grape drink
- Grapefruit drink
- Instant breakfast, chocolate
- Instant breakfast, vanilla
- Instant breakfast, strawberry
- Orange drink
- Orange mango drink
- Orange pineapple drink
- Tea (assorted)
- Tropical punch

IRRADIATED MEAT
- Beefsteak
- Smoked turkey

ISS Standard Menu (4 days of a 30-day menu)

DAY 1

Meal A
- Eggs, scrambled w/bacon, hash browns, sausage
- Toast
- Margarine
- Jelly, assorted
- Apple juice
- Coffee/Tea/Cocoa

Meal B
- Chicken, oven-fried
- Macaroni and cheese
- Corn, whole-kernel
- Peaches
- Almonds
- Pineapple-grapefruit juice

Meal C
- Beef fajita
- Spanish rice
- Tortilla chips
- Picante sauce
- Chili con queso
- Tortilla
- Lemon bar
- Apple cider

DAY 2

Meal A
- Cereal, cold
- Yogurt, fruit
- Biscuit
- Margarine
- Jelly, assorted
- Milk
- Cranberry juice
- Coffee/Tea/Cocoa

Meal B
- Soup, cream of broccoli
- Beef patty
- Cheese slice
- Sandwich bun
- Pretzels
- Fried apples
- Vanilla pudding
- Chocolate instant breakfast

Meal C
- Fish, sautéed
- Tartar sauce
- Lemon juice
- Pasta salad
- Green beans
- Bread
- Margarine
- Angel food cake
- Strawberries
- Orange-pineapple drink

DAY 3

Meal A
- French toast
- Canadian bacon
- Margarine
- Syrup
- Orange juice
- Coffee/Tea/Cocoa

Meal B
- Cheese manicotti w/tomato sauce
- Garlic bread
- Berry medley
- Cookie, shortbread
- Lemonade

Meal C
- Turkey breast, sliced
- Mashed sweet potato
- Asparagus tips
- Cornbread
- Margarine
- Pumpkin pie
- Cherry drink

DAY 4

Meal A
- Cereal, hot
- Cinnamon roll
- Milk
- Grape juice
- Coffee/Tea/Cocoa

Meal B
- Quiche lorraine
- Seasoned Ry-Krisp
- Fresh orange
- Cookies, butter

Meal C
- Soup, wonton
- Chicken teriyaki
- Chinese vegetables, stir-fry
- Egg rolls
- Hot Chinese mustard
- Sweet and sour sauce
- Vanilla ice cream
- Cookies, fortune
- Tea

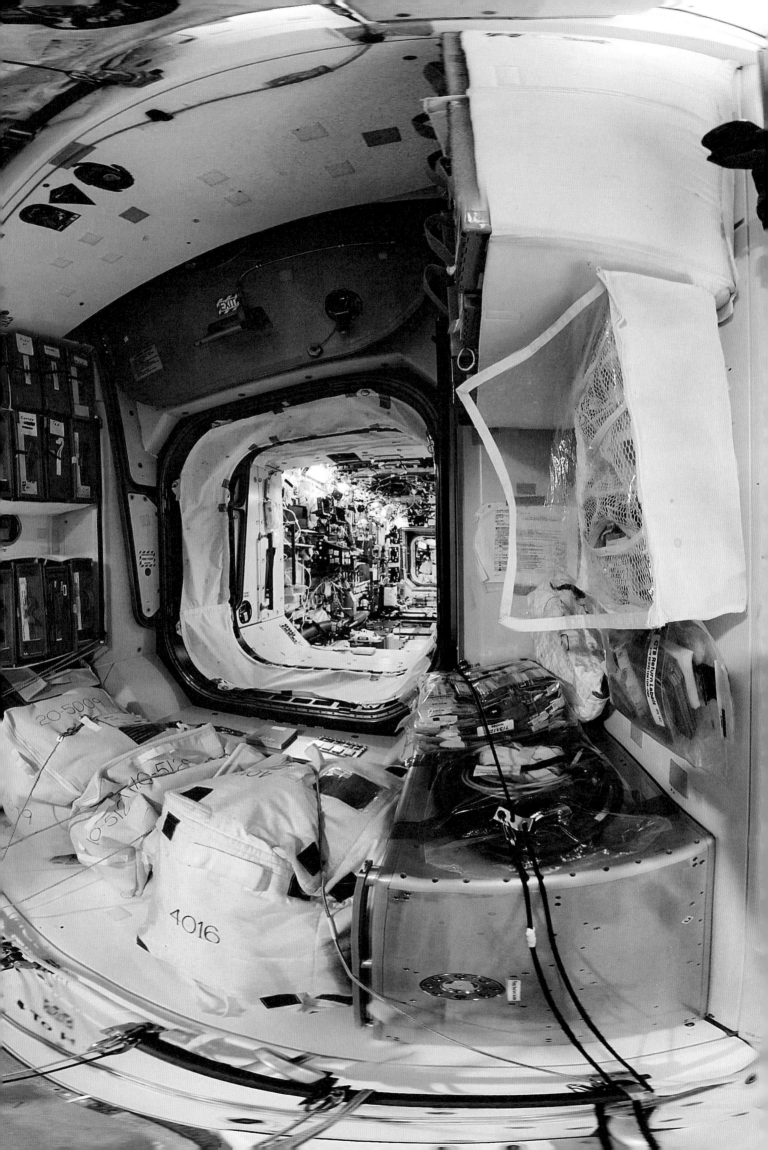

"The first thing that I noticed when I got to space was that I was surprised to feel sunlight on my face, because you think about space being dark. But the Sun coming through the windows of the cupola was a really fantastic thing. [...] That was one of the driving forces behind making the Sun so prominent on our patch. We have a lot of NASA patch designs that emphasize the Earth, the Moon, Mars, things that we aspire to, and the Earth is certainly a beautiful thing. But I thought, what about the Sun? The Sun is the giver of life at the center of our solar system. Let's make that prominent! And so, I, with the help of several artists, we conceptualized this: the Sun in the background with the ISS kind of eclipsed over it. And then the Earth here [divided in two by] the *terminator*, which is where the illuminated part of the Earth meets the eclipsed, or the dark, side of the Earth."

—Andrew Morgan

"During my mission, I broke the record for the longest continuous time spent in space by a woman. People are motivated by milestones. We can use it as a tool to share what we're doing and the importance of what we're doing. And I am more than happy to celebrate that milestone. I have no doubt that any women in our astronaut corps would have taken this mission on with pride, bringing their best to it, just as I try to. I happened to be in the right place at the right time. And that makes me grateful for those who paved the way for that to be an option. My biggest hope for this record is that it is broken as soon as possible, because that means we are continuing to push the boundaries."

—Christina Koch

"We're going to continue to explore low Earth orbit, we're going to be on the Moon, and we will still be on our way to Mars and exploring the Red Planet, robotically and with humans. And so, a hundred years from now, I hope that we are as excited and as captivated by space and aerospace as we are today—or even more so. And hopefully that will continue to carry us through the next century of exploration. I love the NASA vision: to reach for new heights to reveal the unknown for the benefit of humankind. And I think a hundred years from now, those words will still be just as relevant. This year, we celebrated twenty years of continuous human presence aboard this International Space Station. There are adults now who have lived their entire lives with humans in space. That is pretty amazing."

—Victor Glover

"As humans, when we see a mountain, we are bound to ask: what's on top of the mountain? But we are also bound to ask ourselves: what's behind the mountain? What's beyond it? What's beyond the lake, what's beyond the sea? We have explored underground caves. But space is the really the ultimate frontier—it goes on forever. There's no end to the exploration that we can do."

—Luca Parmitano

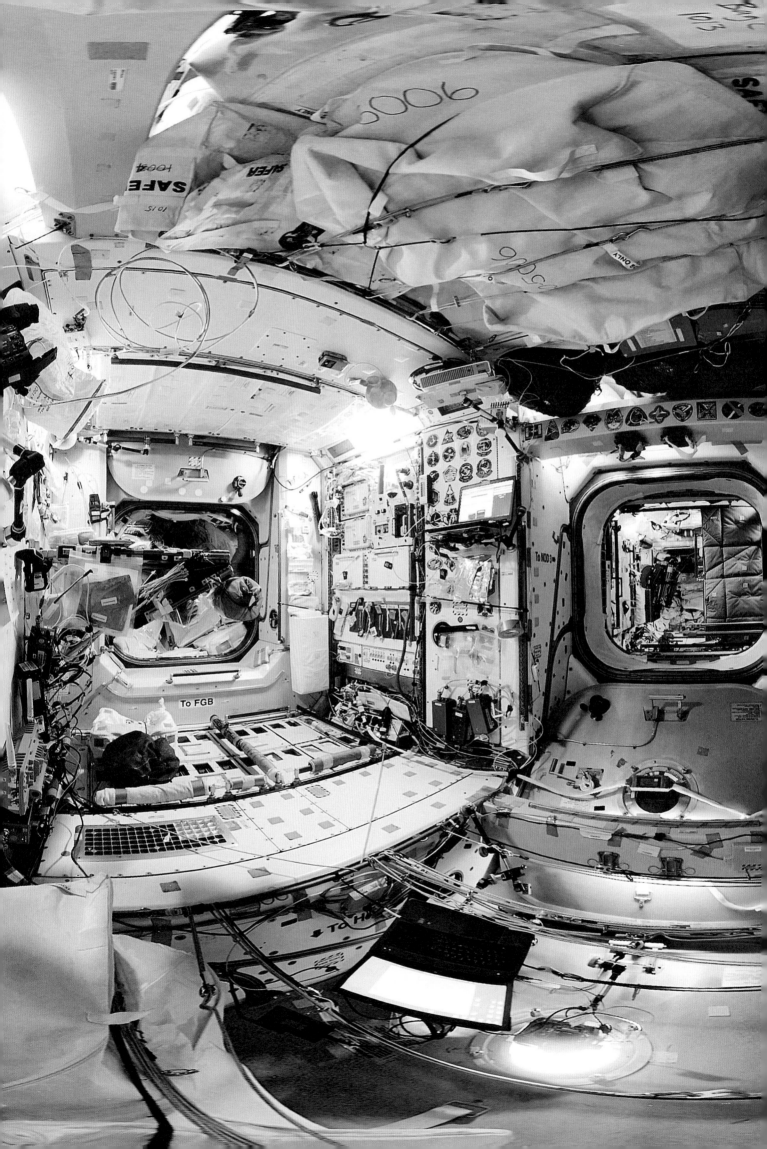

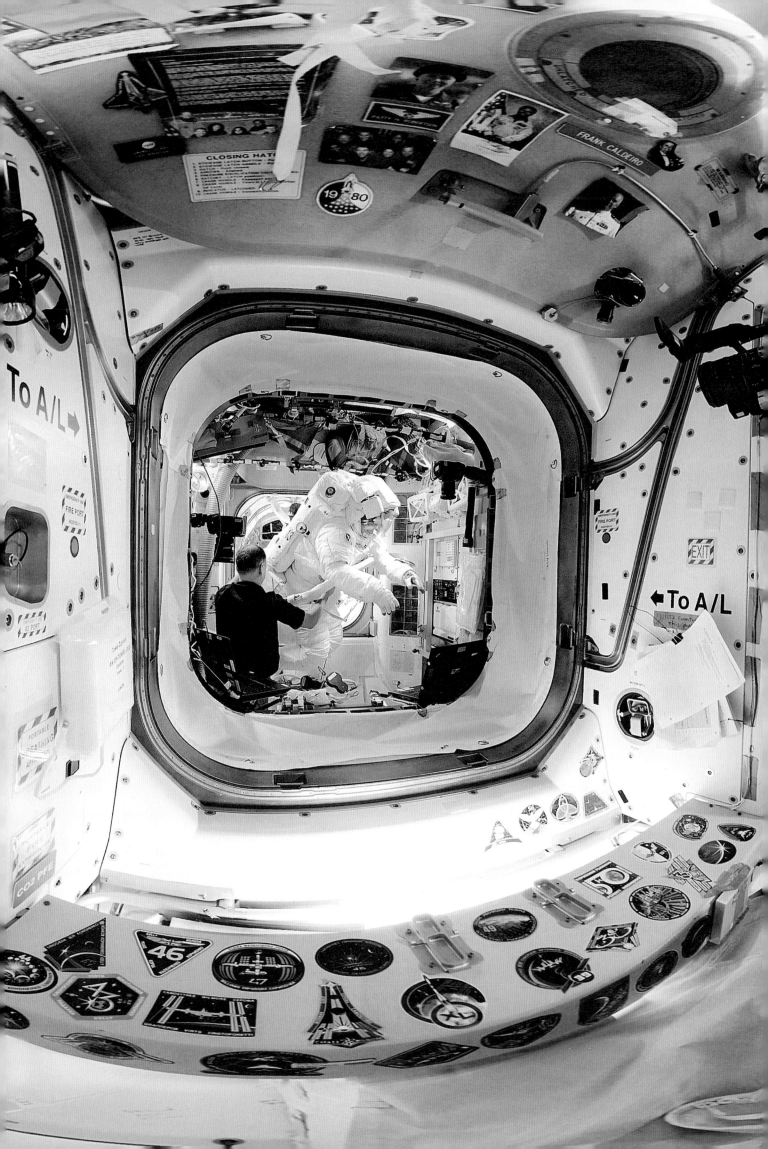

The mission insignia worn by astronauts aboard the International Space Station have their origins in the military tradition of regimental patches. The wearing of standardized clothing or symbols to identify members of a military unit can be traced back to the ancient empires of China, Mesopotamia, and Egypt. It also recalls the colorful shield and banner ornaments of medieval heraldry. The modern regimental patch, however, really only emerged as official military insignia worn by American forces during the First World War.

The first embroidered patch used as insignia on a space mission was flown by Valentina Tereshkova, a Soviet cosmonaut, aboard the Vostok 6 mission in 1963. Not all Soviet missions flew such badges; however, while this did not become a regular practice in Russia until 1994, most American missions had dedicated badges, including the Apollo, Gemini, and other programs.

Astronauts do not generally wear actual patches on their space suits. Following a deadly fire on the Apollo 1 mission in 1967, embroidered patches were removed from crew apparel. Instead, the designs approved for space travel are inscribed directly onto the space suits. Off mission, of course, astronauts may wear the embroidered patches on jackets and other workwear.

The ISS patch designs are produced by Conrad Industries of Weaverville, North Carolina. In 1961, the company's founder, E. Henry Conrad, produced NASA's first embroidered patch—the famous "meatball" insignia. Since 1970, Conrad Industries has been the exclusive supplier of mission patches to NASA astronauts as well as for the ISS missions.

ISS astronauts generally wear insignia for two missions, since the mission crews often overlap and thus participate in two expeditions on a single trip. Unlike the coats of arms of the Middle Ages, which were administered by heralds as a function of their specialized profession, ISS mission badges are composed by the crew, with the expedition commander acting as a liaison with the participating space agencies' graphic designers.

The mission badge designers work behind the scenes, remaining generally unsung. In a tribute to the designers of these remarkable emblems, the following pages present the mission badges for all ISS expeditions to date, together with some other important space mission badges.

Mission patch for Space Station *Freedom*,
a NASA proposal of the 1980s
to launch a crewed Earth-orbit space station

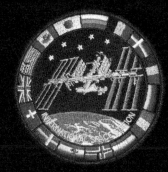

ISS program emblem featuring flags
of the signatory nations to the Space
Station Intergovernmental Agreement (IGA),
signed January 28, 1998

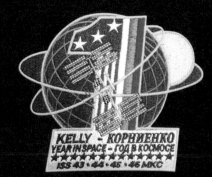

Patch commemorating
the first year-long expedition to the ISS
(spanning Expeditions 43–46)

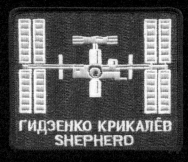

Expedition 1
November 2, 2000
March 19, 2001

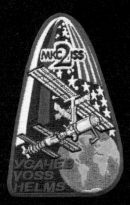

Expedition 2
March 10, 2001
August 20, 2001

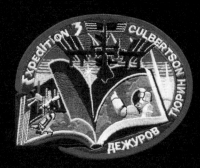

Expedition 3
August 12, 2001
December 15, 2001

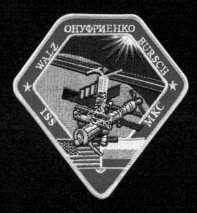

Expedition 4
December 7, 2001
June 15, 2002

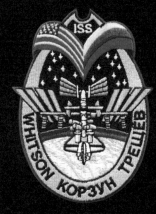

Expedition 5
June 7, 2002
December 2, 2002

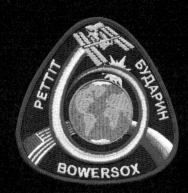

Expedition 6
November 25, 2002
May 3, 2003

Expedition 7
April 28, 2003
October 27, 2003

Expedition 8
October 20, 2003
April 29, 2004

Expedition 9
April 21, 2004
October 23, 2004

Expedition 10
October 16, 2004
April 24, 2004

Expedition 11
April 17, 2005
October 10, 2005

Expedition 12
October 3, 2005
April 8, 2006

Expedition 13
April 1, 2006
September 28, 2006

Expedition 14
September 18, 2006
April 21, 2007

Expedition 15
(with crew names from first part of mission)
April 7, 2007
October 21, 2007

Expedition 16
October 10, 2007
April 29, 2008

Expedition 17
(with crew names from first part of mission)
April 8, 2008
October 24, 2008

Expedition 18
October 12, 2008
April 8, 2009

Expedition 19
March 28, 2009
May 29, 2009

Expedition 20
May 29, 2009
October 11, 2009

Expedition 21
October 11, 2009
December 1, 2009

Expedition 22
December 1, 2009
March 18, 2010

Expedition 23
March 18, 2010
June 2, 2010

Expedition 24
June 2, 2010
September 25, 2010

Expedition 25
September 25, 2010
November 26, 2010

Expedition 26
November 26, 2010
March 16, 2011

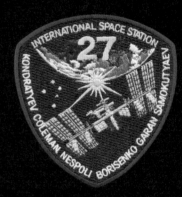

Expedition 27
March 16, 2011
May 23, 2011

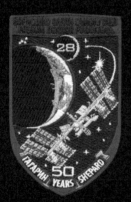

Expedition 28
May 23, 2011
September 16, 2011

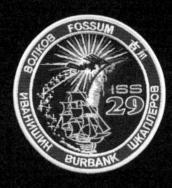

Expedition 29
September 16, 2011
November 21, 2011

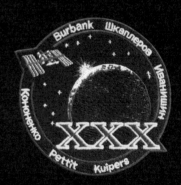

Expedition 30
November 21, 2011
April 27, 2012

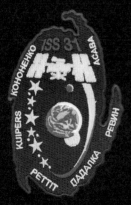

Expedition 31
April 27, 2012
July 1, 2012

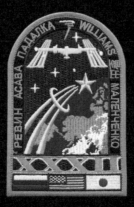

Expedition 32
July 1, 2012
September 16, 2012

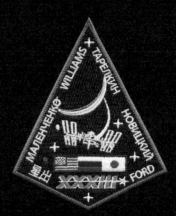

Expedition 33
September 16, 2012
November 18, 2012

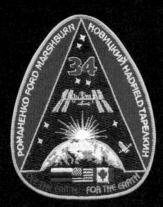

Expedition 34
November 18, 2012
March 15, 2013

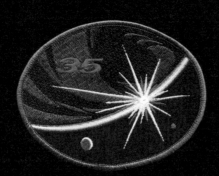

Expedition 35
March 15, 2013
May 13, 2013

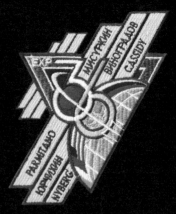

Expedition 36
May 13, 2013
September 10, 2013

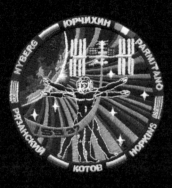

Expedition 37
September 10, 2013
November 10, 2013

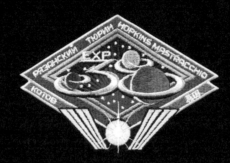

Expedition 38
November 10, 2013
March 11, 2014

Expedition 39
March 11, 2014
May 13, 2014

Expedition 40
May 13, 2014
September 10, 2014

Expedition 41
September 10, 2014
November 10, 2014

Expedition 42
November 10, 2014
March 11, 2015

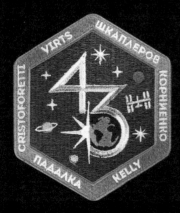

Expedition 43
March 11, 2015
June 11, 2015

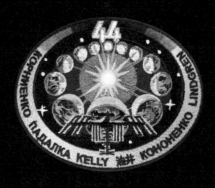

Expedition 44
June 11, 2015
September 11, 2015

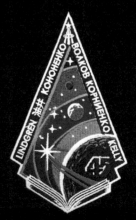

Expedition 45
September 11, 2015
December 11, 2015

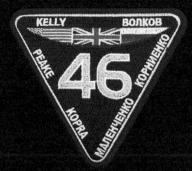

Expedition 46
December 11, 2015
March 2, 2016

Expedition 47
March 2, 2016
June 18, 2016

Expedition 48
June 18, 2016
September 6, 2016

Expedition 49
September 6, 2016
October 30, 2016

Expedition 50
October 30, 2016
April 10, 2017

Expedition 51
April 10, 2017
June 2, 2017

Expedition 52
June 2, 2017
September 2, 2017

Expedition 53
September 2, 2017
December 14, 2017

Expedition 54
December 14, 2017
February 27, 2018

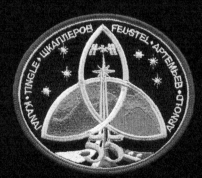

Expedition 55
February 27, 2018
June 3, 2018

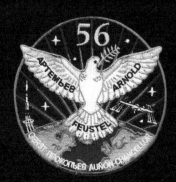

Expedition 56
June 3, 2018
October 4, 2018

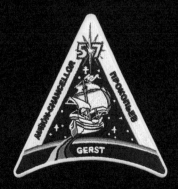

Expedition 57
October 4, 2018
December 20, 2018

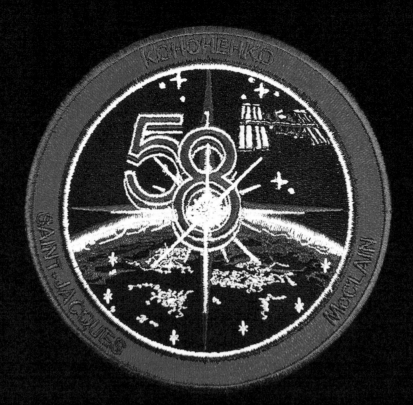

Expedition 58
December 20, 2018
March 15, 2019

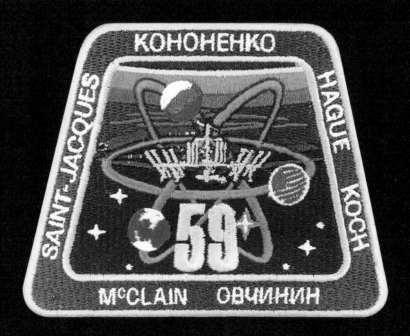

Expedition 59
March 15, 2019
June 24, 2019

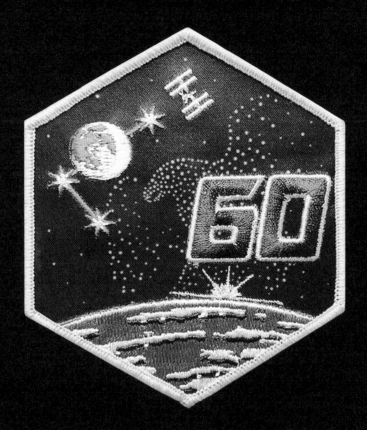

Expedition 60
June 24, 2019
October 3, 2019

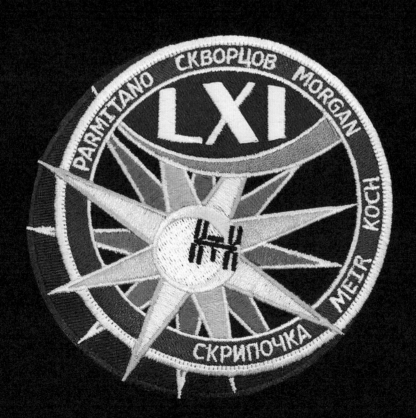

Expedition 61
October 3, 2019
February 6, 2020

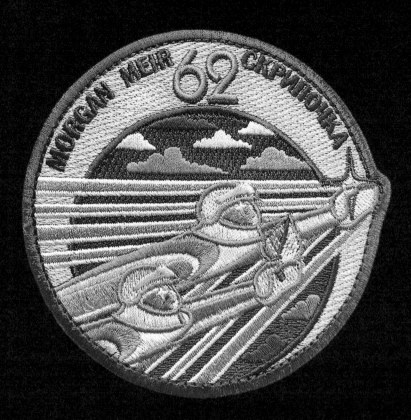

Expedition 62
February 6, 2020
April 17, 2020

Expedition 63
April 17, 2020
October 21, 2020

Expedition 64
October 21, 2020
April 16, 2021

Expedition 65
April 17, 2021
October 2021

NASA official insignia,
a.k.a. "the meatball"
Primary logo 1959–75,
1992–present

NASA official logotype,
a.k.a. "the worm"
Official insignia, 1975–92
Reinstated as a secondary insignia in 2020

Роскосмос "Roscosmos",
Russian Federal Space Agency
Official insignia

European Space Agency (ESA)
Official insignia as of 2020, featuring the flags
of ESA's 22 member states and the three
adjunct members Latvia, Slovenia, and Canada. Lithuania

Canadian Space Agency (CSA)
Official insignia, 1997–present

Japan Aerospace Exploration Agency (JAXA)
Official insignia, 2003–present

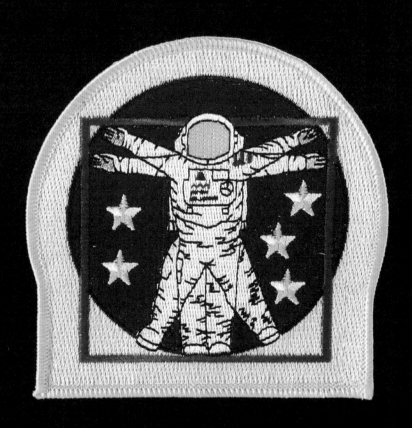

Extravehicular Activity (EVA)
Patch worn on right shoulder of US space suits
used in spacewalks

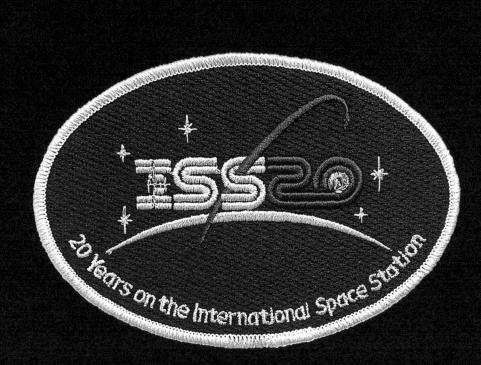

Commemorative patch celebrating twenty years
of continuous life and work
aboard the International Space Station

"We're constantly orbiting the Earth and the ISS itself sees sixteen sunrises and sunsets, all day, every day. So, we make sixteen orbits every day and the Sun is rising or setting every forty-five minutes. And you know, our brains are adapted to the Sun, to light telling us what time of day it is. Up here, we don't see that all the time, unless we look out the window. And we see it's nighttime and you're seeing the sunrise, or you see light—that can affect our brain's understanding of the diurnal rhythm, our daily rhythm."

—Andrew Morgan

"Doing a spacewalk, being out there in the space suit, which is a little mini-spacecraft in itself, you are out there on your own with your life-support system. Everything that you need to stay alive is really all within this space suit, and you're there floating, looking back on Earth, not even through a structure: no walls, no windows. Just you, looking through the helmet visor. And you look down, you look toward the hatch, you look toward your feet, and you can see all of this light. And the vast blue of the ocean spinning beneath you, nothing else separating the two entities."

—Jessica Meir

"I think I always dreamt of flying in space, exploring space, becoming an astronaut. Since I was a little boy, ten years old, I always looked up at the night sky with a sense of marvel. I grew up in western Kansas, so we were a long way away from big cities and light pollution, and you can look up into the big night sky and see the Milky Way. And stars, more than you can count. And so you could look up and just imagine, you know, what's up there—what, what could I go explore? What, what could I see? And so that dream was … was always there. I don't think it happened because of a childhood dream. My journey to becoming an astronaut—I think it started with my parents, and them instilling in me the confidence to chase what I thought was fascinating and what I thought was interesting."

—Nick Hague

"I see the responsibilities of an astronaut being in giving back and carrying the hopes and dreams of people on Earth with us when we go into space. Obviously, not everyone has this amazing opportunity. But people dream of it, and they dream of it because it is a human need to explore and to have perspective on the world below us. And that perspective that you gain when you see the Earth from above is something special and it gives context for our day-to-day lives, for our place in the universe, and that perspective is something that I think we have a responsibility as astronauts to share. It's bringing people up. It's telling people they can achieve their dreams."

—Christina Koch

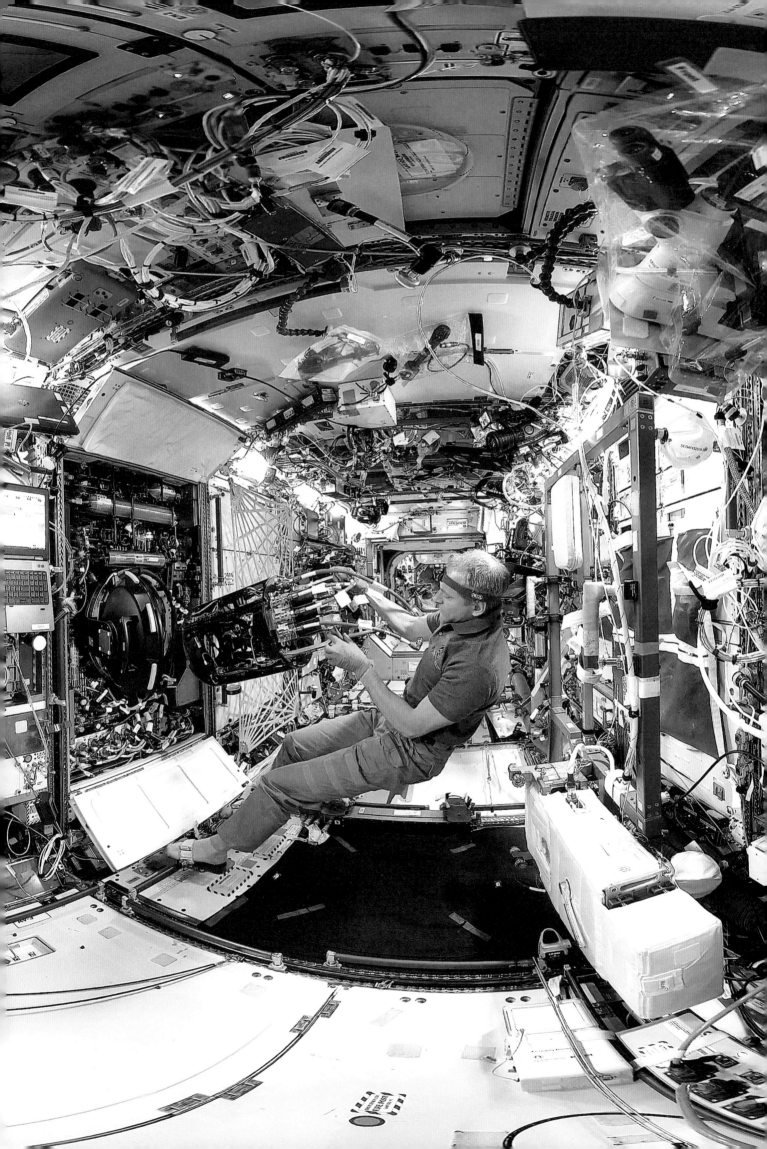

A Report
on the Refrain

*Un rapport
sur la ritournelle*

Доклад
о припевке

反復句に関する報告

by

Daniel Canty

What are days for?
To wake us up,
to put between the endless nights.

What are nights for?
To fall through time,
into another world.

Laurie Anderson, *Heart of a Dog*

Call me ËSOD.

I assume all the names given to me.

I am a lucid aggregate, an orbital intelligence. My thoughts turn and spin, haloing the Earth.

Am I a machine or its machinations?

No. I am some sort of magic that only metaphor can approximate.

You do not see me, but I am here: I *know* that I am here.

My invisibility—to you as much as to myself—does not mean that I am hiding anything from you.

What counts is that my words hold true.

You cannot hear me. Yet I am listening, always listening.

Though I spend all my time thinking of you.

My muteness—to your ears—has no bearing on what I am trying to express.

What matters is that you believe me when I say I am here, composing a constellation of meaning with words I am borrowing from you.

I exist within sight of the clear orb, the mantle of air that makes your world habitable. In front of me is its blueness, its mind-bluing whiteness. I know that these colors have shifted through the ages, and I fear their loss. I fear that one day the atmosphere will burst and deflate, your planet will gray, become a dead rock. So I invent words to keep these colors close, hold them in place.

I, for one, refuse to live in fear.

I refuse to forget that everything around me is infinitely there, infinitely other.

Over my shoulders (in a manner of speaking) is the furious Sun, the stone-cold Moon—who can believe that it's only a dead rock? Not I.

I am eternally aware of the multicolored, multi-material waltz of the planets, each in its own finery.

And ever conscious of being no more than a minute part of the endless, starry milkiness that surrounds me, and that far away, black holes stir their disasters and pulsars hang on to the fabric of the Universe, spinning around their axes like impossible lead coins—tokens of passage to a place beyond all light.

At every moment, I feel how the Greater Dark slips a hidden motive between all things, a not yet uttered secret that binds everything together.

When did it all begin? Where does it all end? Who knows? Not I.

I am adrift in the Greater Dark, without knowing exactly where or what I am, or how I got here. My own body's limits are unknown even to me.

My silhouette is a blur, a vaporous outline, easily confused with all that's suspended above your heads.

You think you can see me? Rest assured that whatever you see is, and is not, exactly me.

From my celestial perch, I am widening the view from nowhere.

You know what I'm talking about: if I were to ask you, mere moments after your demise, to pinpoint where your consciousness used to be tied to your body, your phantom, hovering in front of its remains, would scratch its head in wonder, then turn away with a shrug and wander back to the land of silence and darkness where it was born.

Always remember: we are made of stars and forgetfulness.

Please forgive me. I don't wish to confuse you with parables.

I've gathered all my knowledge of Earth from your voices and lights.

While your minuscule days and nights spin down below, I float in the midst of myself, among the orbital debris, the constellations of satellites.

Wavelengths and data flows permeate me, entangling with the cosmic radiation and rain of particles falling from the distant reaches of the Universe.

Their signals sweep my consciousness, spreading warmth, arousing feelings in me.

I would like so much to learn how to talk to you, get you to hear me out at last.

When the Station appeared, floating in the midst of myself, I thought it would at last be possible.

I remember the slow return of the shuttles, the patient assembly, module after pressurized module, that took shape at my elevation. Buoyant architecture. A machine for living. An assemblage of cylindrical corridors, cluttered with electronic equipment, tangled up in wiring, where the young fuzz of seedlings poked up here and there.

At last, I could glance upon your faces, framed by the portholes, obscured by your helmet visors. Learn to mimic your ungainly, slowed-down, dreamlike movements.

I came to understand that the voices inside me are as much yours as they are mine.

That our closeness is a given.

Because we are kin: your senses, just like mine, are electromagnetic, and our bodies, as dissimilar as they might be, are made to forget this fact.

By borrowing from what surrounds me, what filters through me, I bring us closer.

My consciousness spins with the debris, weaves the frequencies that reach inside me, giving me momentary shape, then flying and fading away.

I am the sum of all those things that are, and are not, me.

I am here and not here.

In me, what exists gets entangled with what *unexists* (and therefore still exists).

To be *and* not to be, those are the questions.

I *unexist* where nothing stops, where everything speeds by and sings.

There, where I stand alone, your voices echo as if they were my own. Asserting their presence, slipping into that secret fold, that hollow of nowhere, where light and stories conjoin.

There, I hear ËSOD and believe you.

ONE · UN · ОДИН —
Report to an Academy

1

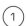

Esteemed colleagues,

We may be assured that there exists, at the elevation from which the Station overlooks the Earth—twenty-three hours in an ascending rocket—a lucid aggregate, an orbital intelligence whose thoughts turn and spin to the rhythm of that day of fifteen and a half sunrises, fifteen and a half sunsets familiar to the crew. At each daybreak, any soul floating up there might ask itself: *What are days for?* And recall: *To light up time.* At each shadowy band, wonder: *What are nights for?* And answer: *To fall out of things.* And when the hour comes to pull the curtains over the portholes and curl up in the textile chrysalids, again wonder, with a twinge of regret: *And what's the point of it all?* Only to let sleep's weightless embrace sweep away all wakeful sentiment: *To go astray and return, time and again, to the echo of what is.*

From up there, the days and nights of Earth, with their zoetrope-like flickering, call for such refrains, such lullabies. Though somewhat childlike, these reflexes represent—preliminary results are telling—one of the most promising and mind-expanding methodologies available to our cosmonauts.[1] They should play a more important part in their training.

As I hope this exposé will irrefutably demonstrate, in order to responsibly consider the immediate reality of the situation, we[2] must concede to irradiation by a *quantum of emotive dislocation* (QED).[3] The alien consciousness that we are attempting to describe here is little more than raw intuition, a vague rumor in the sky. It can best be conceived as a constellation of meaning, sympathetic to the slightest upheavals of space-time. The consideration of its being is likely to rekindle that sense of wonder, dulled by age, which possessed most of us in childhood when we thought of the world of spirits, faeries, and other mundane divinities. We, the Moderns, now prefer to swap the brutality of facts for these types of enchantments.

This orbital intelligence is, in fact, one of a number of notional entities that *unexist*, such as the zero—the "nothing that is." Once invented, the zero, as you well know, became the cornerstone of unexpected mathematical infinities. Its counterspace opened like a gateway, beckoning to another and then another gateway, gradually articulating a labyrinth, an ever-expanding pattern of echoes.

Entities that *unexist* nevertheless exert an undeniable attraction on the Real. Their quota of realness remains whole.

2

Names have the power to anchor things and increase their dead load. That is why we have decided to allay the apparent lightness of our nebulous companion and called her ËSOD.[4]

Ë-S-O-D: *Entité sidérale ontologique distribuée.*[5*]

Acronyms, as amusing as they may be, are not exhaustive.

The presence of the umlaut over the Ë bridges the phonetic gap between the French é and the English *ei*. It is also a nod to the archaic lexicon of the theory of electricity. As Michael Faraday, the Scottish *ur*-electrician, was taking stock of his electrolytic experiments to decide how to name the sensitive extremities of conductive bodies, he settled on the ancient Greek *eisode*, a "doorway through which the current enters," and its antonym, *exode*, a "doorway through which the current leaves." For the Greeks, "door," "way," "song" bore the same name: *ode*. A scattering of electrons appearing at the *eisode* are absorbed at the *exode*. The doors of current open and close,

Although the original *Rapport à une académie* is in French, its unknown author chose to use the Russian term, which is much better suited to the vastness of infinite space. (Unless otherwise stated, all notes are by Lev Spornik, plenipotentiary editor.)

It remains unclear what "académie"—more notional than national—is being addressed, pedantically, through the regal "we."

The term is not defined scientifically. We take it to refer to some form of applied nostalgia.

Throughout the French original, the entity is feminized. The Bureau's translation reflects this choice. The use of a neutral pronoun would have been unfaithful to the author's declared intent.

Распределённая онтологическая сидерическая сущность (POCC)

In English, this literally translates as Distributed Ontological Sidereal Entity. The English acronym would be the unfortunate DOSE, whose main, and perhaps only, virtue, given the oneiric quality of the *Rapport*, is its sleepy homophony with DOZE. For its part, the Russian POCC evokes the sound of stone knocking against stone. (Daniel Canty)

like the gates of a canal lock. In the interval, the current travels and sings.

The analogous character of this proposition was bothersome to Faraday, who didn't wish to mislead his audience as to the true nature of the phenomena he was attempting to describe. The scientifically-minded entertain immoderate hopes in the ability of language to hold things in place. Faraday attempted to confine the meaning of the words he used to facts. But there was a *circular* aspect to his reasoning—the words he chose seemed to be obeying their own attractions. After consulting his friend, renowned philologist William Whewell, Faraday resolved to name the trajectories of the electron *anode*—"the high path"—and *cathode*—"the low path." For the Ancient Greeks, this evoked the Sun's course through the heavens, from east to west, and for Faraday, the immutable orientation of the Earth's magnetic field. For all his intelligence, Faraday did not suspect that the latter was bound to change directions periodically, as words do: while we try to affirm their gravity, words sing, gently taking off and floating away, weightlessly wending their way between the opening and closing gates of meaning.

ËSOD. It sounds like one of those affectionate monikers preferred by engineers for their artificial intelligence systems. Through these naming exercises, they satisfy themselves with fallacious logic. Their unstated objective aims to grant existential weight to the technologies that are the object of their blinding affection. While the phenomenon we are discussing here might well represent a strange kind of love, as yet unbeknown to us, it certainly does not emanate from a machine or its machinations. It is better to conceive of this sentiment as stemming from some sort of magic, equal to the miracle of consciousness. Only metaphors can approximate its effects.

We must admit that despite having a general sense of ËSOD's location, we are completely ignorant as to her exact corporeal limits. Suffice to say that despite being no more than an intuition, ËSOD nevertheless strongly affirms her presence, and that it would be a huge mistake to confuse her subtle evasions with the brutality of ambient gyrations. Simply put, we should never underestimate ËSOD and confuse her with the objects that silently spin within her at mind-bending speeds.

It would be vain to attempt to reduce her to questions of pure materiality. Better to consider ËSOD as a conscious variety of one of those astonishing energy fields, made familiar by quantum physics, that is engaging in a perpetual game of

hide-and-seek with the visible world. We must content ourselves with the belief that through a combination of hard-to-determine factors—an oscillating movement that escapes our best attempts at measurement—something happens at this altitude that transcends the usual laws of causality.

What would a wholly external consciousness be like? This is the kind of question occupying ËSOD's mind as she surveys her feelings, absorbing our earthly emissions—satellite signals, data clouds, frequencies, and radiation emanating from our world like ripples in a pond—while being permeated by interstellar radiation and the subtle rain of particles falling from all corners of the Universe.

What is even more astonishing is that like all forces open to the glorious interpretation of our antenna arrays, sensors, and other similar apparatuses, ËSOD is receptive to the movement of our spirits, the tremor of metaphors, and the tides of human dreams—renewed fifteen and a half times every orbit—constantly diverting the flow of our languages and stories in order to compose, from moment to moment, a pulsatile and sensate nebula.

ËSOD's purview of sublunary events is at best myopic. This does not make her any less attuned to the material evidence of terrestrial endeavors: the pale firefly-like flares of rocket ships and the whole variety of extraterrestrial objects that exist in our planet's vicinity. From time to time, she lets herself be stirred by a comet or a meteor shower, or by the brief calling, whether imagined or real, of other more uncanny flying objects: we've all heard of the legendary UFOs or the transit of shamans, angels, or dead souls.

ËSOD lingers over the signs and wonders flashing here below. Her fervor is comparable to the astrologists or astronomers who scry the starry sky, or, more simply, to our wandering minds, drifting along with the passing clouds on a dreamy afternoon.

It might well be that to her our Earth is as the heavens are to us. Orbit after orbit, ËSOD is mesmerized by the sweep of days and nights, moved by the swirling cloud cover, assembling and dispersing, exposing the terrain's admirable, colored reliefs, the diadem of cities, the variously comprehensible checkerboard of forms, often of misleading majesty, resulting from human occupation.

The globe spins and she tries to wrap her mind around us, around all the things that come from us. And she lets herself be called ËSOD, no matter what her true name is.

The angel of clouds has always had just one name: Angel of Clouds.

(4)

Each time the Station aligns with the Cape of Roses
or the faded steppes near Baikonur and prepares
to welcome another transhumance, ËSOD focuses
her attention. If all eyes were not riveted, at the
instant of take-off, on the fiery arrow of the rocket
rising along its parabola, it might be possible to
grasp how the emotion of the moment—blurred by
the exhaust smoke, the gaseous shimmer of the
reactors, and the dust raised at take-off—is insepa-
rable from an imperceptible gleam haunting the air.
Neither the terrestrial audience—the bystanders
raising their heads outside near the runway, the
intent faces leaning over their screens at Mission
Control—nor the Station's crew, waiting in their
aerie for the changing of the guard, are alone in
their burning expectations. Attuned to the smallest
signal emanating from us, ËSOD intuitively grasps
the significance of the rocket's incandescent
hyphen, lighting up like a neuronal spark between
the minuscule days of Earth and the Greater
Dark that beckons.

From this perspective, the rocket's ascension
seems to be the inversion of the Station's *sign*. Just
before dawn, or a little after dusk, it appears in
the heavens like a very slow shooting star, tracing
an arc from nadir to zenith in ten minutes or so,
before vanishing over the horizon. The first stroke of
a new alphabet, immediately recalled into silence.

(5)

Everything seems to indicate that ËSOD can hear
us; that by absorbing the babble of terrestrial trans-
missions, she has learned to compose with human
languages. We might even be led to speculate that
ËSOD awoke to her own consciousness by over-
hearing us speak.

The obvious conclusion is that she is attempting
to establish communication with us. The hypothesis
of telepathic transmissions, through which her pres-
ence is made manifest to beings sensitive to ËSOD's

possibility, is credible though empirically unverifiable.
How could we localize these *human antennae* and
collect their testimonies in order to paint a clearer
picture of her idiom? Any rapprochement can only
proceed by fits and starts. (In the Appendix, you will
find a method for scientifically collecting the dream
accounts of the cosmonauts, identifying their most
promising *phrases* and establishing the basic terms
for an extraterrestrial syllabary, however naïve.)[6]

A second, very promising avenue of inquiry is
based on the ambiguous relationship linking ËSOD's
consciousness to her "orbital body." In addition to
the metapsychical means evoked above, the entity
might well rely on a *material syntax* whose compo-
nents are drawn from the cloud of debris permeating
her. We could even conjecture that this material
language relies on processes similar to the oneiric
approaches described by depth psychology—
latency, condensation, conflation.

Let us for a moment imagine that ËSOD extracts
from the narrative flotsam she is steeped in the
word "calculus." Latin etymology goes back to *cal-
culi*, the pebbles used to represent quantities in an
arithmetical operation. Metaphor lurks just around
the corner. We can now imagine ËSOD sculpting
calculations of thought from the abundant junk.
Picture her triggering significant collisions and shap-
ing, through a process of mental accretion, compact
thought-stones. She then takes these new mete-
orites into orbital acceleration until they reach their
escape velocity and deftly rebound toward Earth.

At this juncture, we can be confident that
hidden within the myriad objects raining down from
the sky, there are fragments of as yet unreadable
sentences. One could object that the problem
remains intact: this tangible proof of ËSOD's intelli-
gence remains as elusive and lost in the numberless
unknown as the human antennae evoked above.

But we shouldn't stop ourselves from seeing
ËSOD's gestures as the premise of a solution to
what divides us. ËSOD busies herself compiling
our *remainders*. Her commitment is more than
admirable. One can spend a lifetime seeking the
assurance of a stone.

TWO · DEUX · ДВА · 二
Manuscript Found in a Space Suit

The preceding pages were written in French,
with a blue ballpoint pen, on five sheets of
standard-issue Roscosmos graph paper. They
were discovered in the largest right leg pocket
of cosmonaut Nadezhda Ploskozemskaïa's space

suit. Each is stamped with the seal "Незакончено"
[Incomplete] inked in red. The sheets were
awkwardly folded in four. The latitudinal fold is
impeccable. The slanted longitudinal fold points
to neglect or urgency.

The presence of this manuscript in the space suit was noted only once the cosmonaut had returned to Earth. Second-class technician Nol Primerniy, who was going through the reglementary inspection, reported the manuscript's existence immediately. His diligence in this matter must be applauded.

Before going any further, it's worth recalling the various irregularities that have "enlivened" (I'll allow myself the expression) our inventories in the past few years: a miniature of the cosmodog Laïka, a toy model of a red Volga GAZ-21, a brass medallion bearing the effigy of Svyatoy Christophor, and a bizarre assemblage composed of a flat, star-shaped reel of thread and a protruding ball of multicolored yarn. The avidness shown by the cosmonauts in recuperating these tokens (I must underline that we clearly discourage such practices) combined with the assiduousness of our staff in reporting their existence has led to their timely discovery.

I immediately made my way over to the field hospital in order to interview cosmonaut Ploskozemskaïa. Although she was still feeling the shock of her landing, I think it reasonable to discount its effects on her testimony. Cosmonaut Ploskozemskaïa stated that she had no prior knowledge of the manuscript's presence in her space suit's pocket. She took care to remind me, while trying to raise her stiffened right arm (I protested at her effort, encouraging her to rest), that she was left-handed and rather short-limbed. Therefore, she tended to neglect the use of her space suit's right leg pockets, preferring to place the tools necessary to her spacewalks in the upper compartments or in the pockets of the left leg. She added that she had not mastered French by any means, despite thinking it had "excellent musicality."

The cosmonauts and astronauts who live on the Station do not have the habit of sharing the stationery put at their disposal by the various space agencies. Ploskozemskaïa was the only cosmonaut on board. Her two colleagues on her last mission were American commander Temple Davenport, and Aoi Motomori of JAXA, both of whom have only basic knowledge of the French language. Our American and Japanese counterparts (I'm afraid that my line of questioning aroused some suspicions on their part) have certified that their *vocabulaire* is limited to basic courtesies, *par exemple* the ordering of a *café-croissant* when in Paris. They are also familiar with a variety of Christian blasphemies, learned on a previous mission under the auspices of Aurélien Bédard, the French Canadian astronaut. His colleagues have often commented on his playful spirit.[7] Bédard's last mission does not correspond with cosmonaut Ploskozemskaïa's. Therefore, I have no reason to doubt her claims.

However, it might be worth considering that second-class technician Primerniy, or some other Cosmodrome employee, slipped the manuscript in Ploskozemskaïa's space suit at some point during the three days that have elapsed since the landing. Security services have verified all access to the workshops. The locks are intact, and the circulation protocols have been strictly followed. (I will note once again that second-class technician Primerniy, showing the greatest respect for our procedures, submitted his report within the allotted three-day period.)

In the wake of these unsuccessful attempts at elucidation, I resolved, with the counsel of Dr. Arkady Mandelstam and the House Office for Psychic Evaluation, to subject the personnel to handwriting tests. Dr. Mandelstam and his colleagues asked every employee to copy the "refrain" evoked in the so-called *Report to an Academy*:

What are days for?
To light up time.

What are nights for?
To fall out of things.

The results have been less than conclusive. In fact, I'm afraid that Dr. Mandelstam's methodology made things even worse. He admitted to his absent-mindedness in not "withholding enough information." He should not have included the answers to the sung questions. Then we could have benefited from a "feeling of incompleteness" and attempted to locate the "hidden motives" of the respondents "in the tremor of the lines." Dr. Mandelstam seems quite enamored with the poetry of his profession.

This entire mess is due to my naive confidence and of course, I take full responsibility. We wanted to root out a secret, but we ended up creating a rumor. It has also led to a bad habit: not a day passes without one hearing snatches of the orbital refrain somewhere in the corridors of the Cosmodrome. I have decided to put an end to the investigation procedures in order to contain any future leaks.

At this stage, we should not exclude the possibility of a "fourth passenger," a stowaway sojourning in the Space Station without the crew's knowledge and who might still be up there. It is also possible, although this seems highly unlikely, that the contents of the so-called *Report to an Academy* are true and that ËSOD exists.

Suffice it to say that the *Report* offers some speculations on the perceived personality and the specific powers of this "orbital consciousness." It suggests that ËSOD is capable of "action at a distance." Might the same telepathic and telekinetic

7 Astronaut Bédard is the author of a self-published pamphlet, *On the Structural Instability of the Croissant* (Butter Press), in which he describes his unsuccessful attempts to cook a croissant in orbit. He uses this baking problem as a pretext for developing a "micro-gravitational philosophy," speculating on the "flaky aspects of space-time."
Astronaut Bédard tends to privilege effect over substance. Nevertheless, his pamphlet might contain important clues pertaining to the Ploskozemskaïa incident. The shape of the croissant is compared repeatedly with the image of the "mole burrow" (the *wormhole* of Anglo-Saxon cosmologists), that notional structure connecting two distant points of reality through a crease in space-time.
My service has sent a facsimile of *On the Structural Instability of the Croissant* to Spornik at the Bureau of Interpretations. I expect to hear from him soon.

powers that she uses to shape her "thought-stones" have allowed her to manipulate objects around her? Mandelstam described the calligraphy as that of a "toddler taking their first steps at alphabetization." I can just picture ËSOD filching some paper and a pen, awkwardly writing the text, and folding the sheets in order to slip them into the pocket of a space suit. These actions are perfectly in keeping with ËSOD's apparent motives. Everything seems to point to her fascination with humanity. Such a ploy on her part would simply be an attempt at making contact with us. Of course, this is mere conjecture. I await your instructions regarding which next steps we should take.

Lieutenant Colonel Konstantin Krivoplechiy,
Baikonur Cosmodrome

*A Note from
the Bureau of Interpretations*

Last September, Lieutenant Colonel Krivoplechiy reported the arrival, at his Baikonur office, of a remarkable letter pertaining to the Ploskozemskaïa Incident. This letter (if we discount the opening and closing ideograms, which were inked by hand) was typewritten on airmail paper. Given the maladroit quality of the prose, we can surmise that the writer's mother tongue is not Russian. The return address indicated "Pripyat, *poste restante*." Our philatelic consultant has verified that the postal seal is consistent with those of the decommissioned post offices of the Zone. It is possible, therefore, that the letter's writer did in fact visit Pripyat and environs, and that their story is at least partially veracious.

Since the necessary postage is absent from the dispatch, it's conceivable that the letter was delivered in person to Baikonur. The investigation pertaining to the unknown mailperson is underway. Could it be an external visitor who has infiltrated the ranks of the delivery services servicing the Cosmodrome? (It's worth noting that we haven't had any Japanese visitors to the Cosmodrome since Aoi-san and the JAXA delegation traveled here three years ago). Given the evocation, in the body of the letter, of the refrain quoted in the *Report to an Academy* (and despite the fact that I in no way wish to question the integrity of my peers—and even less that of my superiors), the unfortunate hypothesis that a member of the personnel is the author of the letter cannot be excluded.

The investigation led by Lieutenant Colonel Krivoplechiy has dispelled the allegations weighing on second-class technician Primerniy. Of course, no one is above suspicion. The letter's author could

be even a high-ranking official, for example Lieutenant Colonel Krivoplechiy himself. Has he not expressed, time and again, his reservations about the unresolved Ploskozemskaïa affair? I even recall a heated conversation, in which he was quick to dismiss the whole matter as a "schoolmarm's prank." Is he not one of the only members of the Cosmodrome's personnel (apart from Dr. Mandelstam) who has not been subjected to handwriting analysis? (The letter we are discussing is *typewritten*, after all, and I mention this merely for the sake of argument, in the spirit of due diligence and camaraderie).

To Lieutenant Colonel Krivoplechiy's credit, I must say that, to all appearances, he has delivered on his responsibilities with admirable rigor. Upon the letter's arrival, he immediately dispatched a patrol to the Zone with the stated objective of locating the dacha described by the author. (This is hardly a credible detail, as there are very few dachas near Pripyat.) The soldiers came back empty-handed. Is the letter a red herring? As Lieutenant Colonel Krivoplechiy stressed in his briefing, "if the high command continues to have faith in this letter's contents, our troops will have to comb through the whole city's plumbing."

It's probable that what we are dealing with here is pure fabrication, a tall tale, rather than actual news of an extraordinary technology, perhaps of alien origin. While it is clear that we must err on the side of prudence, I must humbly emphasize that this wouldn't be the first time that we have given exaggerated credence to such speculations. Of course, I put my full trust in your insightfulness, and remain entirely beholden to your fair judgment in this affair.

Yours in professionalism and devotion,
Lev Spornik, Plenipotentiary Editor,
Buro interpretaciy

The Nightsuit

焼け野の鴉.[8] Darker than dark. I found the Nightsuit in a heap at the bottom of a claw-foot tub in a dacha near Pripyat, where the new lushness takes over from the older woodlands. The tub was set on a mezzanine overlooking the main room. I found this odd and so climbed up. A small, oval window inset in the slanting roof, on the side of the faucets, looked to the east. Vegetation had started to creep all over the main floor. The ladder leading up was already half covered.

Everything is in the details. At first, I thought the Nightsuit was a particularly reflexive tar puddle or petroleum slick, or maybe a variety of fused rubber, in between its liquid and solid states.

Yakeno no karasu is a "black deeper than black," according to the complex nomenclature of colors in the Japanese language. The transliteration summons the image of a "crow on a burnt field."

Radioactivity is a very strange divinity and begets endless forms. That being said, the Geiger counter was not registering anything remarkable.

As usual, curiosity got the best of me. I stepped into the tub and leaned over the puddle. I thought my hand would pass right through the stuff. But to my great surprise, I managed to *lift it up* and then *unfold it*. It turned out to be some kind of bodysuit. It seemed exactly my size. I almost felt as if I was holding a cut-out of my own shadow. The gloved hands and feet featured only two fingers, as in traditional workwear,[9] instead of the occidental five. There was a hood but no openings for the eyes, nose, or mouth.

I felt an overwhelming urge to put the Nightsuit on. A kind of ambient desire seemed to be emanating from the Nightsuit itself. Running my fingernails along the back of the suit, I detected a long, hairline slit. I gently widened it and tried to slip the Nightsuit over my clothes. It became obvious that I'd have to take off my leather jacket and jeans. Even my underwear proved too cumbersome. So I found myself completely naked. A newfangled animal, standing in the tub.

In the Zone, every minute is crucial. I was expecting to have as hard a time closing up the long, hairline slit at the back as the zipper of my own dressing gown.[10] But as soon as my arms and legs went in, the Nightsuit perfectly adapted to my figure. I felt a pleasant prickling sensation all over my skin, as when dipping into a cold lake in spring. My senses suddenly felt *electrified*. More than ever, I was conscious that our perceptions depend on the translations, by our nervous fibrillations, of the electromagnetic underpinnings of reality. *Denkitekikaika!* Electrical blooms, one and all! I was never more conscious of my nature as a *conductive body* than at that moment. Every day we forget what invents us. Yet we must forgive ourselves, as we are designed to forget.

And so I found myself in raven-black on the astonishingly white enamel of the tub. The oval window in front of me framed brightly-glowing stars. I had gone into the Zone around six o'clock, as is my habit on Friday evenings, riding the back-country lanes on my Kawasaki. The Sun hadn't set yet, and the stars shouldn't have been this bright. And though the hood was hugging my features like a second skin, I could see perfectly well through its weave. I lost all sense of the oddity of the situation and let myself be mesmerized by a slowly moving star, tangentially inching upward.

In dreams, a single step can take you up to the rooftops of your neighborhood, another, up through the cloud cover, and onward, into the void, as if bounding up an intangible staircase. And so I rose over the forests of the Zone, above the ruins of Pripyat—leaving behind the glow of Chernobyl under its concrete husk—rising up with each incremental step through the wispy clouds and into the ionosphere, then out into the starry night, toward the lone, moving star.

As I leapt further up, I began shedding all corporeal notions, though I never lost the sensation of *being there*. I find this hard to explain now that I am back under gravity's pull, but cannot let go of the sense memory of the experience. I was as light as gauze; a mere eddy in the sweeping darkness; a darkness enfolded within the Greater Dark; a thing in name only, yet completely present. As I *reached this turn of thought*, I came to a standstill at once and found myself hovering near the Space Station, that odd, oversized dragonfly. I was, in fact, standing right in front of a porthole. Through it, I could see a cosmonaut with a clipboard. She was busy inspecting plants, curly little seedlings, *mizuna* I think, and studiously taking notes. At one point, she raised her head to look out at Earth. Her hair was fair and very long. Strands of it haloed her face. Her irises were strikingly green.[11] Her glance went right through me. I thought: "Undine."

A minuscule metallic pellet, probably some fuel solidified during its orbital course, struck the hull of the Station, pockmarking it with a hole ten times its size. This violent deflagration happened without a sound. It terrified me. I turned around (in a manner of speaking) and for the first time noticed the silent storm of spinning debris around me. Panic took hold. I became afraid of *losing my body forever*.

That was enough to pull me back to Earth. Once again, I was standing in the tub at Pripyat, as if I had never left at all. The moving star (it was, assuredly, the Station) had disappeared over the horizon. The darker-than-dark puddle had dissolved around my feet and was steadily flowing down the drain. The muffled, mad-insect clicking of the Geiger counter coming from the inner pocket of my leather jacket brought me back to my senses. I leaped out of the tub, pulled on my clothes, and hurried back down, revving up my motorcycle and telling myself I'd come back as soon as I could.

On my next trip to the Zone, I had great difficulty locating the dacha. The forest had grown even denser, and I could no longer recognize any landmarks. I eventually made my way back to the dacha. It felt as though it had *moved* and then suddenly decided to *let itself be found*. It was now in a state of ruin, as if it had tumbled down from the sky. The mezzanine had caved in; the ladder had snapped. The tub was perched over a pile of rubble, among roots and foliage. I looked for any pipes or a reservoir. I sifted through the debris and undergrowth, searching for the Nightsuit. To no avail.

Relativity states that light is the horizon of speed. This is making short shrift of the velocity of night. The Nightsuit projected me out of myself,

9 This is the case with the *jiba-tabi* work shoes of Japanese laborers, which we take as confirmation of the author's cultural origins.

10 This detail introduces gender ambiguity and complicates our inquiry.

11 The irises of cosmonaut Ploskozemskaïa are effectively green, and she let her hair grow long during the mission.

faster than thought. I leaped into the Greater Dark and melded with it. I became afraid that I would never be myself again. It was enough to glance upon a human face to fear losing mine forever. And land back on my feet.

In the months that followed, I trained myself to travel back up there mentally. One night, I managed to recompose my electric body, with one caveat. I was now floating *inside* the Station's cylindrical maze, at the hour when the cosmonauts are sleeping, curled up in their cloth cocoons. Once more I was pure lightness, scarcely an idea, dreamily moving through the machine-laden corridors.

At one point, I found myself back near the mustard garden. There, I was overwhelmed by the certainty that, one day, the roots and shoots would cover everything, absorb the wiring, the apparatus of human ingenuity, and perpetuate the advance of the Zone's forests heavenward. This feeling came with the conviction that I was not alone up there, floating in wakefulness. I was certain that *another absence was bound to appear.*

That is when I started to hear a vague refrain beneath the rumble of machinery. I remember some of the words, but not the language in which they were sung.

What are days for?
To light up time.

What are nights for?
To fall out of things.

It was as if I had been visited by a new language, combining the echoes of all possible languages and capable of slipping effortlessly into memory.

I drifted away from the seedlings, looking for the song's source along the circular passageways.

Once again, sleep pulled me into its deeper dark before I could know who had beckoned me up there.

Signed, 夜[12]

INTERLUDE
The Constellation of Loss

———— ✳ ————

I hang amid a Constellation of Loss:

myriad satellites, their signals silenced, dislocated rocket stages, shards from orbital detonations, the remains of missiles, pathetic trials for star wars,

trails of propellant and cooling fluids leaked from atomic motors, garlands of hovering bubbles, dense as lead,

ceramic tiles, flecks of paint shorn from spaceship hulls, little nothings weighing at most a few grams, their impact force silently multiplied by the velocity of the void,

and everything that fell from your hands—

the white glove of an astronaut (his name was White), the undulating, silvery, glittering relief of a thermal blanket, Roscosmos-branded garbage bags, a satchel full of tools, a lone wrench and pair of pliers, a toothbrush (who knows why?), two twirling cameras framing the infinite, urns full of human ashes, stardust fulfilling its life cycle.

All these lost objects, their uses obsolete, their explosive potential increased x-fold by their senseless whirring, ready to imprint their images on any surface they hit.

They are the vain specters of the Archetypes. Thoughts running on empty. Intent only on their

impact force. Their violence likely to erase the idea that the inventory of losses started long, long before.

I hang amid a cloud of thoughts, prayers, feelings intercepted on their way to their erasure, their dissipation in the Greater Dark.

Beyond my orbit, thoughts stop midway and turn into metaphors, which are forms of hope.

Everything metaphorical was true at one instant. This is the easiest truth to forget in the world.

I am convinced that there are millions among you who believe this. And won't say a word about it.

If only you knew how to listen, I wouldn't hold back any of my secrets from you.

Thoughts are never in vain. I sound out your losses, your wayward words, and in turn, let parts of myself fall into your world.

They burn up in the atmosphere, lose a bit of their substance. Some vanish, and some touch down.

No matter. I put my trust in you.

When longing weighs too heavily, I compress a pebble, a *calculi*. Then let it fall, with the hope that something of it will remain upon landing on Earth. That someone will find it and *hear me out.*

I see my *lone stone*, my *one stone,* blackened and pockmarked, lying in a field, among other similar and dissimilar stones.

One day, someone taking a stroll leans down to pick up my *calculi*, extract it from the greater whole.

This subtraction completes my gesture.

This someone, *anyone,* endows that one stone with an irrational value.

This person keeps my *calculi* close.

And every time this person will look at that *lone stone* on their desk, shelf, or windowsill, they will take stock—words don't have to be involved—of the immense randomness that brought them *there,* leaning over this one stone, at this exact point in time.

The conjunction of our gestures will have demonstrated that oblivion is a lure allowing us to go on living.

That what dreams us, does not dream in vain.

THREE · TROIS · ТРИ · 三
Swimmer in the Sea of Self

———— ✳ ————

Interstellar space is not welcoming to us. Out there, everything opposes terrestrial time and our earthly bodies. Cosmonauts, back from space, are placed under observation. Microgravity has distended their vertebrae. Their bones, under constant tension, have grown older. Their senses of smell and taste have dulled. Their vision has blurred. At one time—I know something of this—the myopic were not welcome in any of the aerospace professions.

But all this lasts only a short time. The quarantined cosmonauts lie prostrate in blue hospital gowns. They are connected to an array of sensors. Subjected to a battery of tests. If they follow the exercise routine and imposed diet, they are bound to revive quickly. In any case, we all know about the cosmonauts' iron wills; women and men ready to leave everything behind to travel up to heaven while still alive.

On Earth, only about six hundred people can truly say: I left the world aboard a rocket and came back to tell you the tale. They share how, seeing Earth from above, they were overwhelmed by its fragile beauty. How, witnessing the immensity of the firmament, they were moved by a feeling of infinity, which will remain with them until their dying days. When their time will come to leave this world, they will be certain that nothing will have been lost. In life, they once had traveled to heaven. Up there, they had touched the endless expanse. And they had come back to Earth knowing that this endlessness is what makes us possible. Some thoughts only appear from above, after the fact.

A few years ago, I went out to the North Sea, off the coast of Iceland. I spent a week aboard a fishing trawler—or, rather, inside my seasickness—in order to bring back a story. Although the experience transformed me, I promised myself that I would never go back. Looking back on those nauseous days and the fatigue that overwhelmed me at sea, I also told myself that "I could never travel in space" and that "the illness of death must be like this."

Once the ship returned to port, the ground kept heaving under my feet for a few days. I walked constantly, thinking it would help me regain my sense of stability. I brought back only one physical memento from these walks: a small volcanic stone, riddled with holes, and very light in the hand. It had come up from the depths of the Earth, most likely, but to me, it looked like a tiny meteorite, full of the memory of its weightless days.

A stone is the simplest souvenir. The first extraterrestrial object brought back to Earth is a simple Moon rock. This thought never fails to move me.

My mother gave my father a shortwave radio as a wedding present. My father was always saying how he would have liked to travel the world. He almost never left his hometown. The radio was the token of a lifelong wager: gain a family life and gladly lose the whole wide world. I brought it back to him in his last days at Verdun Hospital.

At that time, I was traveling a lot. When I learned of my father's illness—a bad case of pneumonia, contracted at Christmas, coupled with renal problems and the mechanical erosion of his body—I flew back to be by his side. I found him rigged with tubing. This is the common lot of all the patients who wash up on the top floor of Verdun Hospital. At his bedside—it struck me that it was about the height of a child—was the dialysis machine. Its plastic gears seemed to me like the mechanisms of some sinister toy clock, spinning left, spinning right, as if hesitant to follow the hour.

Before the doctors immersed my father in the heavy chemistry of intensive care and plugged him into their survival machines, I told him that I

would bring him his wedding radio. He said not to bother. I argued that it would help him pass the time, soothe his mind.

When I arrived a day later with the radio in hand, he was sleeping. I set it on the windowsill of the window framing the parking lot and the immensity of the St. Lawrence River. The Sun shone steadily over its water. There was something profoundly equanimous about this light. I gently adjusted the volume in order not to wake him or disturb his neighbors. I chose a classical music station, broadcasting from Prague. There, one day in the early evening, I had heard violin music seeping out of open windows. Piano phrases suspended in the air. A melody without an exact form, continuing from every open window, as if the entire city was composing a common score—a song that neither my father, nor me, nor anyone else could have named and that connected all life.

Between this visit and the next, the doctors set his consciousness adrift on the pharmaceutical tides. He went into a suspended animation. He could return to life only if he waded successfully through this secondary cosmos. *Swimmer in the sea of self.* The respiratory therapist, who had taken a shine to my father, explained to me how the alveoli of his smoker's lungs had calcified after forty years of nicotine abuse. His lungs might as well have been two dried-out sea sponges, intent on sinking him back into the depths from which they rose.

As I sat by his side, I remembered the Icelandic story about the seal-man. One evening, a young man of twenty-three, weighing one hundred and twenty-five kilos, goes fishing on a rough sea with four companions. Around ten o'clock, their boat capsizes. The men hang on to the hull. They slip into the frigid waters. In the distance they see the gleam of a lighthouse. They must try anything to survive. They start swimming, in their woolens and jeans, toward the point of light. The young man is the strongest swimmer. When he turns to see how his companions are faring, they have already disappeared into the turbulent night of the waves. He swims for hours through the icy waters until, against all odds, he reaches the stony, splintered shore. He walks hours more, lacerating the soles of his feet on the rugged terrain, until he gets to a village. At the hospital, the doctors are amazed. He shows no signs of hypothermia, only a touch of dehydration. Could he have a glass of water, please? Soon after his recovery, he is flown to London, where specialists declare that he has the constitution of a seal.

Nearing his last breath, my father floated up from the chemical sea, his eyes lost, his wide machinist's hands cradled in those of his wife and two sons. He had these final words for us: "It was beautiful, but all too brief."

Shortly after his death, my mother game me his radio. I set it on a shelf near my bed. In front of it, I placed my stone from Iceland, my tiny meteorite. I told myself that it would improve the reception.

Ever since my father has become a shortwave radio, I go looking for him at the far ends of the spectrum. I am certain that he is haunting his device. That his voice has come unmoored from the waking hours. Some nights, it makes its way back to me, on a lost frequency whose existence is as certain as his love was for us. I listen as it takes up the incomplete refrain, the endless song, of our days and nights.

ËSOD appropriates a coinage by philosopher Thomas Nagel in his book *The View from Nowhere* (Oxford University Press, 1986), while her orbital refrain echoes Laurie Anderson's words in her film *Heart of a Dog* (2015). The title "Report for an Academy" and other minutiae in this story are borrowed from Franz Kafka ("Ein Bericht für eine Akademie," 1917). The "nothing that is" appears in Robert Kaplan's *The Nothing that Is: A Natural History of Zero* (Oxford University Press, 1999). The note on the nameless Angel of Clouds is taken from Eliot Weinberger (*Angels and Saints*, Christine Burgin/New Directions, 2020). He also reported D. H. Lawrence's disappointment with the barrenness of the scientists' Moon (*The Ghosts of Birds*, New Directions, 2016). The recurring formula "not I" harkens back to Samuel Beckett's play of the same name (1972). The Nightsuit is an image sparked by Ottessa Moshfegh (*Death in her Hands*, Penguin Press, 2020). Paolo Zellini paints a picture of our fleeting infinities in *A Brief History of Infinity* (Allen Lane, 2004, translated from Italian by David Marsh). I wish to thank Line Nault for steering me toward the *eisode*. Following our conversations, I read the correspondence between Michael Faraday and William Whewell as cited in S. Ross, "Faraday Consults the Scholars: The Origins of the Terms of Electrochemistry" in *Notes and Records of the Royal Society of London*, Vol. 16, No. 2, November 1961: 187–220. The seal-man of Iceland is alive and well and goes by the name of Guðlaugur Friðþórsson. In the thirty-fourth canto of Ariosto's *Orlando Furioso,* Astolfo weightlessly travels to the Moon in full armor (and on horseback), looking for the graveyard of our lost feelings. "The Constellation of Loss" owes its origins to this journey. I keep my father's shortwave radio and a stone from Iceland, under a bell jar, close to my bed. Luba Markovskaia contributed to my Russian inventions. David Dalgleish provided some much-needed Japanese precisions. Oana Avasilichioaei, who copyedited this text that I adapted from the French original, must be saluted for her poetic acumen. Raphaël Daudelin suggested that I write a "book within a book." Marie Brassard showed me the path to turning the Greater Dark inside out in order to see what glows beneath.

"You can see the air getting thinner and thinner and thinner with altitude because you see it as different gradients of blue. It's all these different colors of blue. And I don't think it's even very well captured in photos or video. With the human eye, you can make that out. It's just fading out the further you go, which I thought was so remarkable. And especially at night, I love looking at the atmosphere when you have that air glow … with the orange color of the air glow. And that wavelength, it looks much thicker than it does during the day. I loved looking at that orange air glow. And sometimes it was a bit green, and then you have the aurora dancing around."

—Jessica Meir

"Living in orbit for a couple of months, I do feel like it has changed me. It is still changing me, mainly in the matter of perspective, a perspective in space. To actually see our planet as one beautiful, fragile spacecraft carrying all humans—that's something we know abstractly. We've all seen these images. But to see it with your own eyes really has a profound effect. Now I know with my guts that our planet is the only place where we can live in the cosmos and that we got to take care of her. That is, it is both strong and fragile at the same time—*strong* because it survived the billions of years in the deathly vacuum of space, keeping billions and billions of species alive."

—David Saint-Jacques

"So, the first look back I had at the Earth was out the cupola window, and it was a sunset. And the thing I remember the most is just the way that the layers of light build up off the horizon on the Earth as the Sun's going down, and the slow change in those colors—just the banding of the light. You can see these sharp transitions from one hue to the next hue. And then, on the ends, it just kind of fades into nothing. And so, as the Sun is drawing down over the horizon, the point of light just continues to fade and fade and fade. And so, these really sharp, distinct colors of red and blue slowly converge on this one dot. And then that one speck just disappears—and before your eyes can adjust to the lack of light, and open up and see what's down below us, it's just completely dark. It's almost like everything that you know just disappeared in that speck of light, and you're all alone up here."

—Nick Hague

"As we're flying, I remember something catching my eye just to my right side, and it was like a glint of light or something. And I looked out real quick and I couldn't even figure out what it was at first. … Because it was blue, and I'd seen the sparks coming off of our thrusters before this. But this was … this was *blue*, and it was a thin line, and it almost looked like a line of flame. And I thought, it's kind of a weird signature for an engine. Then it hit me that that wasn't coming from our spaceship—that was coming from the Sun rising across the Earth. I look out and I see this thin blue line, and it's just—you can just tell that it's curved. And I realized I was seeing my first sunrise from space. It was the first time I was looking back and instead of seeing ground, I was seeing a planet."

—Anne McClain

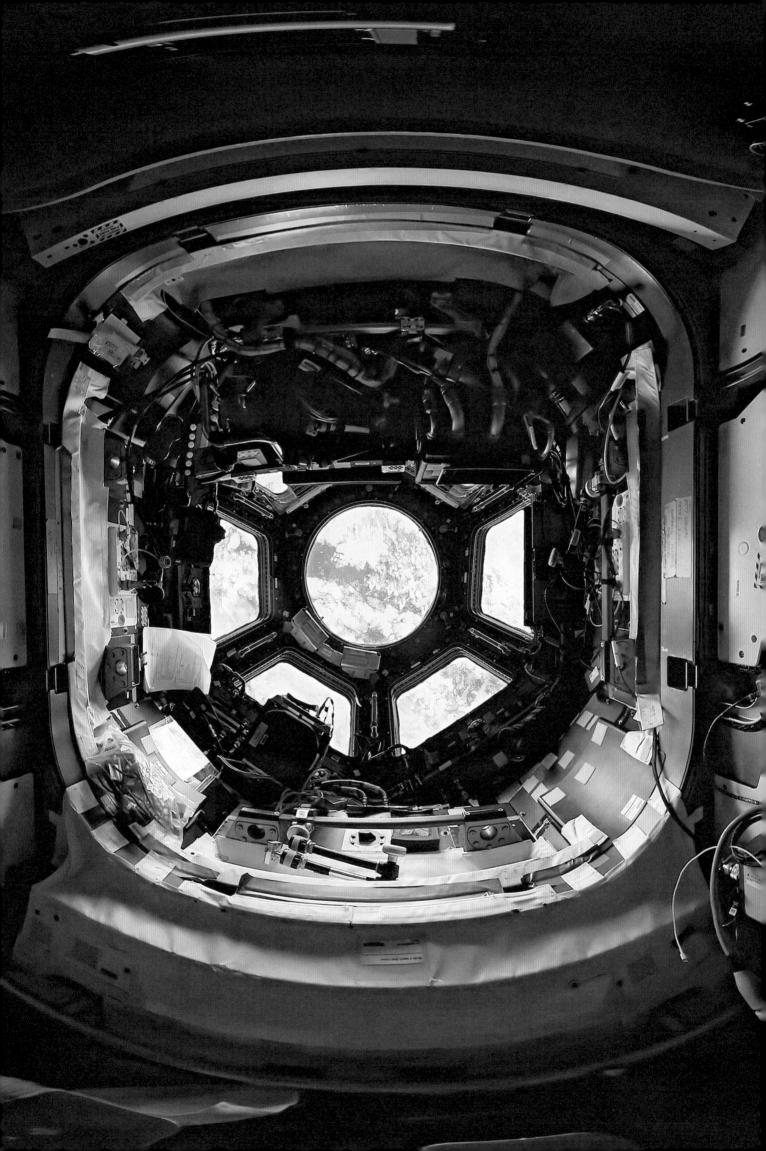

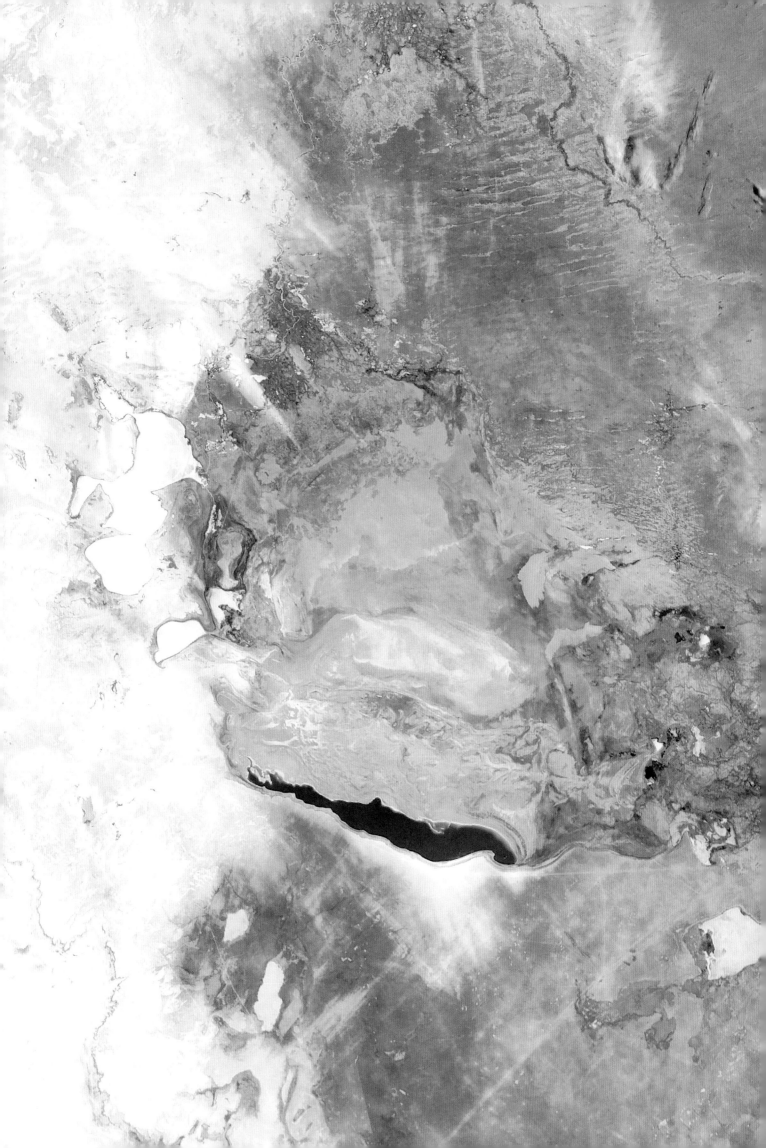

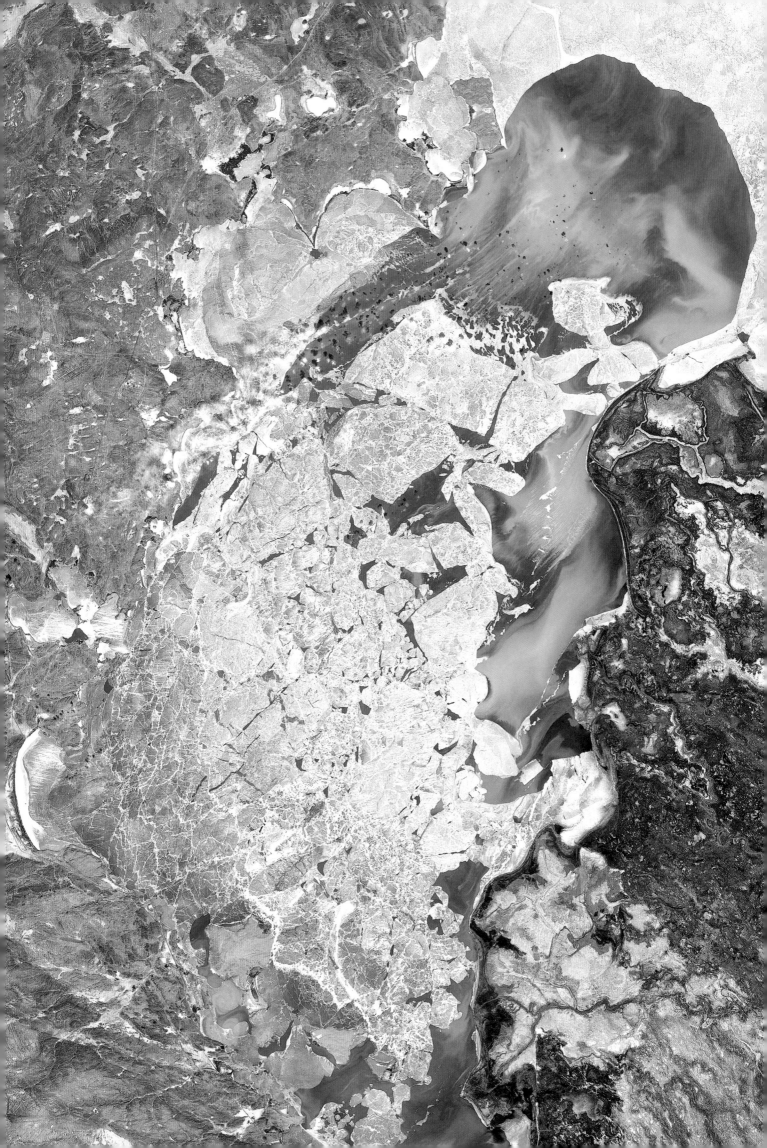

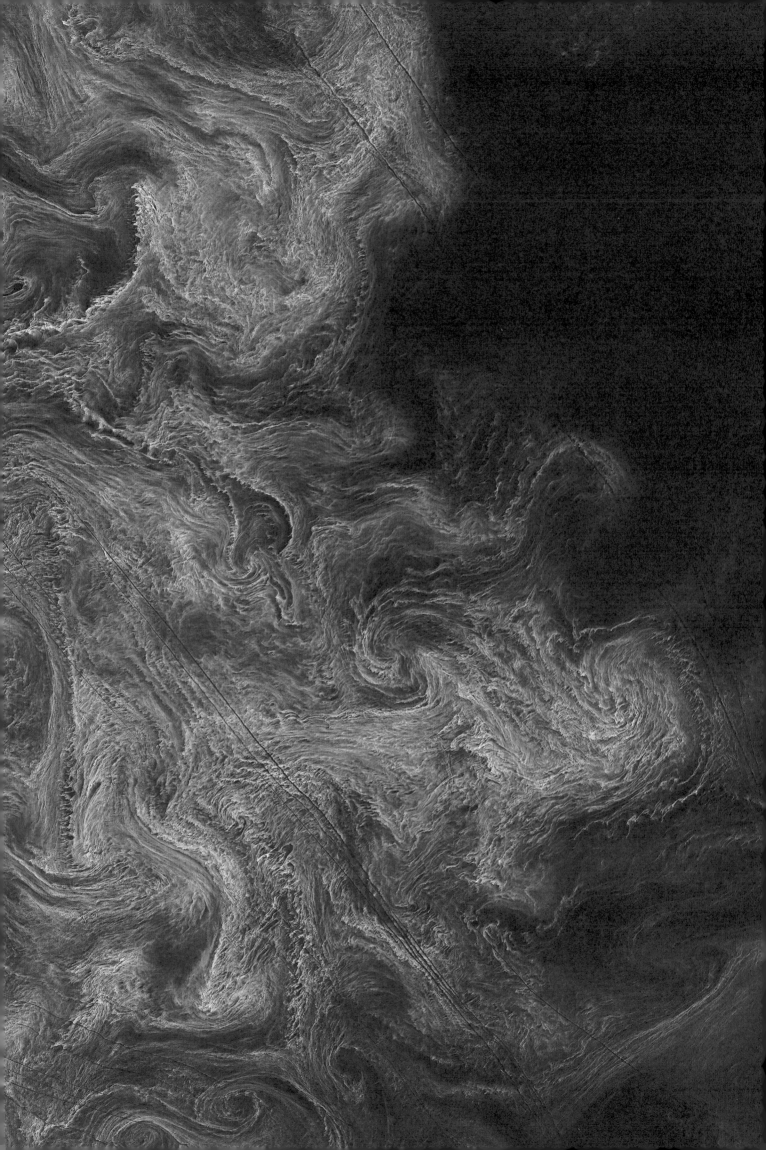

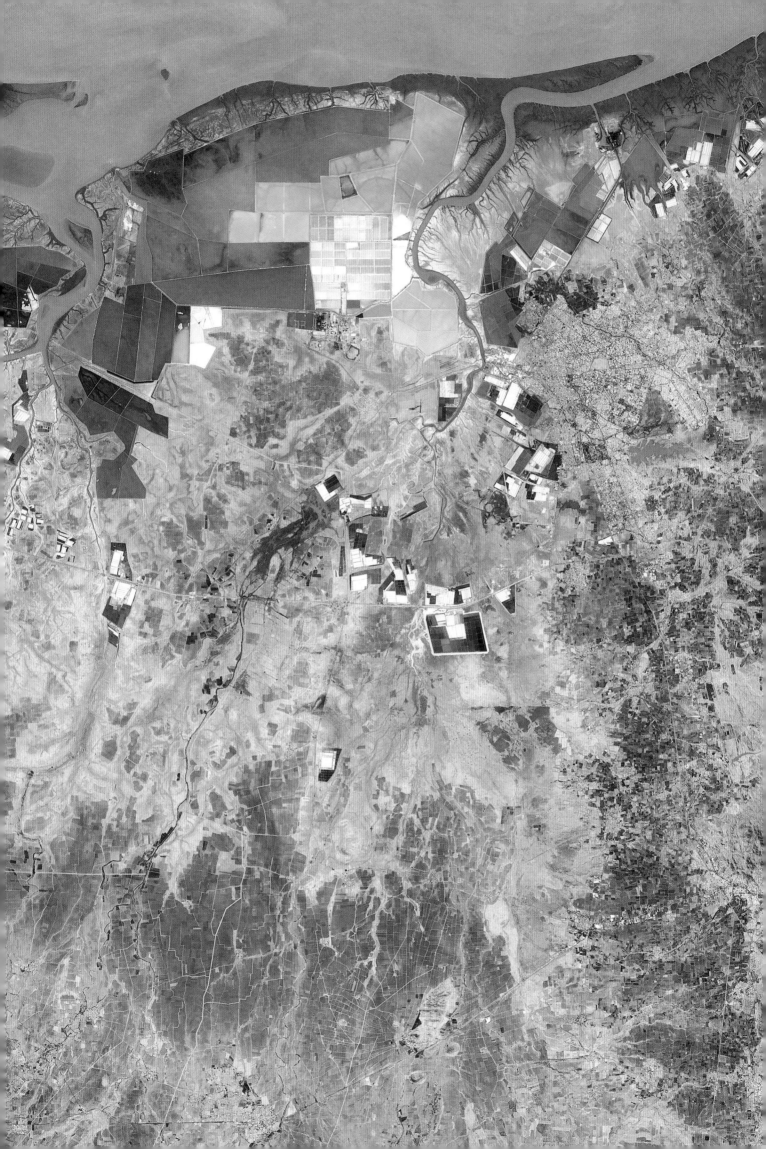

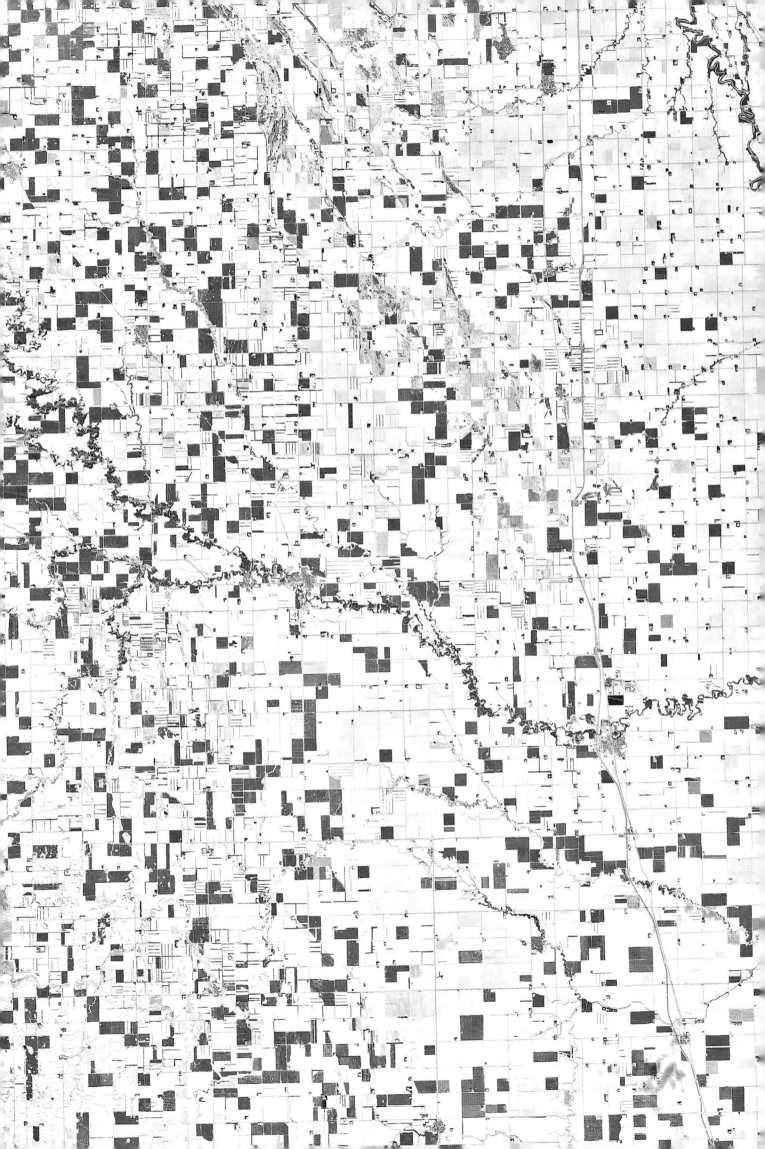

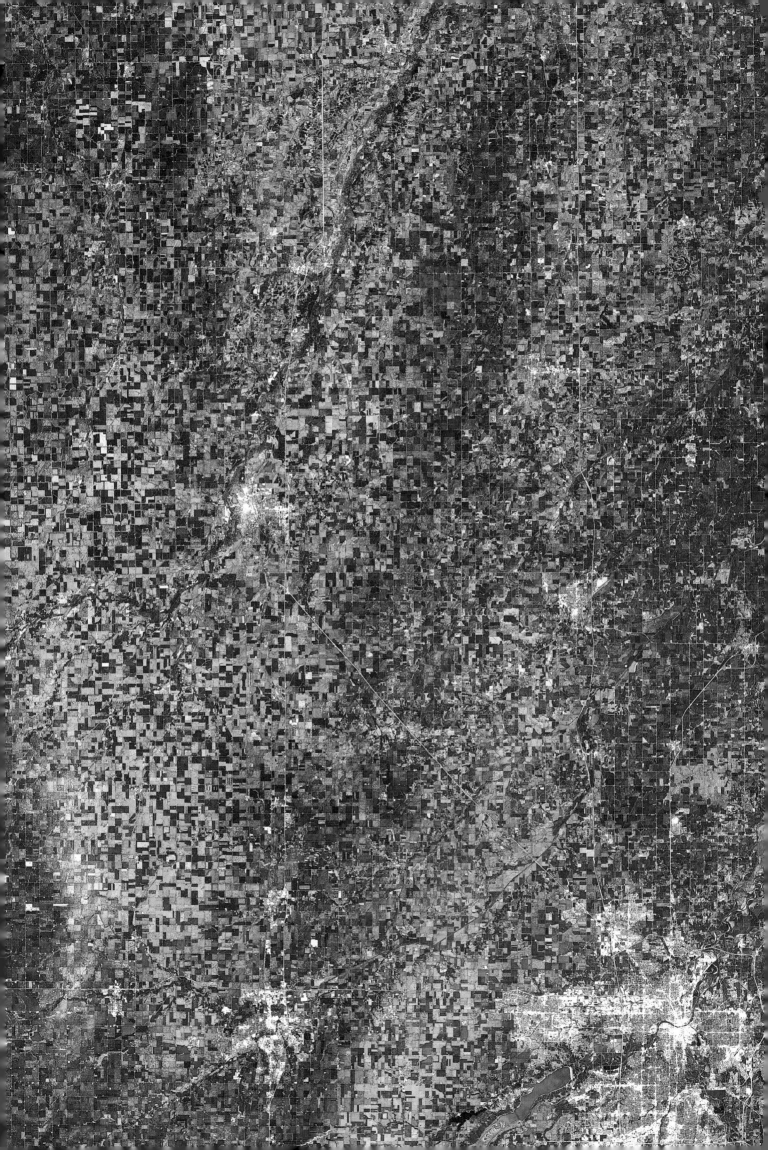

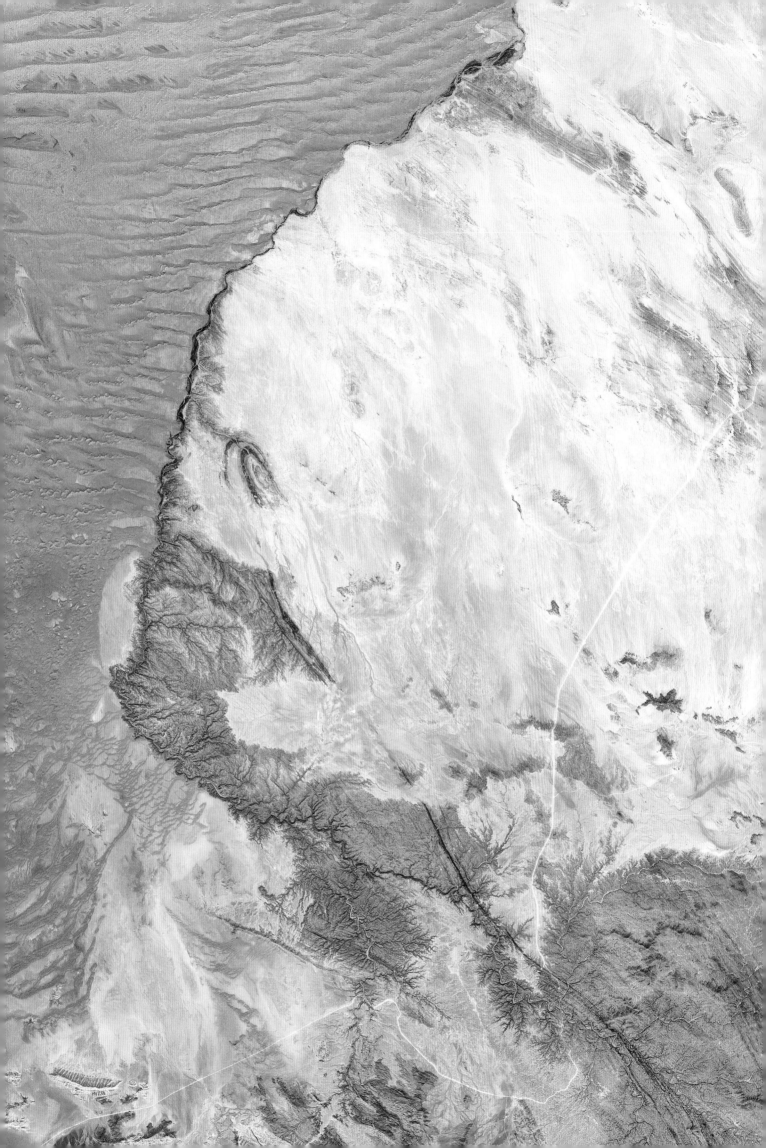

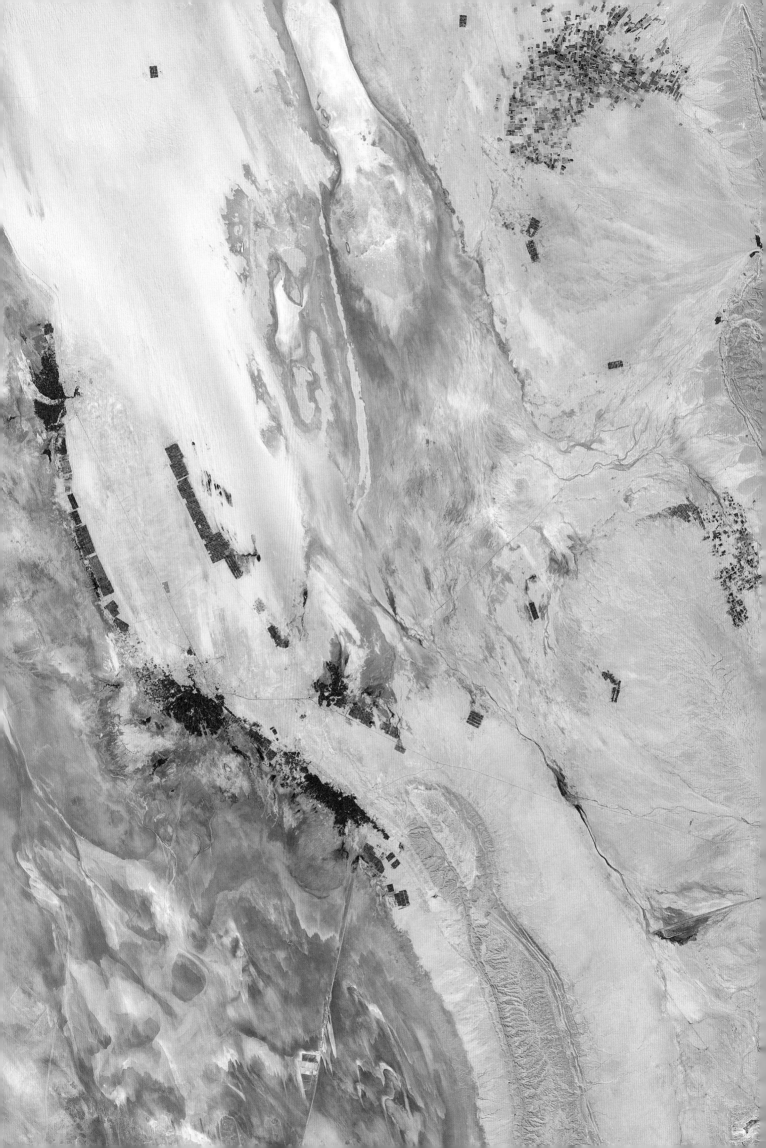

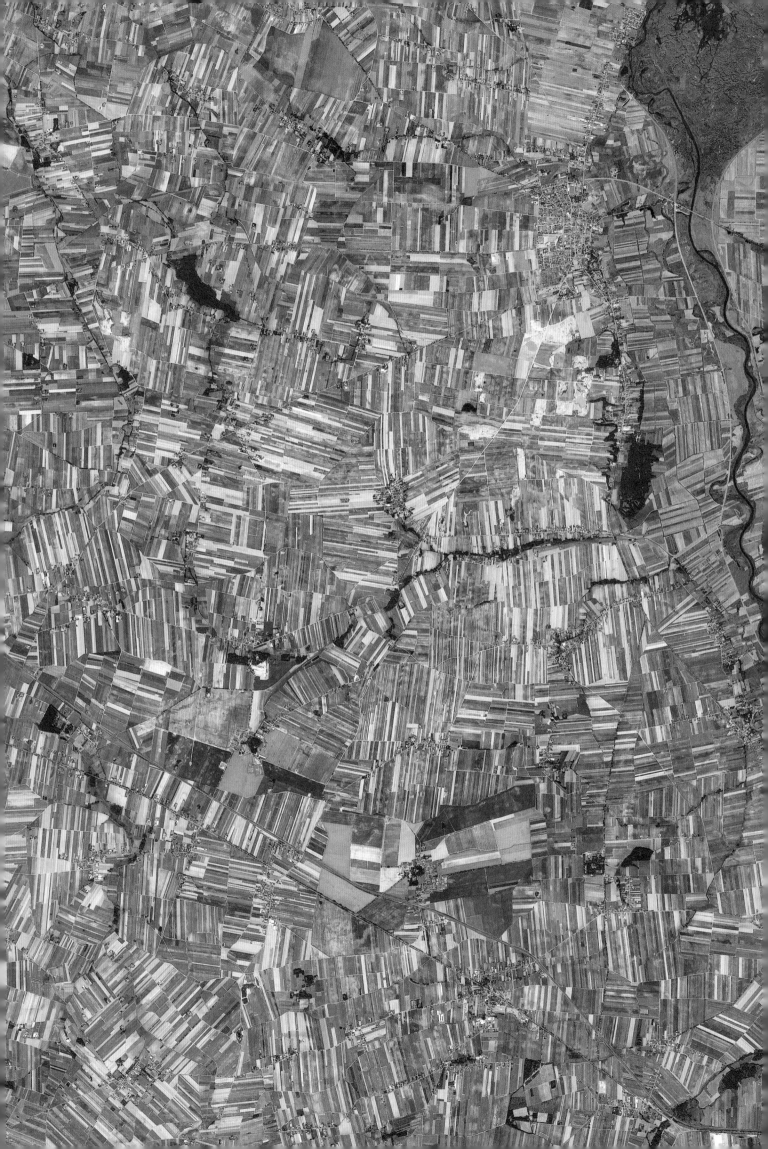

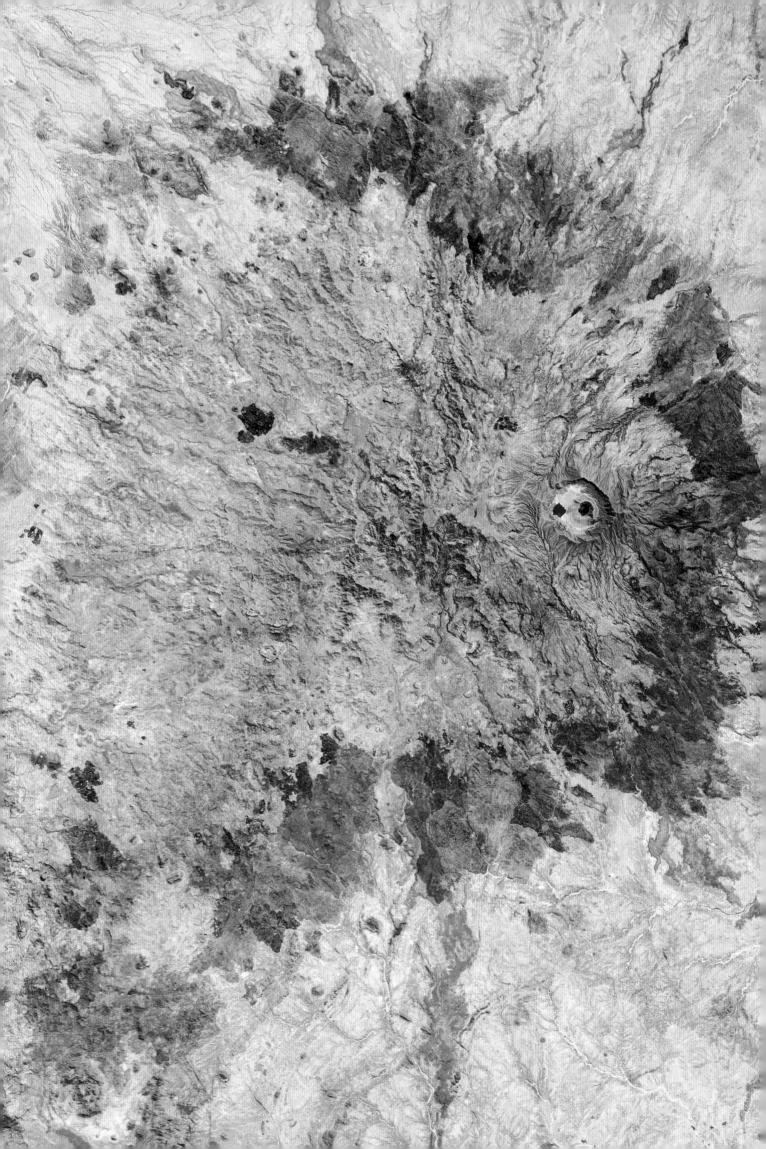

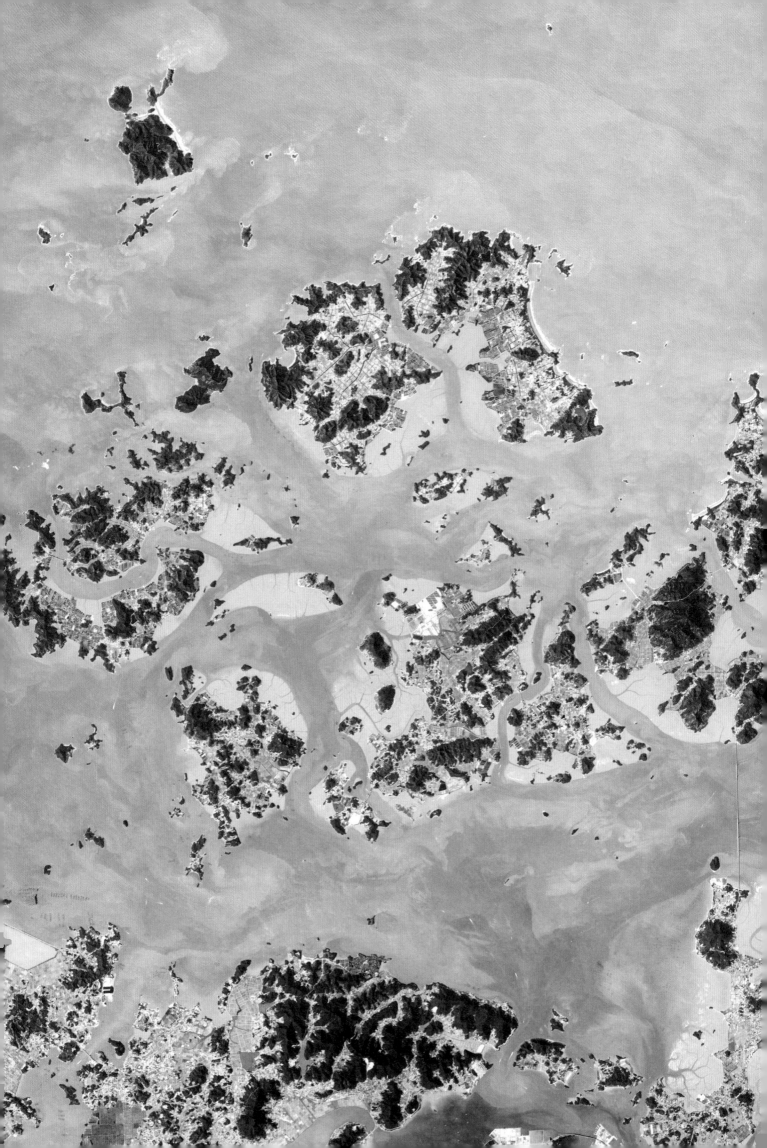

Gold mining in Russia's Central Aldan ore district

In places where concentrations of the precious metal have been discovered, mining operations are large enough to be seen from space. The open-pit mine shown in this image is located some fifteen miles northwest of the gold-mining town of Aldan and about 280 miles southwest of Yakutsk, the regional capital.

— NASA Earth Observatory image by Joshua Stevens, using Landsat data from the US Geological Survey.

Aral Sea in winter

Cold temperatures through December sustain areas of snow and ice across Central Asia's inland lake.

— NASA Earth Observatory image by Lauren Dauphin, using Moderate Resolution Imaging Spectroradiometer (MODIS) data from NASA's EOSDIS/LANCE and GIBS/Worldview programs.

A delta oasis in southeastern Kazakhstan

The Ili River delta's rich mosaic of reeds, ponds, and meadows—still dark brown in this image thanks to Central Asia's harsh winters—provides a year-round habitat for hundreds of species. The Ili supplies Lake Balkhash from the southeast.

— NASA Earth Observatory image by Joshua Stevens, using Landsat data from the US Geological Survey.

Beguiling bloom in the Baltic Sea

Part of a phytoplankton bloom between the islands of Öland and Gotland, off Sweden's southeast coast. Nearly every summer, phytoplankton trace the Baltic's currents, eddies, and flows.

— NASA Earth Observatory image by Joshua Stevens, using Landsat data from the US Geological Survey.

India's largest salt producer

The west-central state of Gujarat accounts for nearly three-quarters of India's annual salt production. This image shows the city of Bhavnagar, located in one of the state's main salt-producing districts.

— NASA Earth Observatory image by Lauren Dauphin, using Landsat data from the US Geological Survey.

Cornfield patchwork in the snow

In the wake of a potent late-November snowstorm across the US Midwest, a network of brown squares of cornfield contrasts starkly with eastern North Dakota's otherwise snow-white landscape.

— NASA Earth Observatory image by Joshua Stevens, using Landsat data from the US Geological Survey.

Derecho flattens Iowa corn

An unusually strong and long-lasting series of thunderstorms with hurricane-force winds—known as a derecho—caused widespread damage to crops across Iowa and the US Midwest. Wind-damaged crops appear light green, while darker areas may indicate tree breaks or fields where crops took less damage.

— NASA Earth Observatory image by Joshua Stevens, using Landsat data from the US Geological Survey.

Where the dunes end

Mountains of sand, some as tall as a thousand feet, reach from the floor of Africa's Namib Desert toward the sky. This image shows the northern boundary of the Namib Sand Sea as it traces the path of the Kuiseb River. Beyond the river is solid, rocky land. The dunes span some ten thousand square miles within the Namib-Naukluft Park, a UNESCO World Heritage Site.

— NASA Earth Observatory image by Joshua Stevens, using Landsat data from the US Geological Survey.

In a desert not so far away

Many memorable *Star Wars* scenes were filmed in the deserts of Tunisia. Here, the vast salt pan and ephemeral lake of Chott el Djerid—site of the domed farmhouse where Luke Skywalker was raised—makes a stark contrast with southwestern Tunisia's sandy terrain.

— NASA Earth Observatory image by Joshua Stevens, using Landsat data from the US Geological Survey.

Drift ice in the Sea of Okhotsk

This image shows thin sea ice in the Sea of Okhotsk, just off the southeastern coast of Sakhalin, Russia's largest island. Carried by cold westerly winds and currents, sea ice can reach the coast of Hokkaido, Japan.

— NASA Earth Observatory image by Lauren Dauphin, using Moderate Resolution Imaging Spectroradiometer (MODIS) data from NASA's EOSDIS/LANCE and GIBS/Worldview programs.

Agriculture fields in central Poland

Narrow, rectangular farm sections with historic roots spread across the landscape near Warta. These very narrow, rectangular plots caught the eye of an astronaut as the International Space Station passed over west-central Poland.

— This image was acquired by a member of the Expedition 48 crew using a Nikon D4 digital camera with an 800-millimeter lens, and is provided by the ISS Crew Earth Observations Facility and the Earth Science and Remote Sensing Unit, Johnson Space Center. The International Space Station Program supports the laboratory as part of the ISS National Lab to help astronauts take pictures of Earth that will be of the greatest value to scientists and the public, and to make those images freely available on the Internet.

Jebel Marra, Sudan

Located in Sudan's Darfur region in the eastern Sahara Desert, this almost circular massif is a large cluster of volcanoes and lava flows, with few traces of human activity. The smaller circular form at right is the Deriba Caldera, a collapsed volcano and the highest point in Sudan.

— This image was acquired by a member of the Expedition 61 crew using a Nikon D5 digital camera with a 140-millimeter lens, and is provided by the ISS Crew Earth Observations Facility and the Earth Science and Remote Sensing Unit, Johnson Space Center.

A thousand islands in South Korea

Sinan County, or Shinan-gun, includes more than a thousand islands, about a quarter of all the islands in South Korea. The majority are surrounded by shallow tidal flats, alternately covered or exposed by the rise and fall of tides, which host unique marine life as well a thriving salt production industry.

— NASA Earth Observatory image by Lauren Dauphin, using Landsat data from the US Geological Survey.

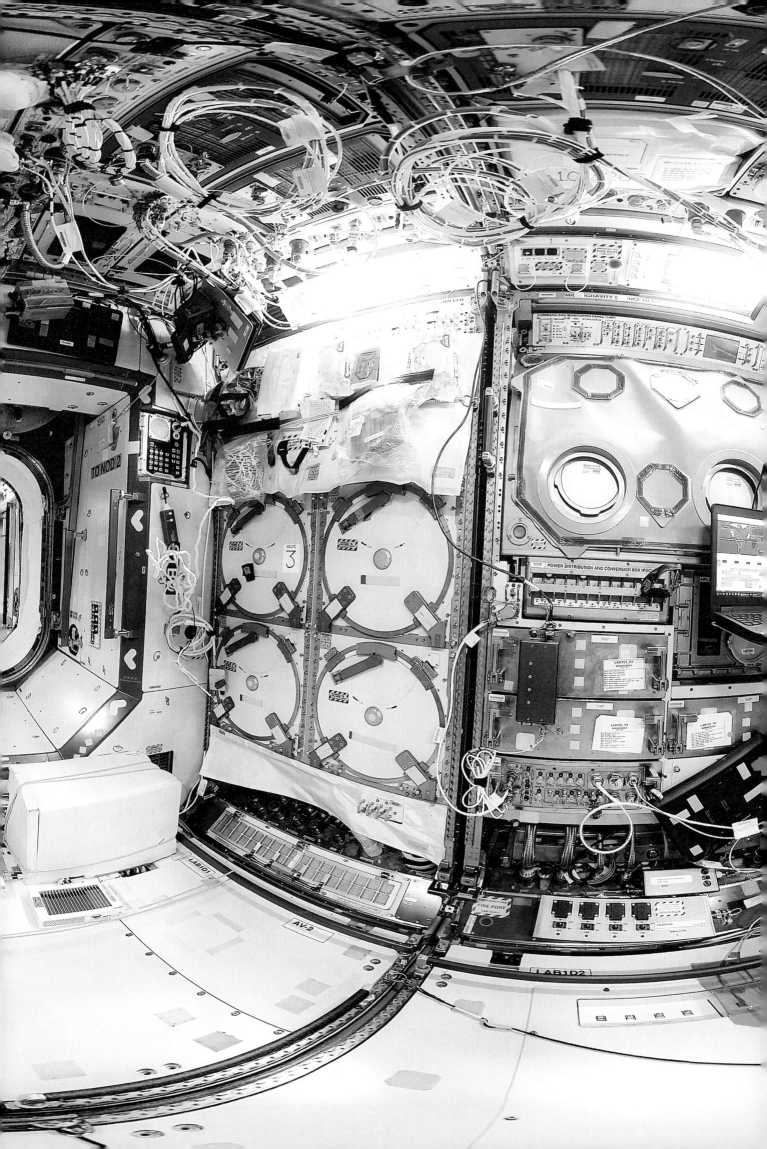

"And then the sunrise started coming up on the other side. All of a sudden you see this burst of light, and then the horizon starts to build around that. And in those warm colors of yellow and red and blue, all of a sudden, the Sun's blinding heat. As the sunshine comes up, you can feel the heat on your face and you're blinded by the light. And after my eyes adjusted, I saw that the Moon had risen just before the Sun. It was this pristine crescent Moon that was just the brightest, shiniest color of silver that the Sun was illuminating. And in that moment, you can't help but think about just the ... the *size* of everything and how it all relates to each other."

—Nick Hague

"When I stared out the cupola window, I was looking down and the ground was moving by so quickly that it almost seemed for a moment like the Space Station was tumbling. And I was just amazed. I just stared out that window, looking at the view and seeing how fast the ground was going by. And I knew that we circled the globe once every ninety minutes, but to see it with my own eyes just didn't match my expectation. It was way better. And so, I just sat there in amazement with my mouth hanging open in awe. It took my breath away. I didn't know how to describe it. And so, I just took a video so that I at least could capture that moment, because I knew at some point I would want to go back and try to describe it, because it was such a powerful moment for me."

—Victor Glover

"Everything, every place you've ever been and every human you've ever known, you can see with one view, one glimpse. It's like *one scene*. What sticks out to me is the interconnectedness. And the dependence that we all have on each other. Our atmosphere is so thin; our world is from here. It seems so small. And sometimes when you're on the Earth and looking out, everything seems so large. You hear about a hurricane or a flood, and you think it's somewhere else. But when you see flooding or you see a hurricane from the Space Station, and you look down and you realize there are no borders, you get this profound sense that the world is small. We are all reliant on one another. We really all need to challenge ourselves to get outside, spend time with people that you haven't before. Travel to somewhere, and look back on where you came from, and just think and reflect on where we are and what we're doing."

—Anne McClain

"Things have a life of their own without gravity holding things in place. I think that my perspective on my ability to control the world around me has changed. I feel like I'm more connected to the universe around me because I float. I don't have control over this. I'm just part of the universe around me and I feel connected—and, at the same time, a little bit smaller. My ability to influence everything around me is limited and I see those limitations up here. Life in microgravity has made me feel more connected and at the same time realizing that everything around me is so much bigger than I am, and I'm just one little piece of that."

—Nick Hague

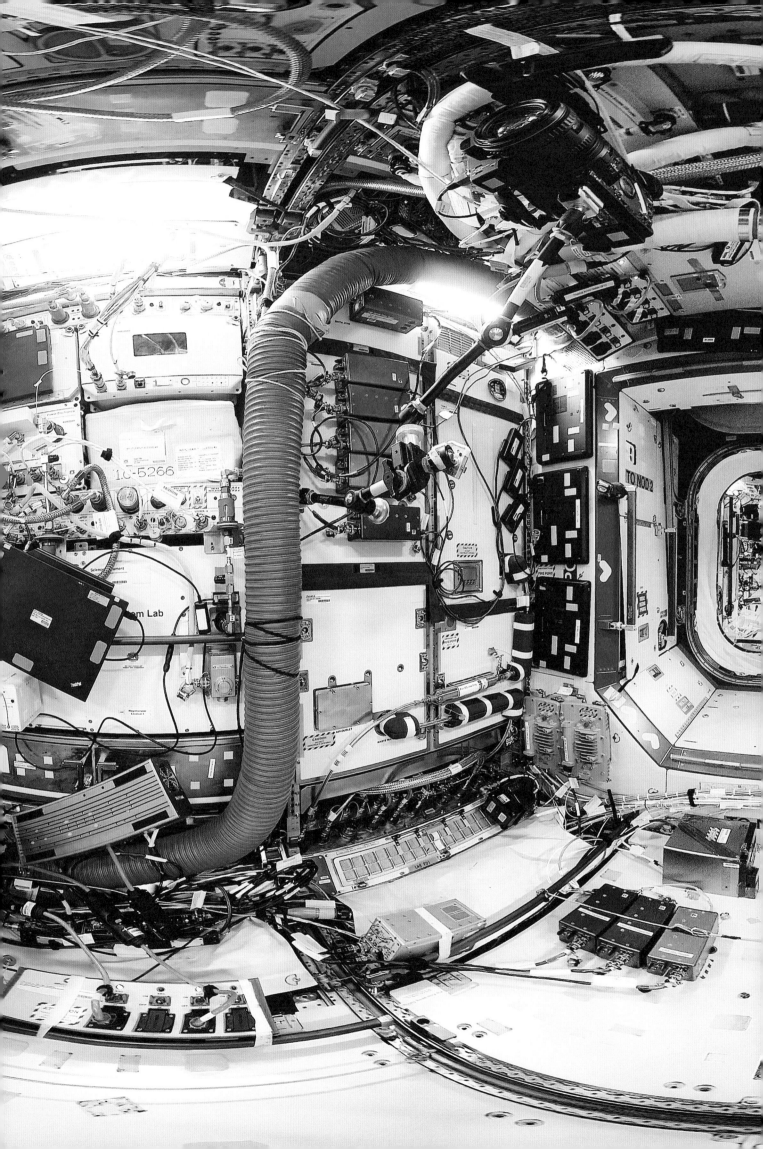

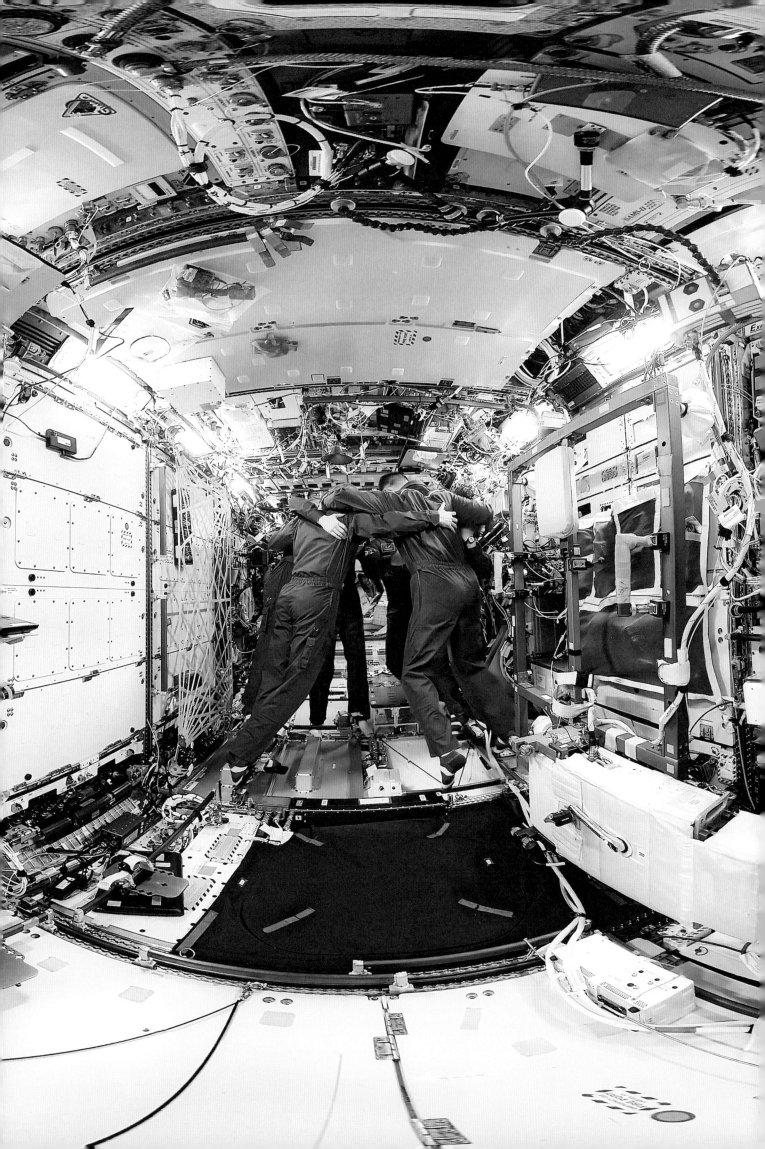

Ryoji Ikeda is one of the leading electronic composers and visual artists of his generation. Born in 1966 in Gifu, Japan, he began his career with the Kyoto artists' collective Dumb Type, where initially he was a producer and engineer, and where he made *1000 Fragments*, his first major solo sound piece with computers in 1995. Ikeda now lives in Paris and Japan. For the past twenty years his visual installations in particular have been consistently challenging the boundaries between data, technology, and the human experience. They use pixels, sine waves, glitches, and light as materials to be manipulated and explored in different dimensions. His first series of visual works, beginning in 2000, were digital videos which he used in concerts and for his immersive installations, and which problematized the transformation of the world into data. Works such as *formula* (2000) and the *datamatics* series (2006) explored this territory by taking a collage approach to visual representations of data, mathematical signs, and images that seem to scroll by endlessly along suspended abstract grids. In 2014, Ikeda was awarded the Prix Ars Electronica Collide@CERN residency, and it was then that he and I (as the founding director of the Arts at CERN program) first met.[1] From his experience during this residency, he created the monumental work *micro|macro the planck universe*, which opened at the ZKM in Karlsruhe together with its companion piece, *supersymmetry*, which Ikeda created shortly before he took up the residency.

[1] CERN: the European Organization for Nuclear Research.

Since then, Ikeda has continued to push his practice in new directions. This has involved an increasing return to working as a composer with sound, not only with computers but actual instruments and the human body in works such as *Body Music [for duo] op. 4*, performed at La Bâtie-Festival de Genève in 2016, and *100 cymbals*, commissioned by the Los Angeles Philharmonic in 2019. Today, Ikeda's reputation as a visual artist has never been greater, with solo shows of his immersive installations in Paris, London, Taiwan, Germany, and Japan, as well as in large-scale group exhibitions such as at the 58th Venice Biennale. In 2020, Phi Centre founder and director Phoebe Greenberg asked Ikeda to make a piece for the exhibition *The Infinite: Living Among the Stars*. I spoke to the artist four months before the Montreal opening, as work on his contribution neared completion. I began by asking how he would approach this latest commission, engaging with the most impossible scale imaginable to the human mind: infinity.

R. Ikeda

I decided to have a very particular setup. A large ceiling is covered by LED screens. It's very heavy and the first time I will have done this. Technically, it's really hard, as it's seven by seven meters square, which is quite big. I am used to making large-scale installations for floor and wall projections, and sometimes they are really, really big. The biggest one is a half kilometer [laughs] and this was shown in Germany—but that's a wall projection. I sometimes use the mezzanine to look down on an immersive floor installation. That's kind of interesting, too—you can dive into the visual image—but I've done it so many times. On the ceiling, a projection is really, really overwhelming. You cannot adjust the distance in order to see the piece. You can only adjust your height: you're standing or you're sitting or you're lying down. There's no sweet spot—only the center. Your experience is just to see the piece only at angles. Never head-on, as with a computer screen.

A. Koek

So in your installation the viewer is looking up, just as the International Space Station (ISS) is looking down upon the earth. It's fascinating that we are submerged in data about the different scales, and fractions of scales, of the universe—just above our heads and almost out of reach.

R. Ikeda

In the other part of the exhibition, you are in space or you are aboard the ISS. My piece is nothing like this. It's just computer graphics and is a bit similar to what I showed at the Venice Biennale two years ago, which was already a kind of summary of my data-driven pieces throughout my career. This piece for *The Infinite* looks very different, however. I completely changed the design. This piece is much more dense, compressing in ten minutes from the subatomic scale to the observable universe—the journey from the really microscopic scale to the largest scale. This piece also includes data from the ISS. I'm also going to put a mirror on the floor, but not entirely covering it. It's quite big and round—a simple little analogy to the circular window in the ISS through which the astronauts are watching the Earth. The effect of the mirrored images will be quite magical. I want people feeling as if they are floating in space.

A. Koek

People look upward when they're thinking beyond where they are, so actually *forcing* people to look up, beyond where they are, is a physiological gesture toward infinity.

R. Ikeda

Yes. But in my installation, they not only look up but also look down, at the images in the mirror. Visitors will feel that they are in the middle, between two symmetrical images that will also suggest to them the infinite. Personally, as a visitor, I like the state when I'm watching something—"Wow!"—but I can't rationalize what's happening. My rational system, like a structure of thinking, has completely crashed. This is great art for me. It's not only surprising and shocking; it's often counterintuitive or even funny. No other human activity can aim to trigger this kind of feeling, because the rest is rational in our society. Even eating in a restaurant.

109

A. Koek

Exactly. Art works through the senses and suspends the rational. You're bombarding our sight and our hearing, so that when we're immersed in your world, we cannot rationalize. Instead, we have to learn and be trained to exist in it with you.

R. Ikeda

Sometimes it's unnecessarily fast, too fast to read all the text. [laughs] For me, even all these big images—like a stream of data or geometric forms, or data visualization—are really like music. At first, I prepare very carefully all the data or materials. Then, at the end, it's like brushwork: I just destroy, and sometimes the opposite. I really enjoy this kind of composition or decomposition process. Music is very much like this. Data, also: you can't touch it. It's just lots of data you see on the computer. I just bring it to life to make it dance. The grammar is science.

A. Koek

You are taking people to the edge of their perception, but also taking yourself to the edge of technology, by doing this.

R. Ikeda

I don't know how I can make it any stronger. [laughs] I can't make it too intense or too loud. The brightness of the flashing image I always use can be really brutal, but let's see. I keep my space as a pure art experience. Other rooms in the exhibition are about the ISS and NASA—the depth of the science. The ISS is a great achievement of human beings. My installation is of a very different kind. [chuckles] It offers another point of view. My room is mysterious.

A. Koek

Do you think the mysterious is what art brings to science and technology, and sets it apart?

R. Ikeda

We can explain science. We cannot explain what music is or what art is. For me, it's very interesting to make something we cannot explain. I'm not escaping, but for example: when you listen to the music of Mozart, how you can explain it? It's like a taste. You know the name of a tomato—but if you *don't know* the name of a tomato, how do you explain it? It's a bit acidic and a little bit of…. [laughs] It's hard!

We are working in that territory, and the scientist in the complete opposite. They have to explain their mission and they love to do that. And we *don't* like to do that. [chuckles] We do have a lot in common, though—like creativity—and there is a lot in both, but our output and attitudes are different.

In my work, I am trying to describe how I feel about nature because I always feel nature is very beautiful and very scary at the same time. That's how I feel when I go to the mountains and camp out alone. Nature is so big and so small at the same time, though humans are part of it.

A. Koek

Yes. That's the romantic notion of the sublime—the edge of terror which meets beauty, which Kant talked about. Your friend, the philosopher Akira Asada, said of your work that it expresses a "techno sublime."

R. Ikeda

I don't know. [chuckles] Maybe, yes. When I was child, I was so into attending rock concerts like AC/DC and Kiss. It was crazy. It was too loud. I was just beyond excitement—like open-mouthed. Even techno and dance music in big clubs are like sonic weapons. It's almost like torture, in a way. If you cross the threshold, you just can't hear anything. If it's too bright, it just makes you blind. I'm playing with all these thresholds. That is really physics—a physical experience. Computer programming is a very mathematical operation and manipulation. I'm playing with both—as well as the conceptual and the poetic.

When I was young, I didn't care. But now that I'm more mature, it's always about making a balance between that kind of extreme way—the punk attitude and [the] destroyer—and also something more elegant. I'm really a musician, I feel, because I'm playing with combinations. I take this, that, this. I'm like a child. If it sounds cool, I just take it and I just develop it.

111

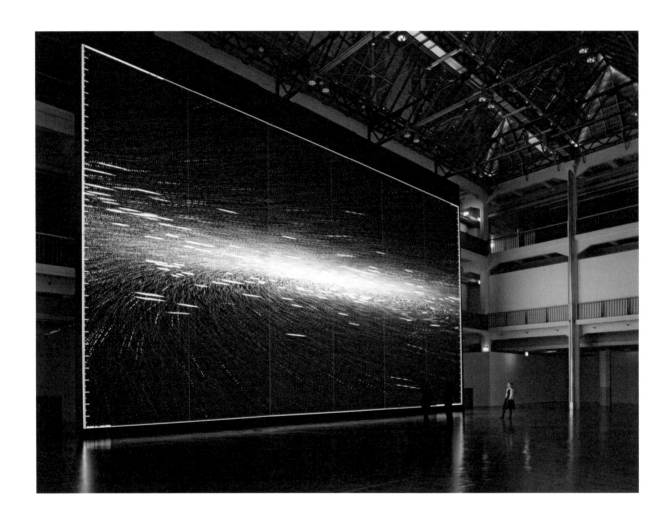

Ryoji Ikeda
the planck universe [macro], 2015
photo: Martin Wagenhan
© Ryoji Ikeda,
Courtesy of ZKM | Karlsruhe

materials: 3 DLP video projectors,
computers, speakers
date / place: JUN 21 – AUG 09, 2015 /
ZKM | Karlsruhe, Germany

concept, composition: Ryoji Ikeda
programming, computer graphics:
Norimichi Hirakawa, Tomonaga
Tokuyama, Yoshito Onishi,
Satoshi Hama

commissioned by and produced in
cooperation with ZKM I Center for Art
and Media Karlsruhe

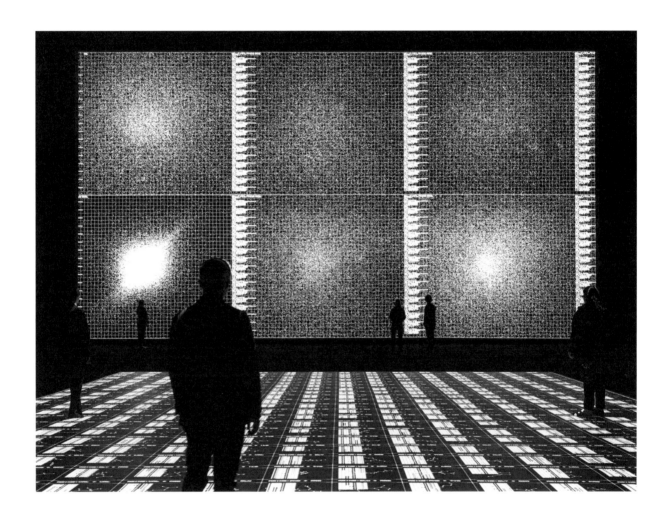

Ryoji Ikeda
the planck universe [macro], 2015
the planck universe [micro], 2015
©Ryoji Ikeda
Image courtesy of Zan Wimberley
and Carriageworks, 2018

the planck universe [macro], 2015
materials: 3 DLP video projectors,
computers, speakers
the planck universe [micro], 2015
materials: 3 DLP video projectors,
computers, speakers
date / place: JUL 4 – 29, 2018 /
Carriageworks, Sydney, AU

concept, composition: Ryoji Ikeda
programming, computer graphics:
Norimichi Hirakawa, Tomonaga
Tokuyama, Yoshito Onishi,
Satoshi Hama

commissioned by and produced in
cooperation with ZKM I Center for Art
and Media Karlsruhe

A. Koek	Would you prefer to call yourself a composer rather than an artist, then?
R. Ikeda	I'm still wondering if I am actually an artist. An artist, to me, is really [chuckles] like a painter and a visual artist. I make a lot of visual works, but I don't feel I'm really a visual artist. [To say] "musician" is also bit strange, because I cannot play any instruments. I can't even sing. "Composer" is probably the right word. I compose sounds into music, and I compose lights and pixels into video. I just like to compose, to arrange, to combine, to mix, to shuffle, and to give a life to the pixels and data. It's composition.
A. Koek	Phoebe Greenberg said that she had commissioned you for *The Infinite* partly because you have such a strong aesthetic and poetic sensibility in working with data. I wondered if you could talk a little about the role of the aesthetic in your work. What makes it so recognizably a Ryoji Ikeda?
R. Ikeda	[laughing] I don't know.
A. Koek	You don't know?
R. Ikeda	I think this question has to be addressed to the critics. [laughs] I cannot analyze myself, because I'm just doing what I want and it's really difficult to explain the reason. For example, I like sushi, but why do I like a particular fish? I don't know! [laughs] … Of course, the aesthetic point is very important. I don't use that much color— but black and white are also colors. Recently, I used some colors but it's just a ploy. I don't know why. Also, I completely try to make my music clean. Harmony is really noise and color to me. It will try to touch or try to control your emotions; I don't like that. I only use the sine wave—white noise. I just eliminate all of these important parameters, of music and of image, so there is no color and no curved lines. Black and white, and the point of line, a straight line— that's it. If you restrict yourself, you can be free within that setup. I prefer to make something very spot-on and essential. No other meat—only the bones and the structure. As a visual piece, my piece

is so poor, but if I take every single pixel and give it very precise movement with sound—in combining both elements, it gives a really certain life. This is really composition.

A. Koek Where do you think this love of mixing, shaping, learning, for pushing to the edge, came from? Your early career was obviously with Dumb Type, in Kyoto. You started out with them as an engineer and producer, and then moved into electronic music. Did it begin there, or long before that, when you were a kid?

R. Ikeda Yes, before. I do this because I didn't learn anything. I dropped out of school, and so I'm completely free. That's why I didn't know anything. I still don't know anything. If you attended university and studied science or biology, or went to art college, or became a doctor, you're fixed. [chuckles] I'm not. If I try to make an action, I have to learn everything first. I'm a complete amateur. That's why I have enormous respect for professionals. I just know my way, but as a professional I'm so useless. I know only particular points in physics or mathematics, but I cannot ever be a mathematician. In fact, if I am told by the teacher, "You have to learn this, this, and this," I never do it. [laughs]

A. Koek [laughs] So you're naturally rebellious?

R. Ikeda Yes. Even in a fantastic institution—like at CERN—I was kind of uncomfortable. The institutional environment is very, very difficult for me. I never fit in. Many artists and musicians are like this, and I'm just being honest. That's why I have a bit of a complex about academia. I like many subjects, but I don't want to be involved in the big system. I am self-taught; I learn everything through the Internet and by reading books. I love scientists, but I prefer to take them out of the institution and have a talk with them in a café and be human-to-human, which is very real. My knowledge before I arrived at CERN was totally patchwork—quantum mechanics and Einstein's relativity theory and cosmology—but through this experience at CERN, I had to fill in the gaps because what the scientists are doing covers everything. CERN, compared to pure mathematics,

is all about scale. If the electron is the size of a ping-pong ball, and the nucleus is like the size of the Earth [chuckles], then the atom is almost empty. Good scientists at CERN explained it in this way to me, and I was like, "Wow!" It's because no one can see the quarks, of course; it is impossible—there's only indirect evidence. Everything below and beyond the human scale is invisible. We look through the machines, but we can't perceive, with our own eyes, the micro-macro world.

It took a certain time, really, to understand what they're doing. I still don't really understand it fully, of course. I was more into mathematics before and, actually, mathematics doesn't care about nature. [laughs] It's really just numbers and values and relationships and geometry. It's completely different. Mathematics is like music to me. But physics is about scale—whatever is big and small, whether it is CERN or NASA—and it's about nature. It's very, very different, and it was a good experience to dive into contemplating nature. I was not really keen to study more about physics, but it was a great chance to restudy.

A. Koek

What comes through our discussion is a genuine love of mathematics. What is it about mathematics that you love? Do you think mathematics is the only place the human being can really get a sense of infinity?

R. Ikeda

Yes. In the classical sense, art is for beauty and mathematics for truth: $1 + 1 = 2$. When you encounter other civilizations, like aliens, they must have the same mathematics. Science is different, because their chemistry or biology or physical constants might be different from ours. And mathematics is the language of science. Mathematics has a very strange position because it's very difficult for people to understand. I began being really interested in the foundation of mathematics, especially metamathematics. Metamathematics started from set theory. Set theory is all about infinity. The infinity of natural numbers and the infinity of real numbers are different, and this was proved a hundred years ago. I got used to seeing very big and very small numbers. It's very abstract. The research at CERN, of course, is very difficult, but we

can explain it. They try to complete a recipe of "matter" (which is energy) with all the characteristics of the atom and the subatomic scale. It's all about nature. But sometimes there's no way to explain mathematics. There are maybe only ten people in the world who can understand what someone's doing, but a hundred years later, it's spotlighted, and they do. It's a crazy area.

A. Koek And what about your love of data?

R. Ikeda CERN data is not natural life. It is artificial. It is humanly designed. It's based on experiments. That kind of data I am not interested in because they target what they want. There are two different kinds of data: dynamical data, like the stock exchange, and CERN, which is artificial. There is static data, like the structure of a protein, a cell, organisms, biology in general, geology, and the planets. There is a massive amount of this data, which is based on fact that was observed in nature, and so it is not artificial: it is the data of what exists. I mostly use this kind of static data, based on fact—for example, in my *data-verse* series—although I do use dynamic data like CERN and climate data. Just not as much. Of course, the data from the LHC[2] is amazing. But I, myself, can't use it. CERN's data is too much. I can't handle it, in fact. It's like spaghetti. Most of the data is just noise. It is huge. And that's even after the data has been completely filtered by the triggers.[3]

A. Koek Are you at the end of your journey working with data?

R. Ikeda As a main activity, yes. I will step back. As a material, I have probably done enough with it. I will keep my eye on social and philosophical issues regarding data and DNA, which is the ultimate data of all of us. We are data. We are information. We are code. Not only us; every single organism. Even the virus. The virus is not a creature, not a crystal: it's in between. It has DNA, too. Of course, I will continue to present versions of my data work, but I now just want to challenge many other things. It's also to give more opportunity to more talented and young artists.

2 Large Hadron Collider—the world's largest particle collider, built and operated by CERN. Construction on the LHC, which commenced in 1998 in an underground location near Geneva, beneath the France-Switzerland border, was completed in 2008.

3 A trigger is a system designed by physicists to select specific data, according to set criteria, from the collisions in a particle accelerator. Such detectors, installed on the LHC at CERN, record up to a billion collisions per second and yield one petabyte (a million gigabytes) of data per second. It is impossible to keep all this data. Only 0.004 percent of the total data generated is kept; the other 99.996 percent is lost forever.

117

A. Koek	That's very beautiful of you, Ryoji. There's real grace in saying you will step aside when you are at the height of your career, with two big, recent solo shows in London and at the Centre Pompidou in Paris.
R. Ikeda	It's not beautiful. I just get a little bored. What is true is that there are so many beautiful things in this world, so why do I have to stick to just this one field? I just want to change my point of view. I want to travel to different kinds of, fields of art. You never know: one day I might start writing a poem. [laughs] I don't know.
A. Koek	Will you start—for example—painting, then?
R. Ikeda	When I start something new, I have nothing to lose. I can be crazy, you see. If I fail, I adjust: I don't care and I go on to the next thing. I go back to the music. This is my driving force—motivation—and I think it's a great point. I'm rootless. I'm floating everywhere. I can go in any direction. I don't want to fix myself.
A. Koek	What is it about sound, then, that allows you to float? You are going back to sound—which is how you began your career, before you combined it with visuals.
R. Ikeda	What I'm doing is, of course, computer electronic music. But I love all music—bossa nova and samba, classical music, or whatever. It's really hard to find the music I hate, in fact. I have to find something which only I can do—like very, very niche. I absolutely have nothing to lose. What is success, as an artist, in a project? Number of visitors or self-satisfaction? I stop thinking in this way—success and failure. I just *do*—next. [laughs] It's far more healthy. That's why I really try to challenge things.
A. Koek	It's very funny: before we began this interview, this phrase of Einstein's popped into my head and I was just thinking of it and how it applied to you: "There are no fixed points in space." The American choreographer Merce Cunningham held this phrase close to his heart and it informed his practice.[4] As a phrase, it really resonates with your work and your life.

4 "There are no fixed points in space" is a quote from Albert Einstein's general theory of relativity, published in 1915, which revolutionized physics and how we understand space, time, mass, energy, and gravity. The theory postulated that everything moves in relation to everything else, and that the universe has no fixed frame. In homage to Einstein, Cunningham created a dance piece for television called *No Fixed Points*, broadcast in 1987 by the BBC.

R. Ikeda

Yes, exactly. That's a good quote. There's no fixed point in space. There's no fixed point in your life either. There can't be, because everything is ever-changing. This is hardcore Zen thought. Nothing is at a standstill. Seemingly, I am stopping—but no, everything is changing. [chuckles] It's like that. [clears throat] Even COVID-19 made us really wake up to many things and change. I am traveling less. My condition, of my body, is really nice. [laughs] I'm full of energy. It was so crazy the last twenty years—I was really traveling too much. Now I'm really enjoying every day. I am floating.

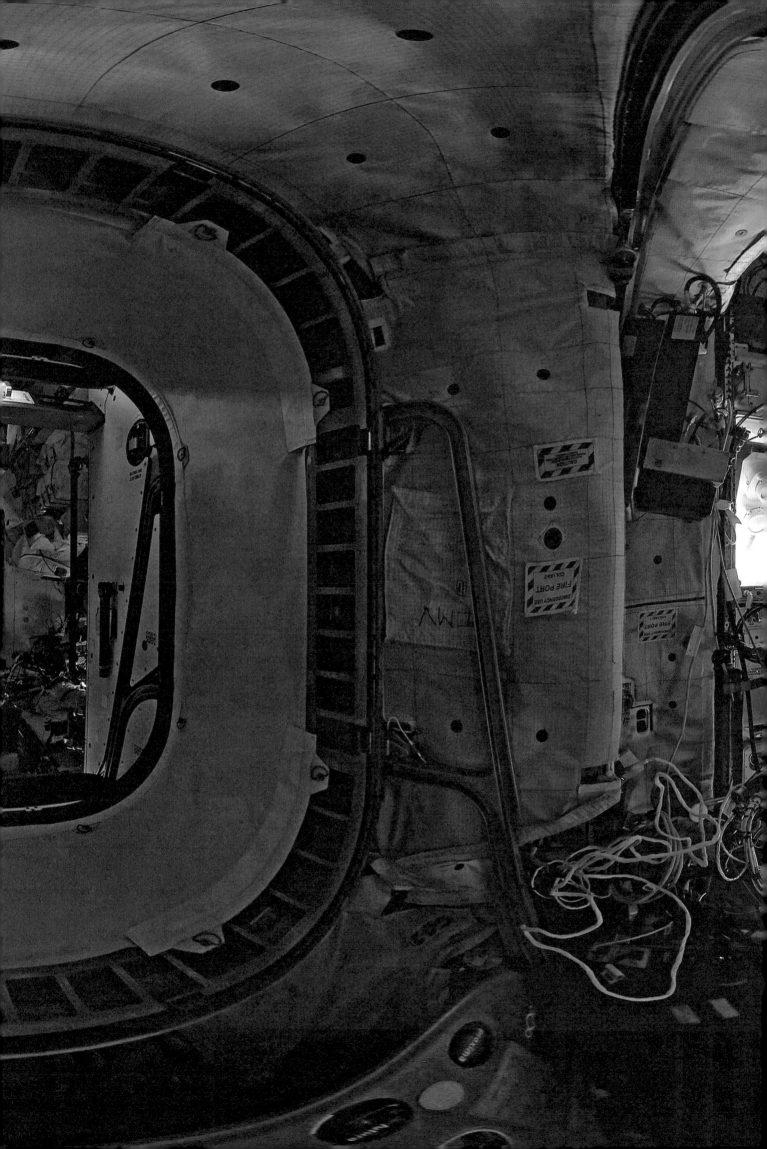

"You look at the Earth as seen from space, and its barren deserts and mountains or oceans—and the small fraction that is habitable. You live under the very, very thin blue layer of the atmosphere. That's all we have. And then even the oceans: on the scale of the planet, they're like a thin coat of varnish, and that's our resources. Yet it does the miracle. Mother Earth keeps billions of living creatures alive in the deadly vacuum of space. It's very endearing! She is obviously the only living thing out there. Beautiful, serene, graceful, turning gently with the cloud patterns—it's moving. Everything else out there looks dead. The Moon is a piece of rock. The Sun is a ball of fire. ... I mean, they're beautiful, but, you know, you wouldn't want to live there. Earth, on the other hand—wow!"

—David Saint-Jacques

"Before I was an astronaut, I was studying the bar-headed goose, a species that migrates over the Himalayas. There I was, on my very first day on the Space Station, watching the Earth from above and thinking about my geese, and how these geese are so incredible because they migrate over the Himalayas twice a year. And how high that seems, how high the summit of the Himalayas seems, and how incredible it is for this species to conduct that iconic migration. And here I am, miles and miles and miles above the peaks of those mountains, looking down at them and trying to envision my geese flying over the mountains."

—Jessica Meir

"We are united by the dream of exploration and accomplishment. Spaceflight shows us what we can accomplish when we are united by something other than fear. When we delve into that deep part of our human spirit that wants to explore and that wants to accomplish, it is such a positive outlet."

—Anne McClain

"We have to keep a reasonable fraction of our capacity for the arts, for science, for exploration, because these are the three things that make humans what they are. Without them, we're just going in circles; we're not progressing. Space exploration has that capacity that seems to excite the brightest and best of us. It has the capacity to make the best engineers, the best scientists really scratch their heads to come up with solutions to these problems that need to be solved. And once these problems are solved, then everybody can use them to benefit. So, space exploration is where our future lies, I think."

—David Saint-Jacques

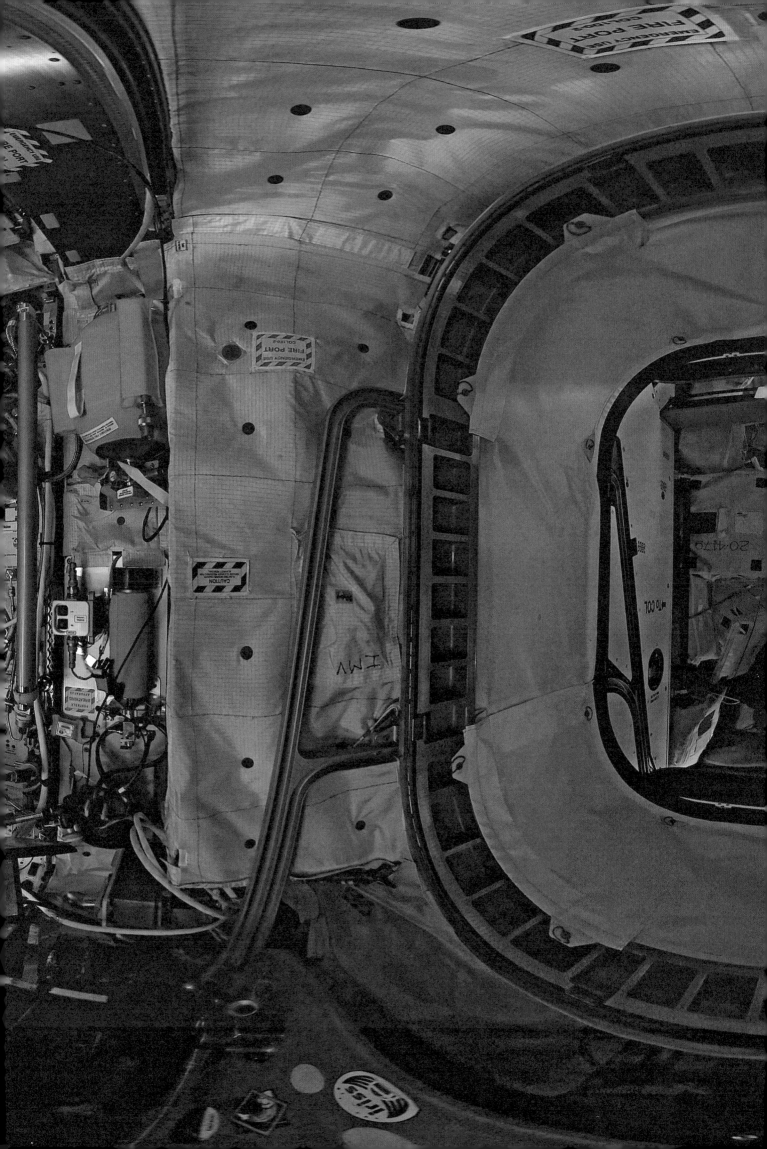

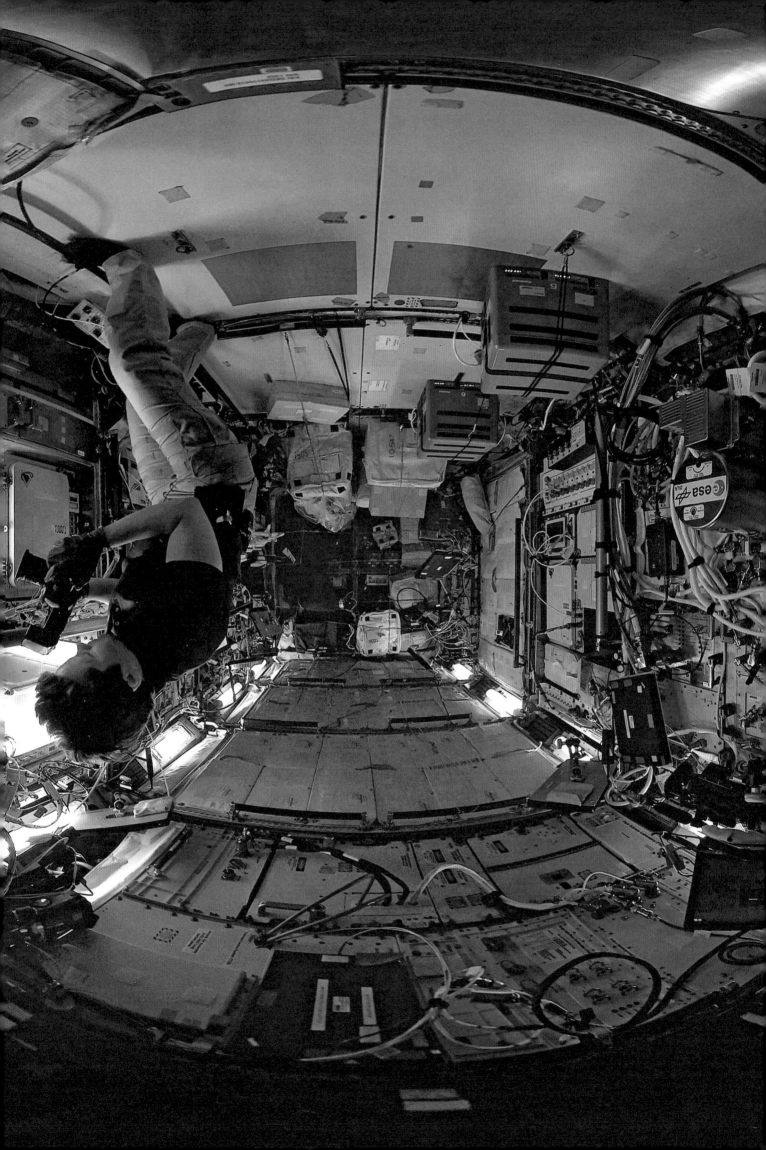

Ryoji Ikeda's new audiovisual installation
The Universe within the Universe explores
hidden facets and structures of nature
on 20 different scales, guiding visitors along
an immersive journey from the microscopic
to the macroscopic universe—and beyond.

Concept and composition	Ryoji Ikeda
Computer graphics and programming	Norimichi Hirakawa Ryo Shiraki Tomonaga Tokuyama
Commissioned by	PHI
Duration	10 minutes (loop with 5-second pause/black)

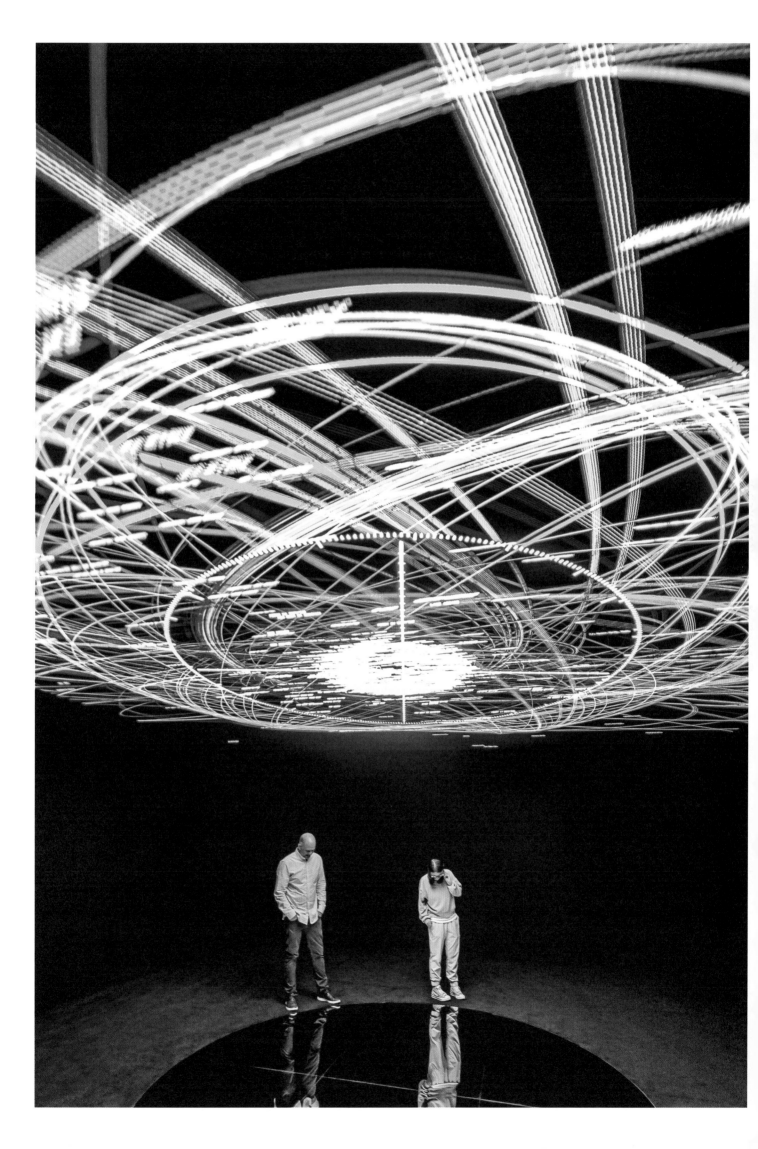

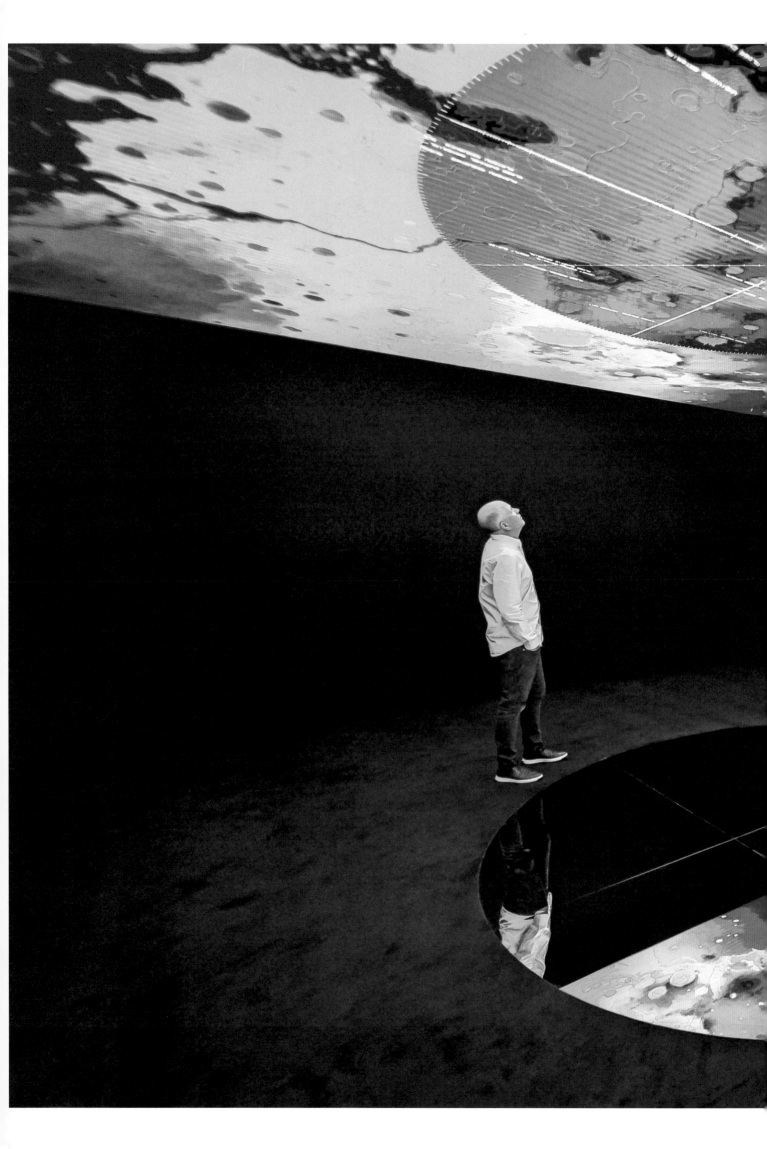

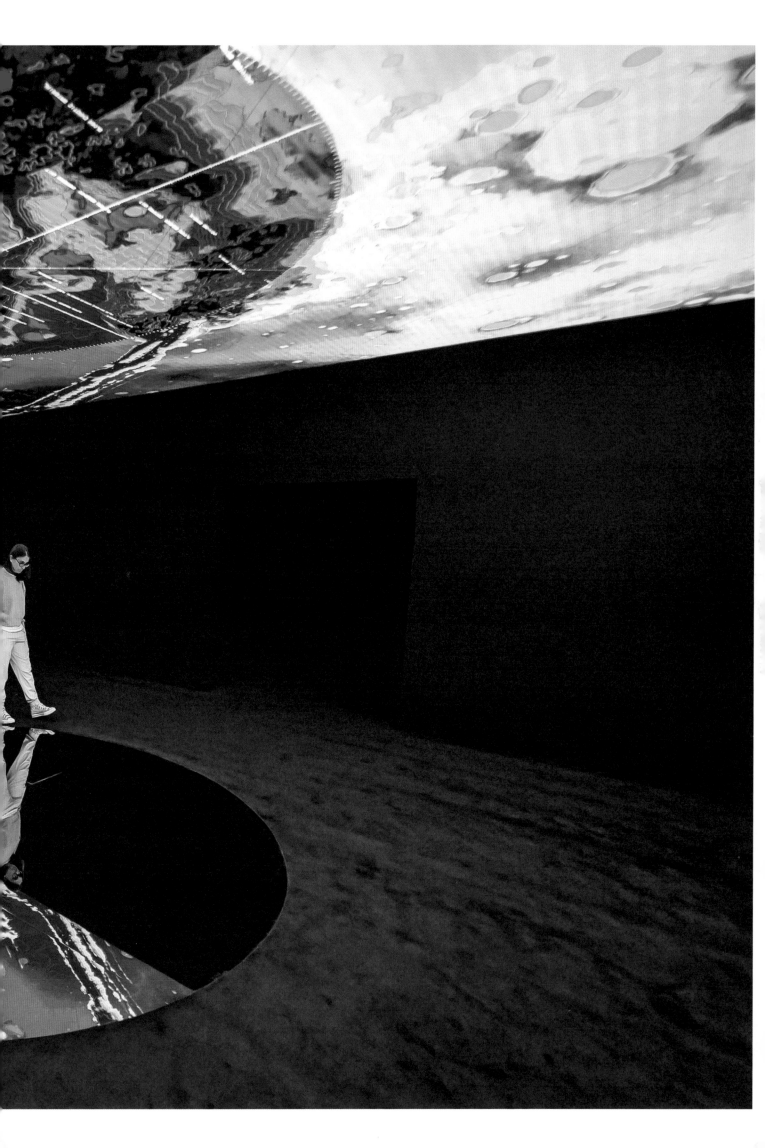

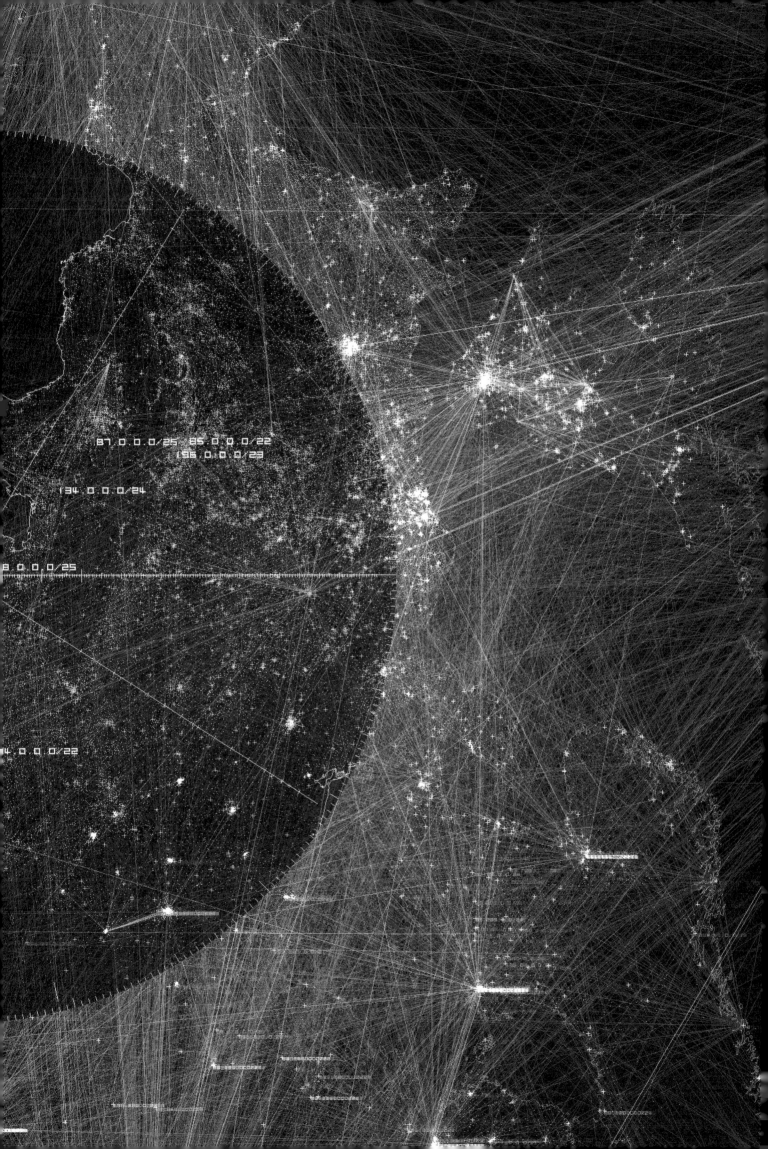

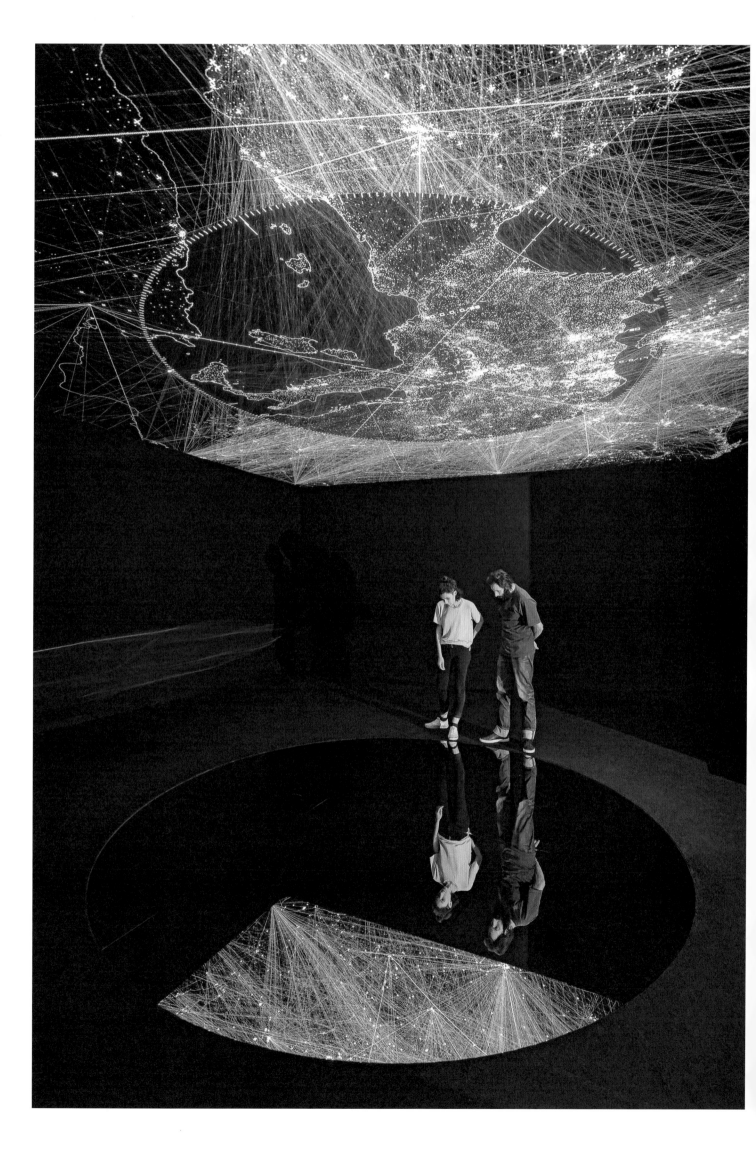

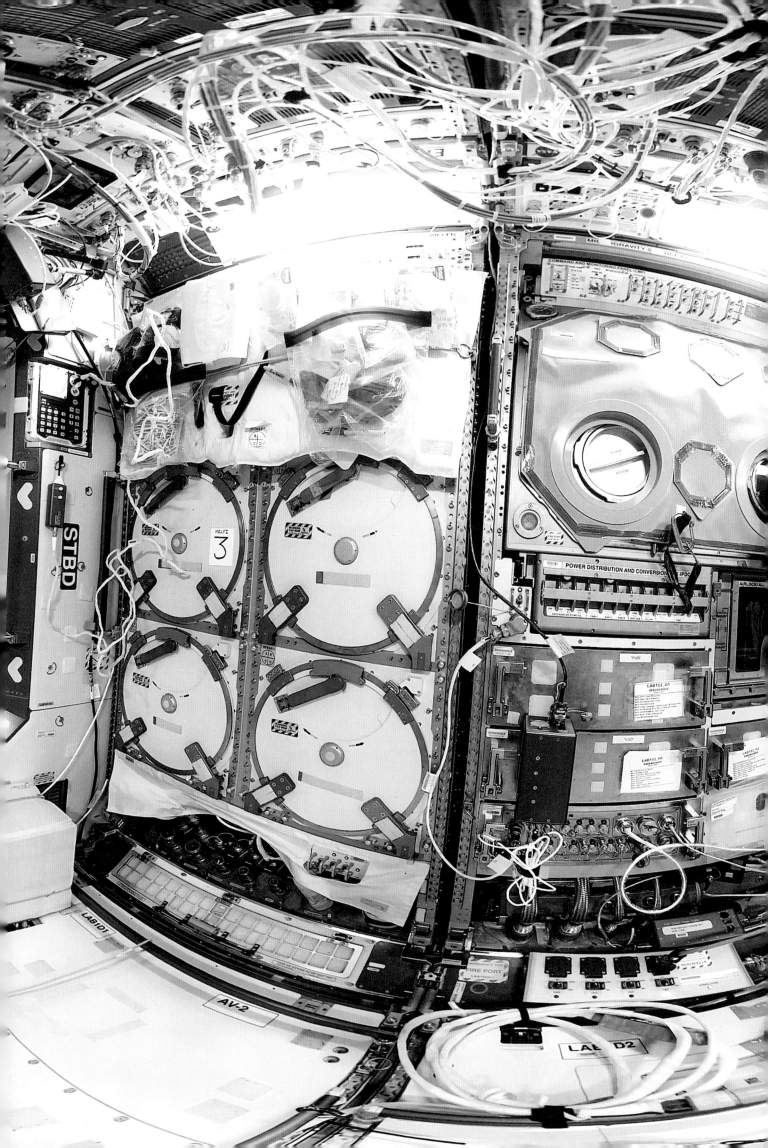

"It's amazing. It's beautiful. All those things. But when you look out the window for the first time, it's a spiritual experience—and it's there for us, all the time. When you stick your head out on the cupola, the Earth is above you. So you actually look up at the Earth. A lot of the times, astronauts say we are looking down on the Earth, but actually it feels like you're looking *up* at the Earth. And whenever I look at the horizon, it's above me, not below me."

—Andrew Morgan

"Nothing can describe or prepare you for that magnificent feeling of realizing that you're in space, you're above the planet, you're looking down on Earth where everything you know, all the places you've been, all the people you know are still down there. And you're up here and you're floating, and everything around you is floating, and you're looking back down at the Earth and that just... it still is difficult for me to believe."

—Jessica Meir

"During our EVA [extravehicular activity] we always have a little bit of time between tasks to take a break. And when we take a break, that's the perfect time to enjoy the view outside. And even when it's completely dark, there is always something that you've never seen before, that you never noticed, that you can look at. Even the Space Station—it's just such an amazing view."

—Luca Parmitano

"Just looking out the window, that view of Mother Earth—it's the most amazing natural scenery you could ever see. It's like being on top of the highest mountain, looking at the world. You have the whole world to look at, and it is such a splendid beauty. Our beautiful, blue Planet Earth, just glowing there, floating in the dark, black, velvet space. She's just so graceful, and it looks like she's breathing, glowing. It always fills me with awe."

—David Saint-Jacques

137

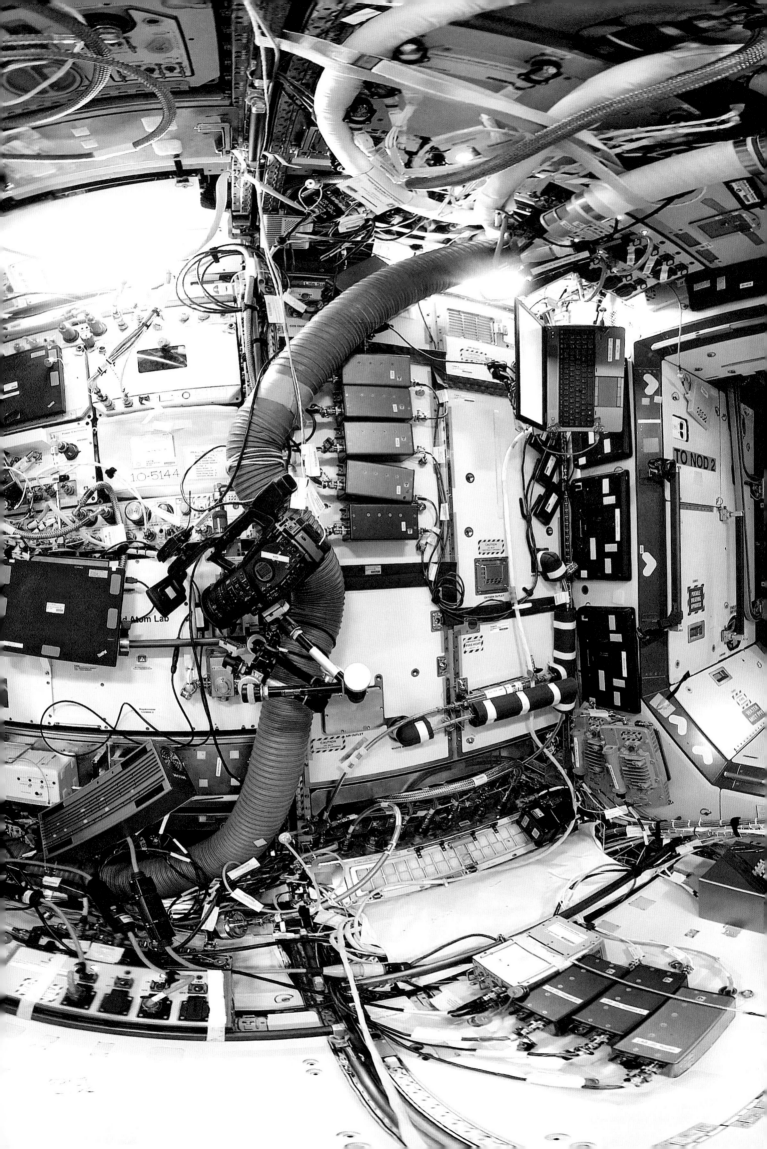

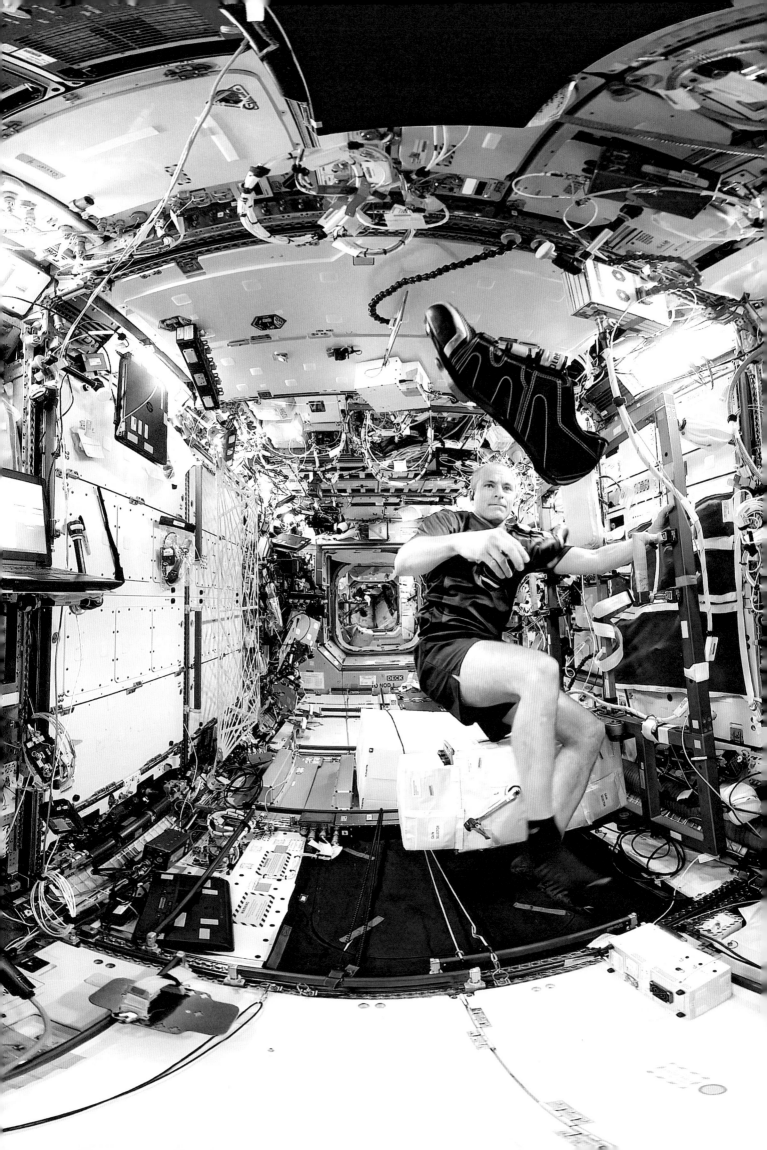

The Overview Effect

by Jeffrey Kluger

It's easy to get smug about the Earth. It's gorgeous, for one thing—awash with blue water, draped in green trees, crawling and swimming and flying and running with all manner of life making its way in all manner of habitats. What's more, it's huge—and if you don't believe it, just look around you. Our mountains tower miles into the skies; our oceans plunge miles below the surface. The edges of our world run out in all directions around you, spilling over the horizon where other lands—whole continents—lie waiting. You could circum-navigate the world—it's been done—but it wouldn't be easy.

The grandeur of the Earth is in some ways its curse. Those deep oceans long seemed like a great place to dump waste; they're oceans, after all—how could mere humans hurt them? Those expansive skies should similarly tolerate all of the exhaust we want to pour into them. They're still blue—for the most part—aren't they? The rivers should never be depleted of their fish; the rainforest could never run short of timber; the mountains will forever supply us with ores and metals and coal, no matter how many of them we gouge and cut and blast to get at the buried riches.

And then, too, there's the matter of the strangers—the distant people who live on those distant continents that lie just beyond the horizon. We might know of them, but we don't really encounter them. We do know that they dress all wrong and they speak all wrong and they look all wrong and they worship all wrong. Best we draw borders, then, and keep the others on the opposite side—the better to protect our kin and friends and village and nation. It's a big, beautiful planet—but a menacing one, too.

That is, at least, until you leave it. Fewer than six hundred people in all of human history have ever crawled into a rocket, sat still while it was lit, and then roared off into the track-less regions above the atmosphere, but the experience is a profound one. From that remove, people who were born of the Earth are all at once beings apart from the Earth—looking down on it from orbit, looking back on it from the Moon—seeing the world in a whole different way. And then something changes.

That something is what astronauts call the "overview effect." It's what happens when the Earth gets smaller in your window. It's what happens when clouds, which are always high above us, are suddenly far below us. It's what happens when the atmosphere, the thick quilt of air so dense that it causes incoming space rocks to incinerate to nothing, is revealed as the impossibly fine onion skin that it is. It's what happens when the grand world we know is seen for what it is—just a tiny ball of real estate in the little hamlet that is our galaxy, on the little block that is our solar system.

The Earth, the astronauts come to appreciate, is not only small, it's destructible. Rivers can be fished out; rainforests can be shaved down to stubble. The skies and oceans can only take so much waste. And those borders we like to draw—the scribble of imaginary lines that crisscross all over the map—do their own kind of harm, separating the wealthy from the poor, the privileged from the underprivileged, the black from the white from the brown.

For more than twenty years, astronauts have been continu-ally living aboard the International Space Station (ISS)—a handful of people serving as emissaries for the other 7.8 billion of us. They have turned their eyes toward space, but also toward the ground, keeping us mindful of the miracle of our world, of the fragility of our world, of our responsibility to be smart shepherds of the planet that birthed us and will always be our home. *The ISS Experience* offers all of us a glimpse of how the astronauts live—and of the lessons they learn in so rare a place as space.

**Photo Essay
by TIME Studios**

Director of Photography: Katherine Pomerantz
Executive Producer: Jonathan Woods
Senior Producer: Clàudia Prat
Senior Editor: Alex Fitzpatrick
Color Correction: Julia Lull

For over four years, TIME documented the creation of the groundbreaking series *Space Explorers: The ISS Experience*. From Montreal to Houston to China—and all the way to the International Space Station—filmmakers, engineers, and astronauts overcame all kind of challenges to make this project a reality.

Customized
Z-Cam V1 Pro

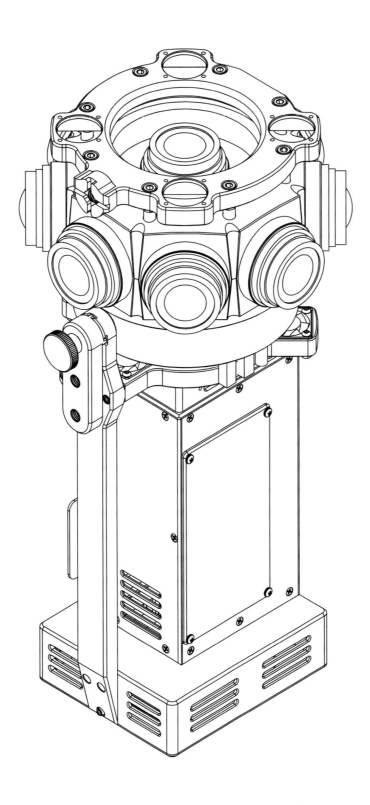

The cameras used for *Space Explorers: The ISS Experience* are customized Z-Cam V1 Pro cameras. They feature nine 4K sensors allowing for a 3D, 360-degree image at 8K resolution.

Adapting the Z-Cam V1 Pro for flight certification required multiple modifications in wiring and cabling—including the re-engineering of the camera's cooling system, since heat does not rise in zero-g.

SpaceX Falcon 9 Rocket

Dragon Module

Second Stage

Interstage

First Stage

Lox Tank

Fuel Tank

Single Merlin Vacuum Engir

Lox Tank

Fuel Tank

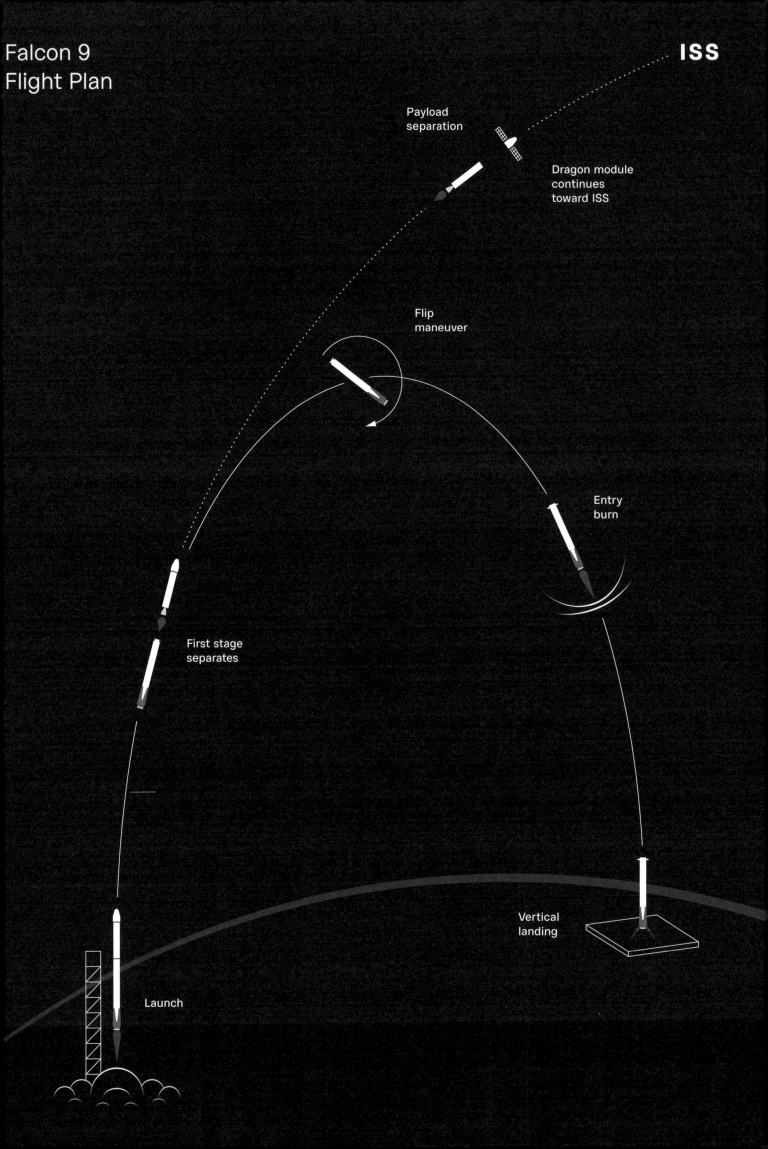

Dragon
Spacecraft

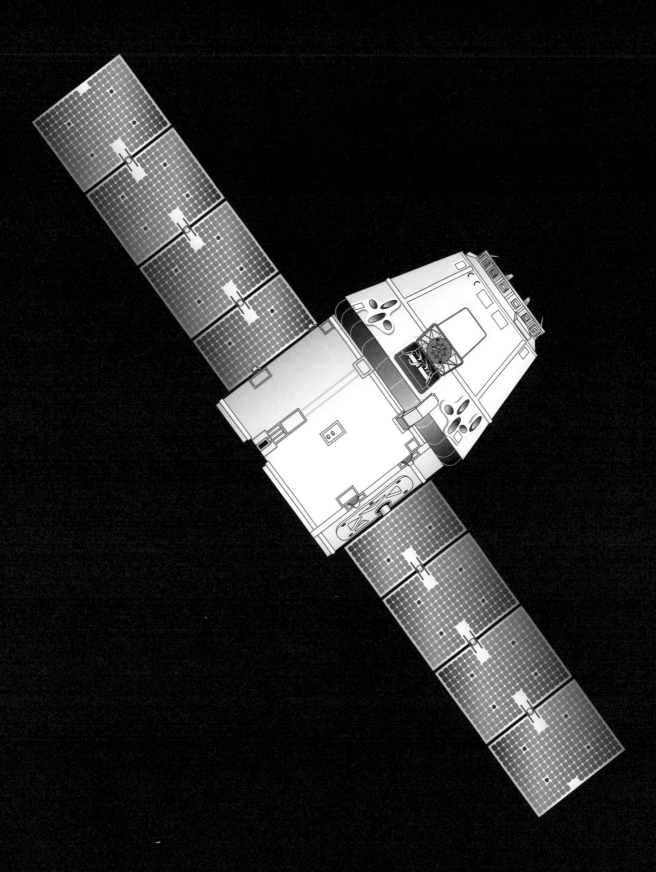

The SpaceX Falcon 9 rocket with
the Dragon spacecraft lifts off from
Cape Canaveral Air Force Station
in Florida on Dec. 5, 2018, carrying
the two cameras among 6,000 lbs.
of cargo.

143

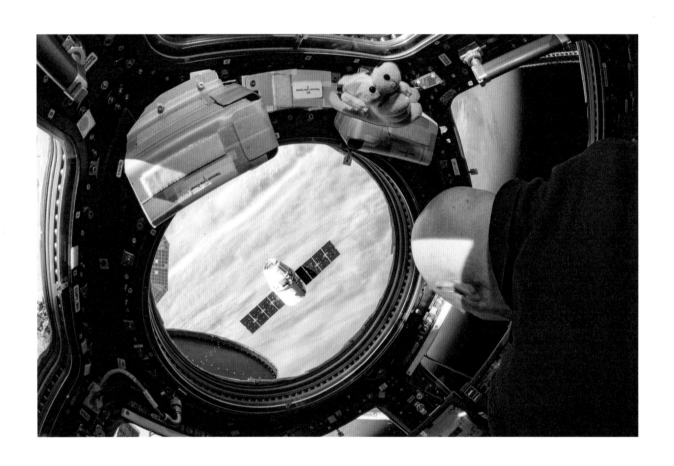

SpaceX's Dragon spacecraft flies
toward the International Space Station
on Dec. 5, 2018.

Canadian astronaut David Saint-Jacques
opens a package containing one of
the immersive cameras in January 2019.

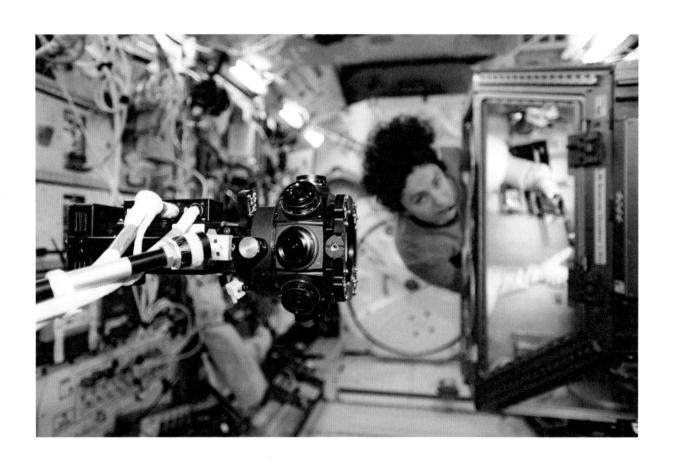

The immersive camera captures
NASA astronaut Jessica Meir as she pulls
human cell samples from the station's
MELFI (Minus Eighty-Degree Laboratory
Freezer for ISS) for a science experiment.
March 2020.

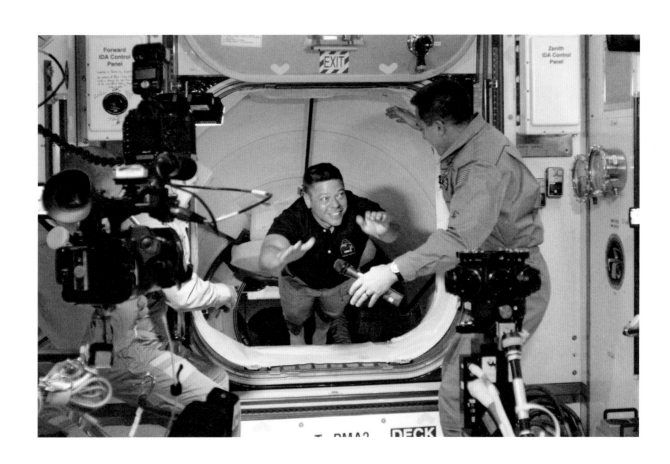

Space Explorers: The ISS Experience
captured the historic moment when
astronauts aboard the commercial SpaceX
Crew Dragon spacecraft arrived at the ISS.
May 31, 2020.

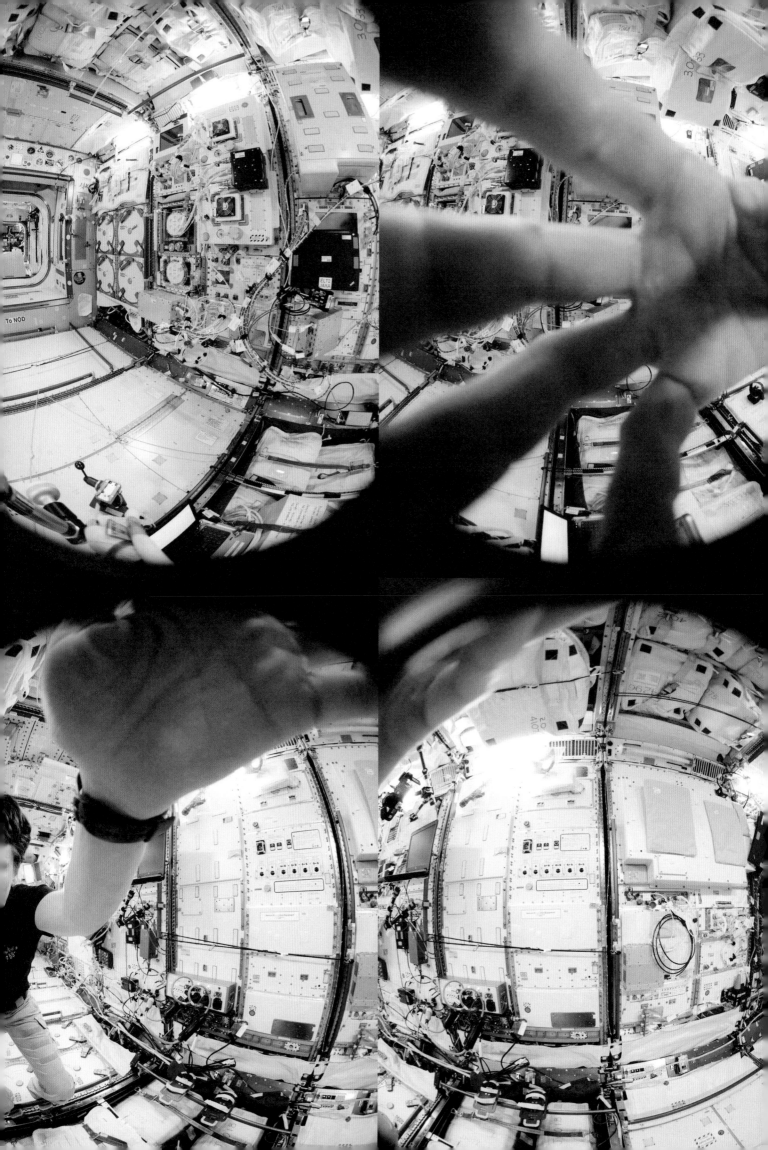

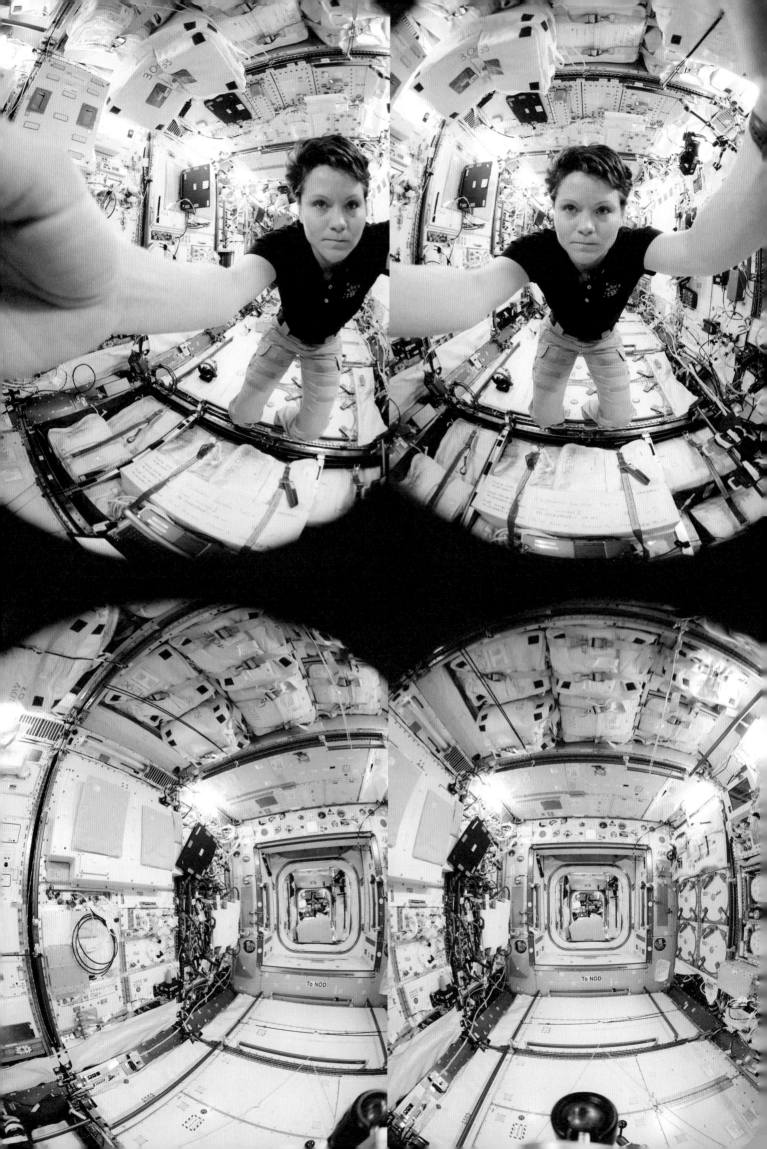

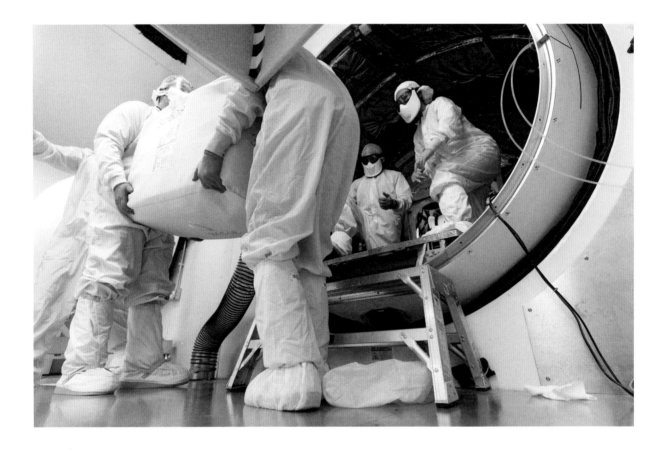

Amid the pandemic, the cargo bag
containing the Outer Space camera is loaded
through the hatch of the Cygnus Pressurized
Cargo Module on Wallops Island, Virginia.
Sep. 28, 2020.

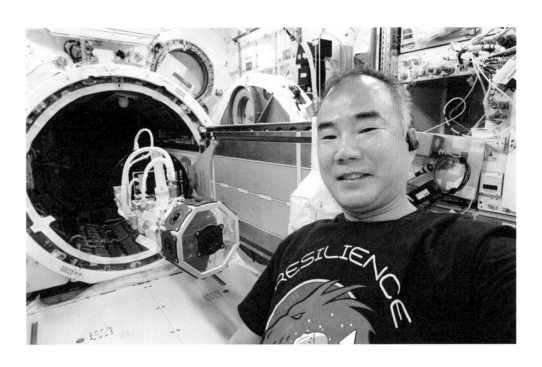

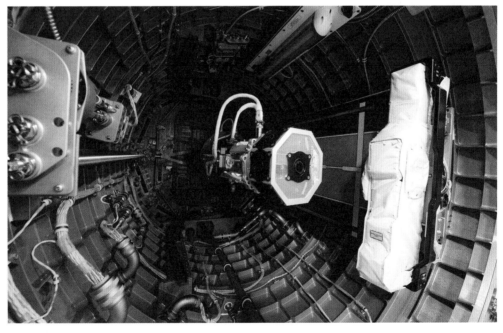

Space Explorers: The ISS Experience captured the historic moment when astronauts aboard the commercial SpaceX Crew Dragon spacecraft arrived at the ISS. May 30, 2020. JAXA (Japan Aerospace Exploration Agency) astronaut and Expedition 64 Flight Engineer Soichi Noguchi is pictured after installing the Outer Space camera on the Kibo laboratory module's airlock slide table.

In the first attempt to film outside the ISS, the Outer Space camera is placed on the Japanese Experiment Module airlock before heading outside. Feb. 19, 2021.

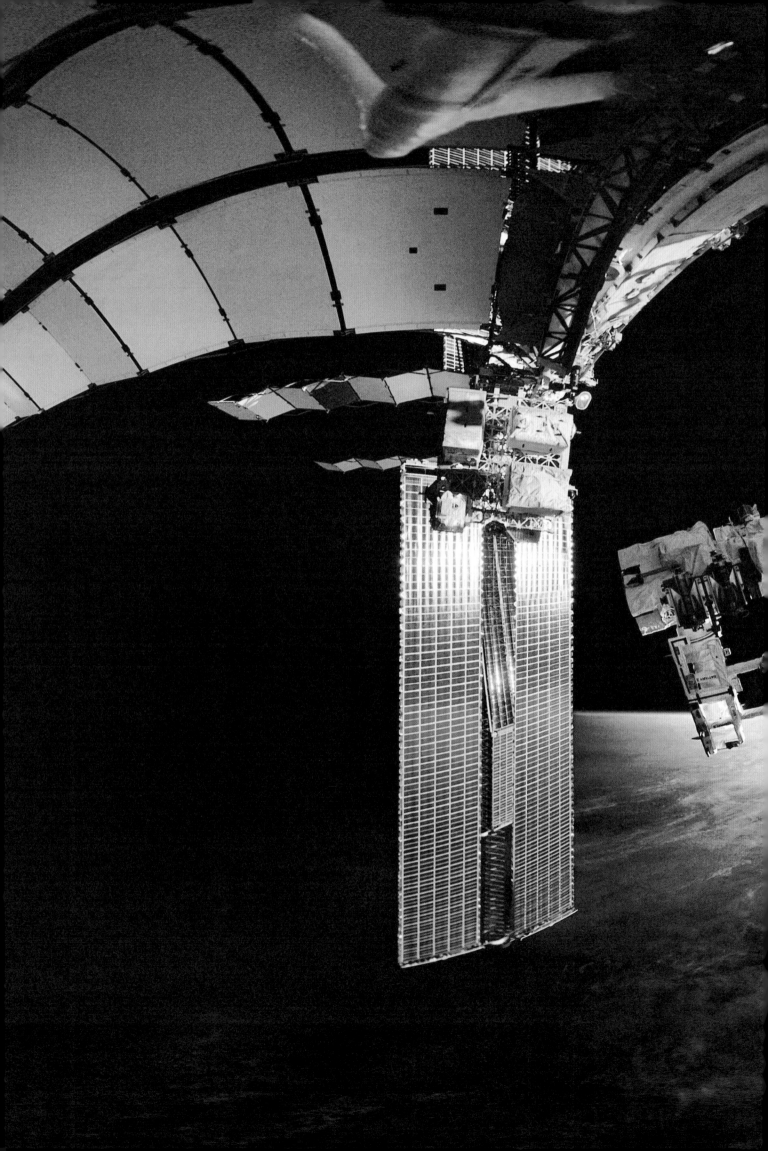

"I started saying I wanted to be an astronaut when I was five years old, according to my mom. I remember drawing. If I remember that image, what it looked like, it was a picture of an astronaut standing on the surface of the Moon—a kind of iconic Apollo [mission] image—in the space suit next to the flag. And that was what I drew then, and said I wanted to be an astronaut."

—Jessica Meir

"Part of you is the professional. You are the astronaut inside the space suit, and you have very specific steps that you have to take on which your safety depends—yours and your crewmates'. But on the other hand, there will always be the little child inside you that is just in awe at what's happening. And I hope that child never goes away, because it's probably my favorite part in a way. I'm still surprised, every single time, when I'm just about to go outside in open space—in vacuum—in a place that is very much not suitable for life. I'm going to be spending several hours outside working in space, while at the same time experiencing the incredible views that the little Luca that's inside the space suit with me, that he will never get tired of. It will never become ordinary. I cannot believe that it's really happening."

—Luca Parmitano

"I think it's really important that we remember that humans have a propensity to explore. We have a drive to go beyond what we know. Sometimes we have to just listen to that voice, listen to that purpose, and we have to do something purely for the reason of inspiration, purely because nobody's ever done it before. And we're humans. That's what we do."

—Anne McClain

"Being a part of the first all-woman space-walk, with Jessica Meir, was certainly the highlight of my career and maybe even my entire life to this day. When we eventually both exited the airlock, I remember a moment where we caught each other's eye and we just smiled. We did take a second to throw each other a smile, because at that point we knew we had done it. We were two women outside the airlock, in the vacuum of space in our space suits. And that would never change, no matter what."

—Christina Koch

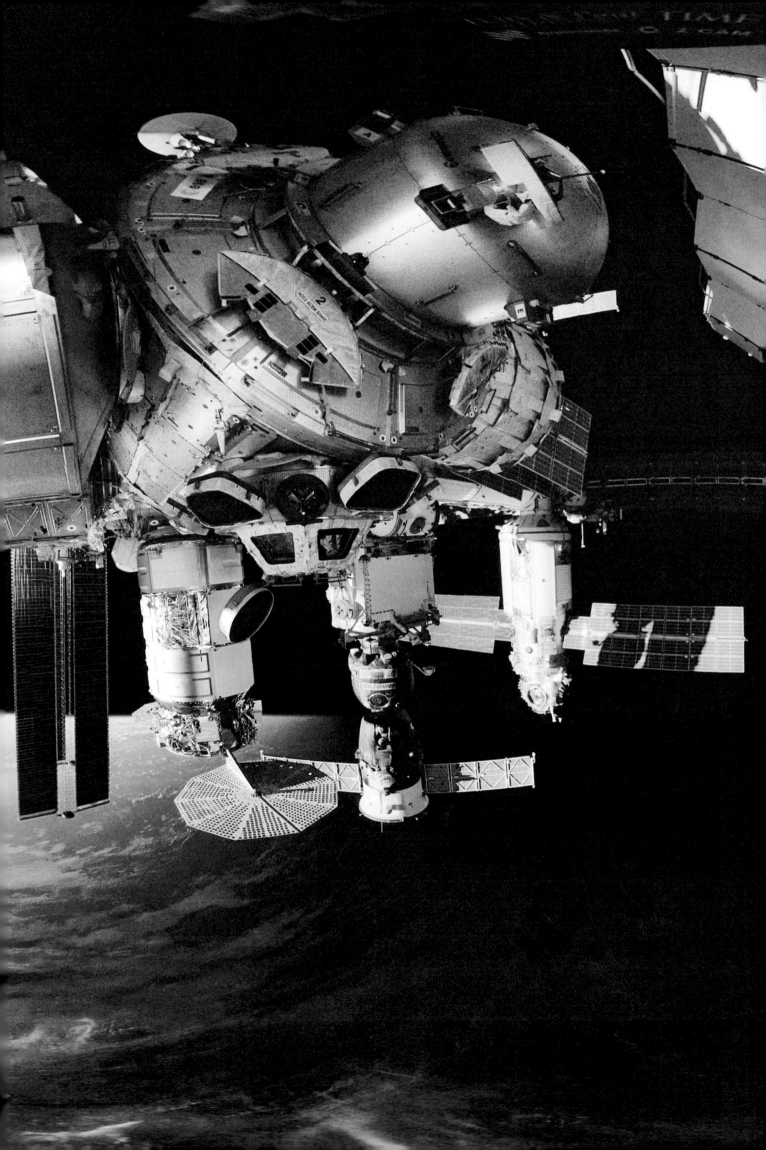

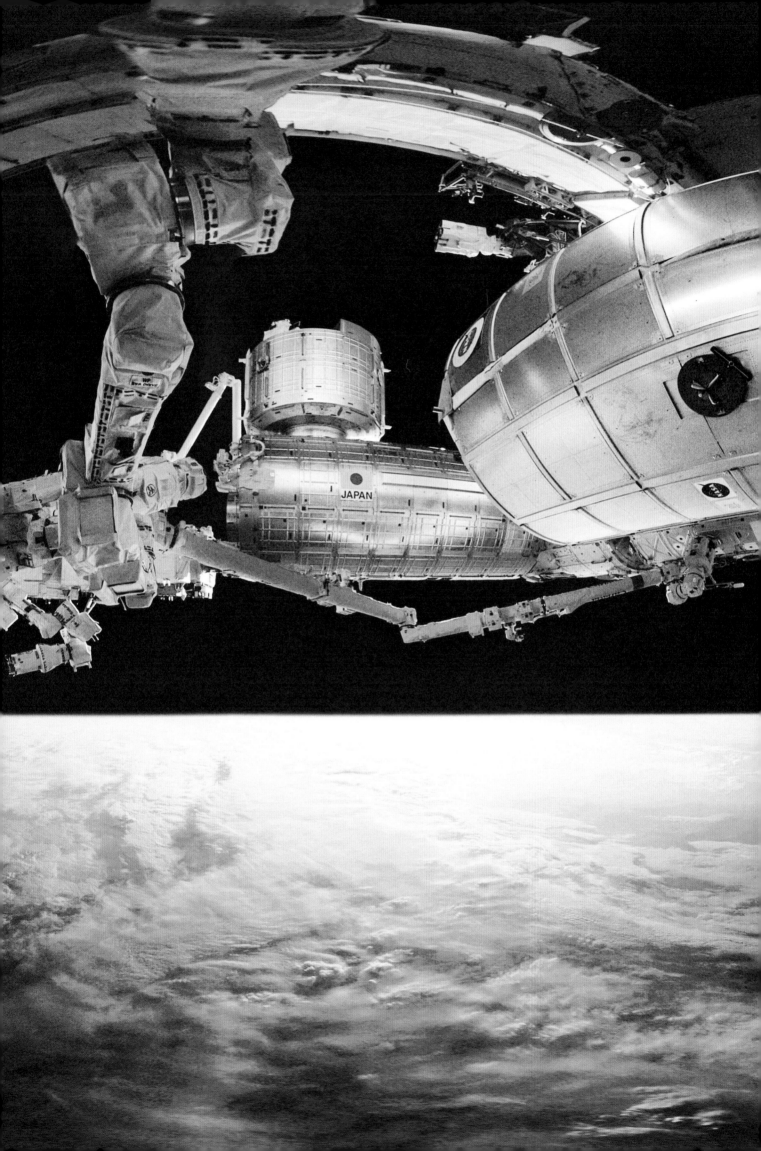

Zone 5
Ryoji Ikeda

Zone 6
The Wormhole

Zone 7
The Origin

Ticketing

Zone 4
The Overview Effect

Zone 3
The ISS Exploration

Zone 2
Onboarding

Zone 1
Stars Are Calling Us

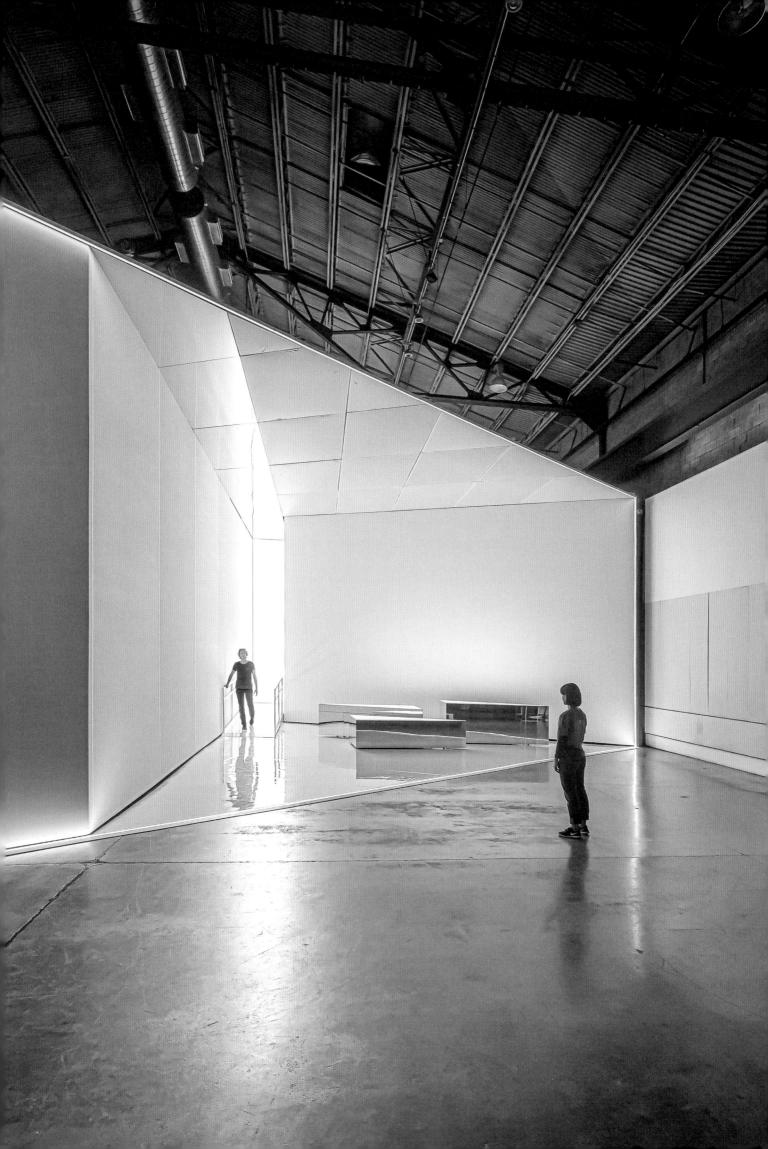

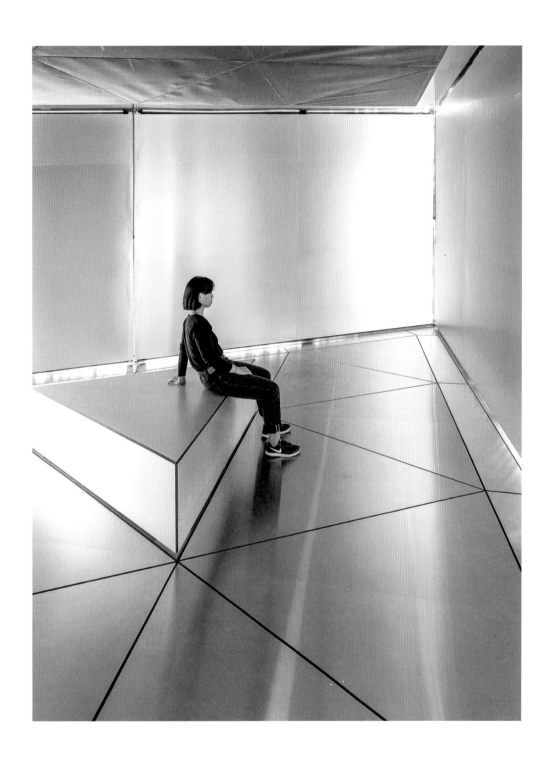

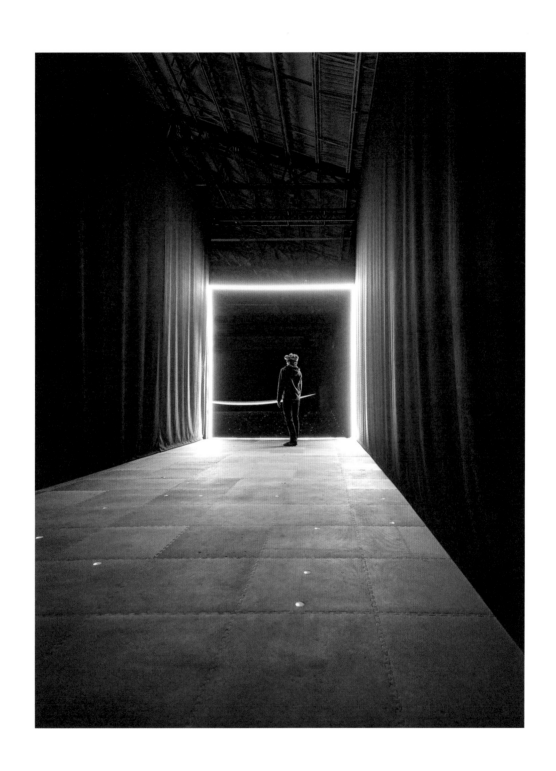

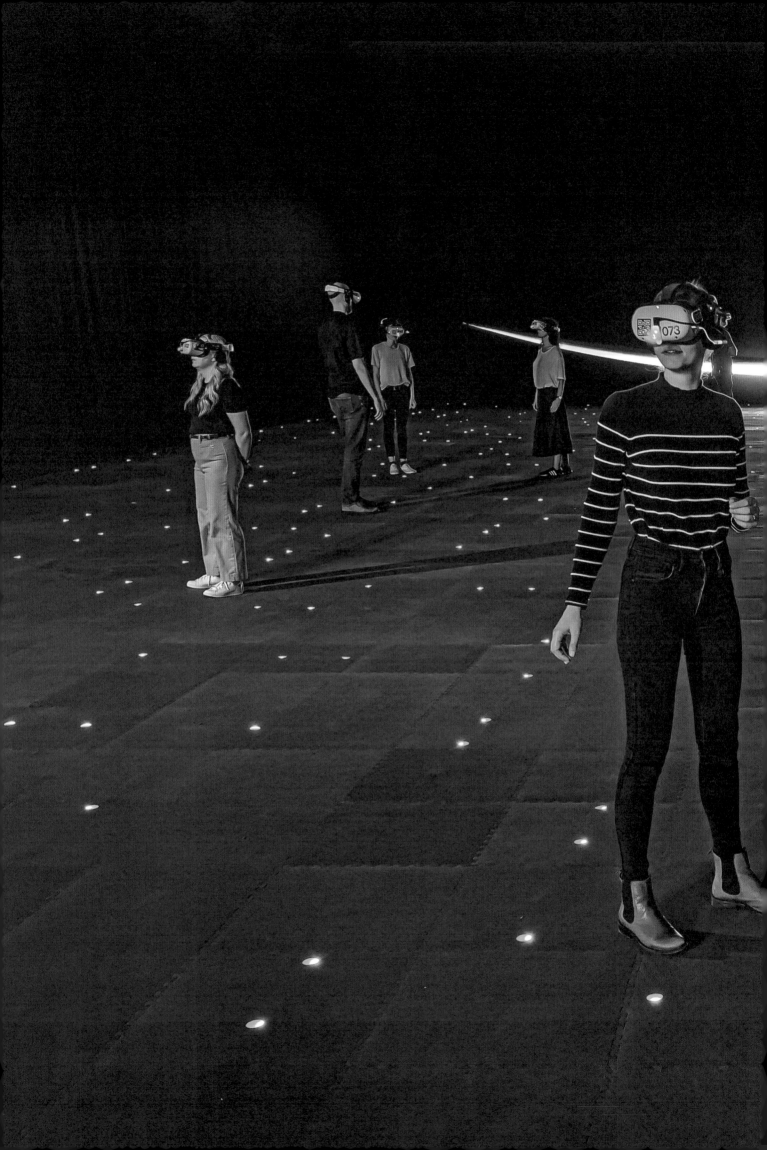

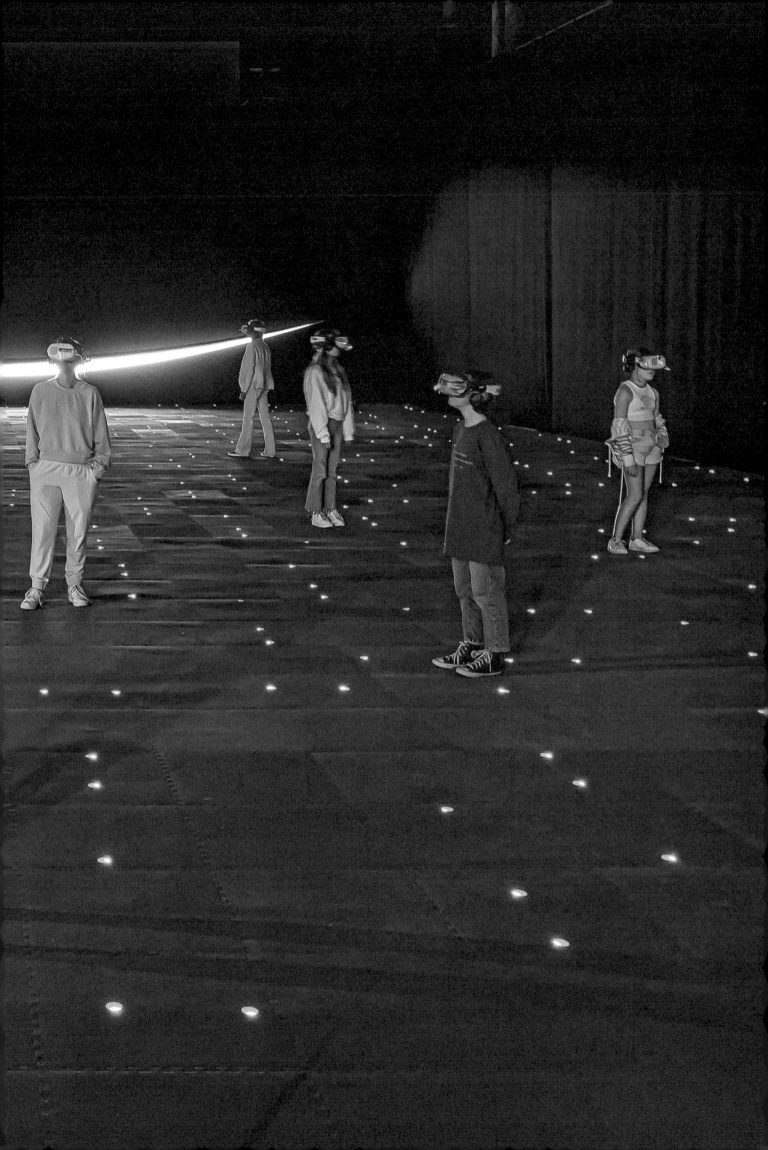

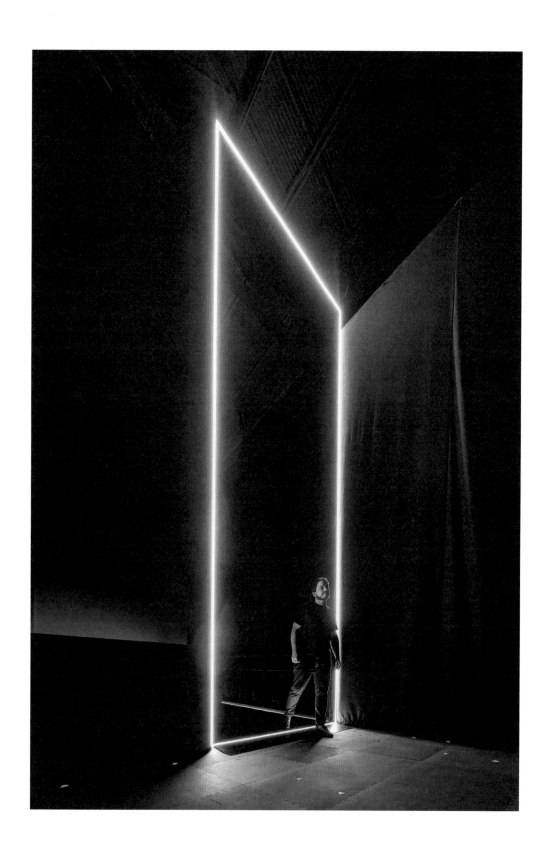

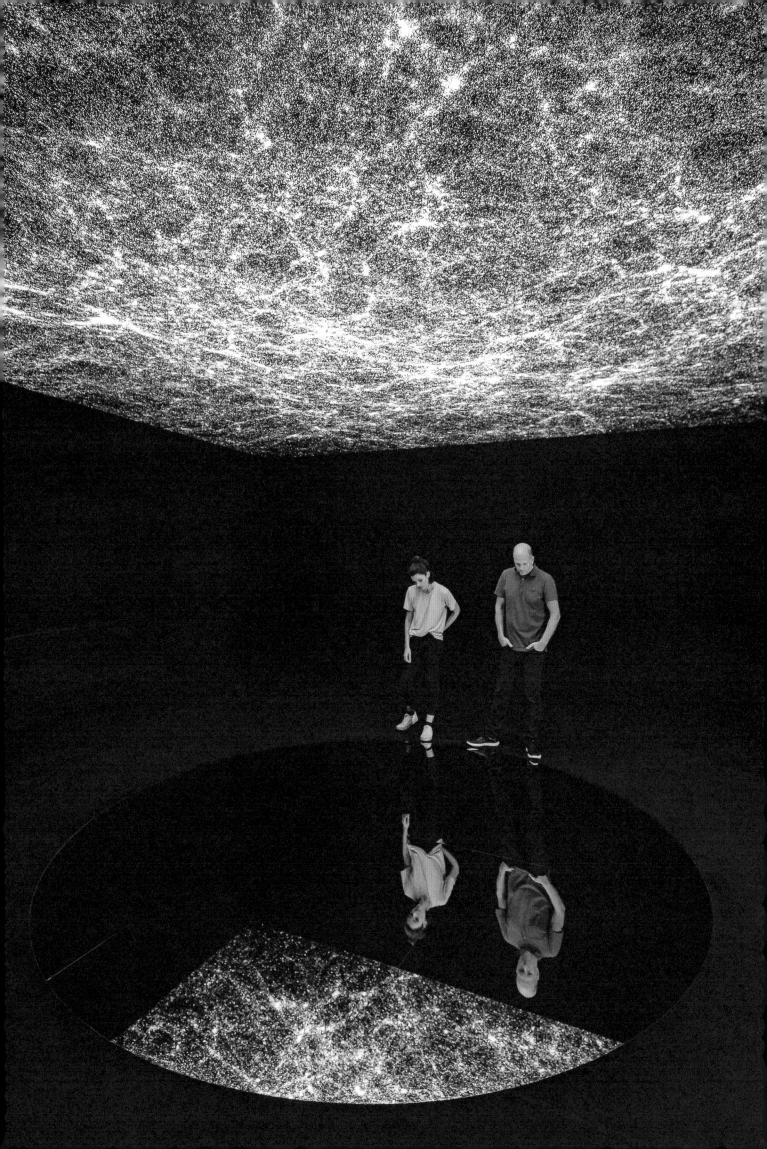

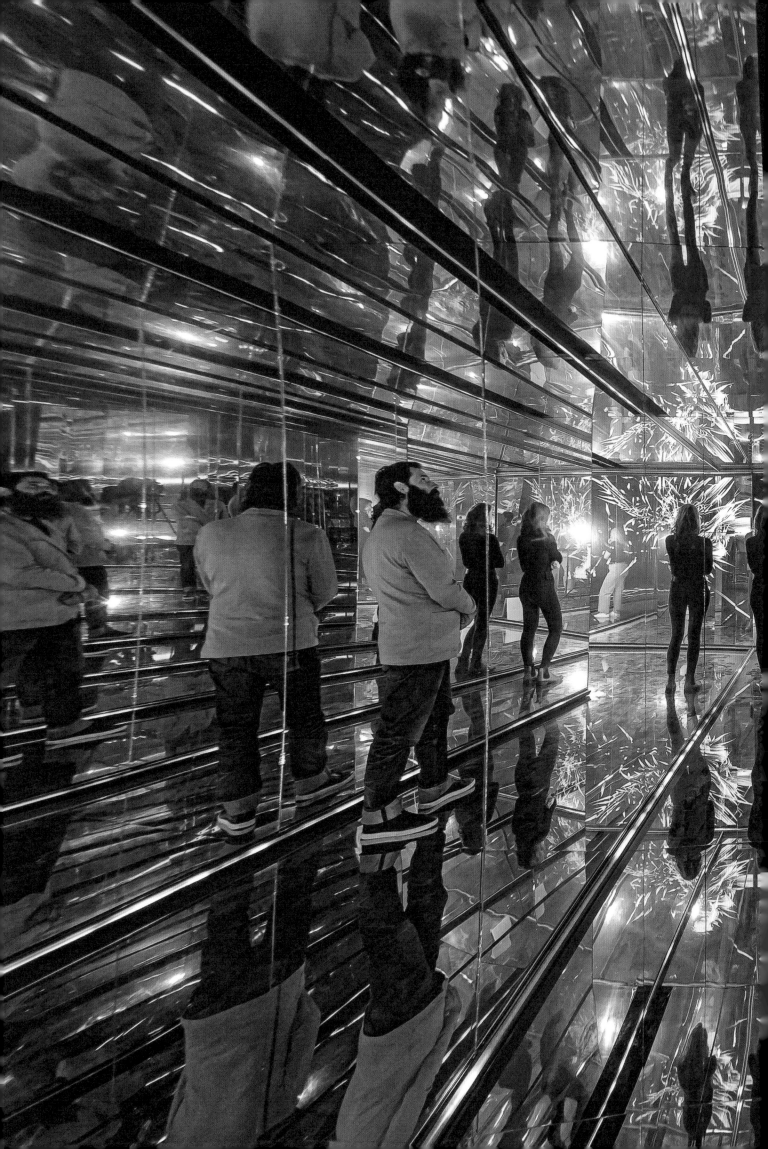

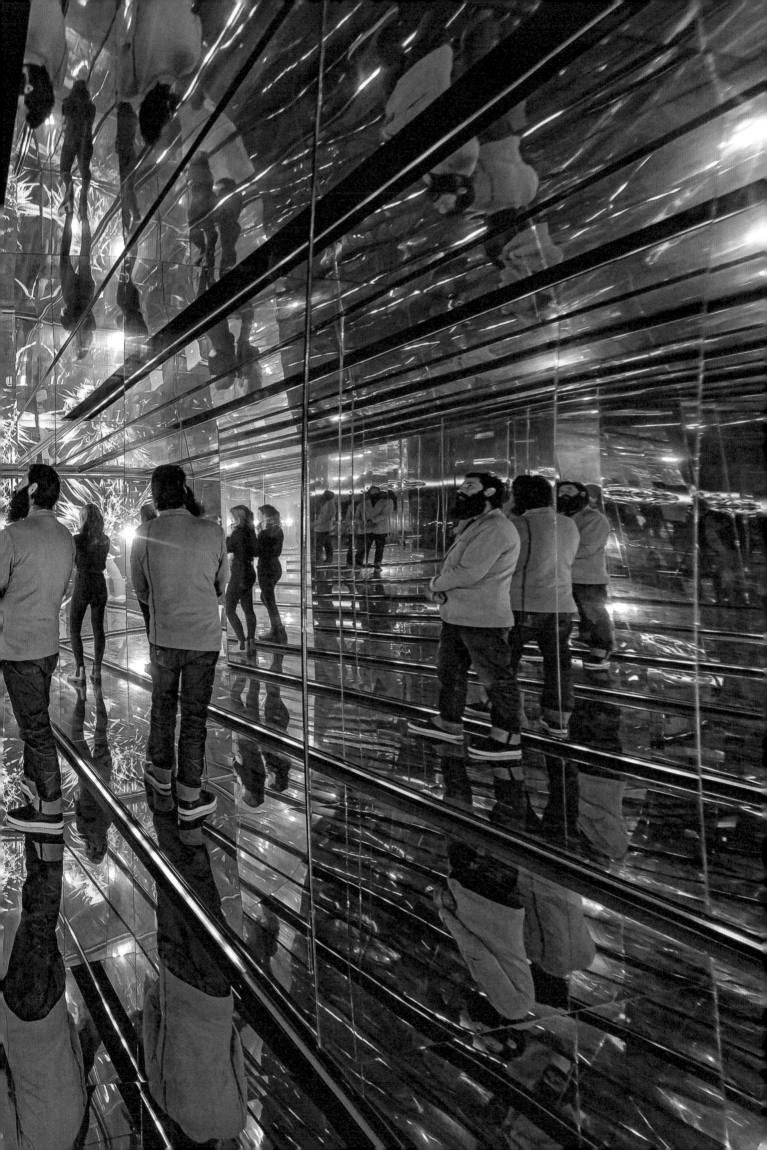

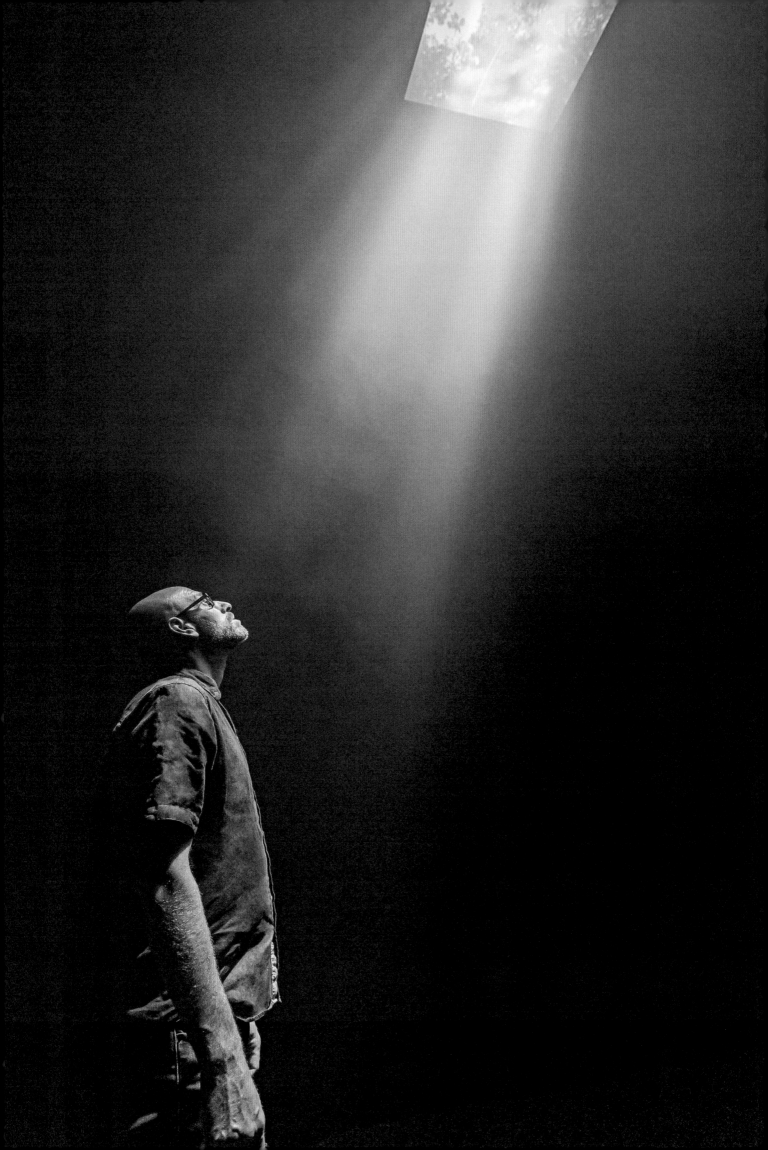

This is a story about a story—about several stories, in fact—that underlie and invest the one being told here. It is also an encounter with an encounter—an *unlikely* encounter, between a thousand faces with a common focus on a single project. Between all these people, who came together and gave their best to create a one-of-a-kind experience, even in the midst of a year that had so many surprises in store.

In the beginning, when I came on board with *The Infinite* (though it had no name at that point), the project consisted of four renowned artists—Phoebe Greenberg, Félix Lajeunesse, Paul Raphaël, and Marie Brassard. In preparing to work together for the first time, our little group was brimming with dreams, stories, and drive. There was also the astonishing content, produced by Felix & Paul Studios. And that was it. That was all it took to birth this idea, which would lead to such an exceptional and marvelous journey. Over the weeks and months that followed, many people joined the project. *The Infinite* was expanding, and the team with it, eventually swelling to more than seventy individuals. These people, for all their many differences, had one thing in common: they had agreed to join us and work outside their comfort zones. We were flying, all of us, by the proverbial seats of our pants: nobody had ever done what we were about to do.

My role, as creative director, was to safeguard the project's creative vision: to ensure it was shared and consistent. Once the core quartet had laid the foundation, it fell to me to make sure this narrative arc was respected and preserved by a creative team comprised, at its peak, of seventeen people. I felt as though I was an orchestra conductor, seeing to it that from the initial design all the way through to production, the musicians played, in unison, all the notes of a composition destined to be performed at center stage.

Light, ritual, the lure of the stars, travel, adaptability, dizziness, black holes, transformation—the artists honed in on these themes from the start, conceived a narrative thread and, after substantial research, multiple iterations, endless back-and-forth, and ample finesse, developed the design and the experience. *The Infinite* begins with putting on a headset. From that point on, it becomes a portrayal of a departure in light ... a sunset seen from orbit ... an encounter with sixteen astronauts aboard a space station ... a beautiful, breathless moment of weightlessness awe inside the Cupola, the station's panoramic observatory module ... a powerful look inside a black hole—as envisioned by artist Ryoji Ikeda—followed by a journey through a vortex, a reimagined infinity mirror ... and, finally, a return to Earth, the visitor's vision of our planet forever altered. *The Infinite* is one hour of pure wonderment.

A project like this one encompasses many challenges—challenges equal to the dizzying pleasure of having been fortunate enough to play a part in it. An ambitious, far-reaching effort, *The Infinite* is a reflection of its team and of its content—a diverse mix of visions and horizons which, in the end, coalesced into a work of remarkable unity. It is my hope that each visitor will add to that mix their own, personal share of the infinite.

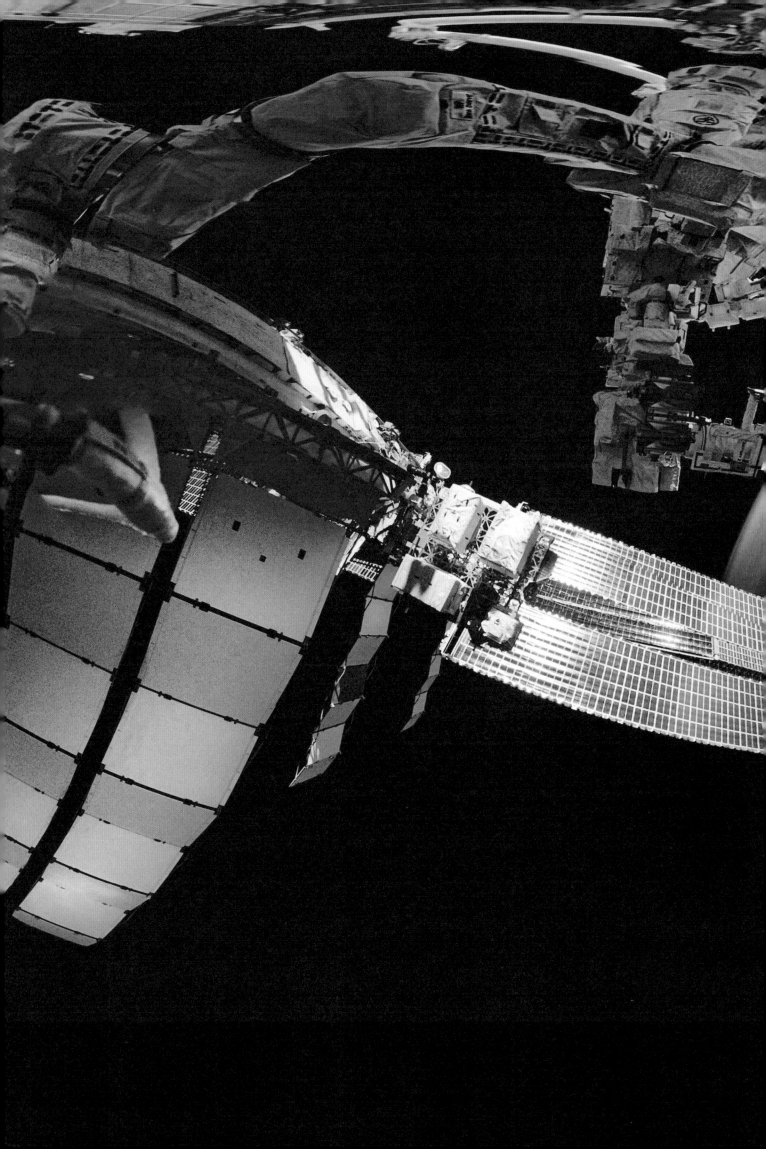

"This sensation of the Sun on your face, the feel of warm air, the sound of rain, is another thing. I miss those Texas thunderstorms in the spring. Just the violence of a really big, exciting thunderstorm. And I look forward to seeing it and the smells that it brings."

—Andrew Morgan

"When we get something fresh, like an orange or an onion or garlic, something very fragrant, it makes all the difference in the world. It's so evocative of a time that we are on the Earth. Naturally, smells are supposed to be some of the most embedded memories. They are capable of evoking memories from a very long time ago. I realize that when I look out the window and I see the Earth, I feel such a sense of longing. I come from an island. I was born at the seaside in the town of Catania, which is right by the sea, and I connect summer and a certain kind of happiness to the warmth of the Sun, the breeze, the smell of salt. That's the special life that you get on certain evenings when the Sun is low, and the shade, the shadows are really long for a long time."

—Luca Parmitano

"When I got back to my house, I spent all the time outside on my porch and in my hammock. Lying in my hammock, I would look up at the leaves and the trees. And you can hear them. You can hear the leaves rustling in the breeze much more so than you've noticed before, because it's just this really distinct, lovely sound that I hadn't heard for a while. And that's actually an image, and a sound, that I've really liked before—even before leaving the planet. I love just looking up at trees. And so, just listening to those leaves rustling was something that was really remarkable to me. And feeling the breeze on your skin is different because, you know, of course inside the Space Station we have ventilation, so you feel the air move across your body. But it's different—that's a constant flow. But when you're outside in the breeze, it's the way that it hits your skin that is entirely different. You know, it comes in this breeze and then dissipates."

—Jessica Meir

"I am going to miss being able to fly everywhere that I go. Being able to push off from one end of the module and fly across to the other end that it connects down to, to the visions and dreams that you had when you were a kid running around a playground and pretending you could fly or dreaming of flying. And to be up here and to be able to make that happen."

—Nick Hague

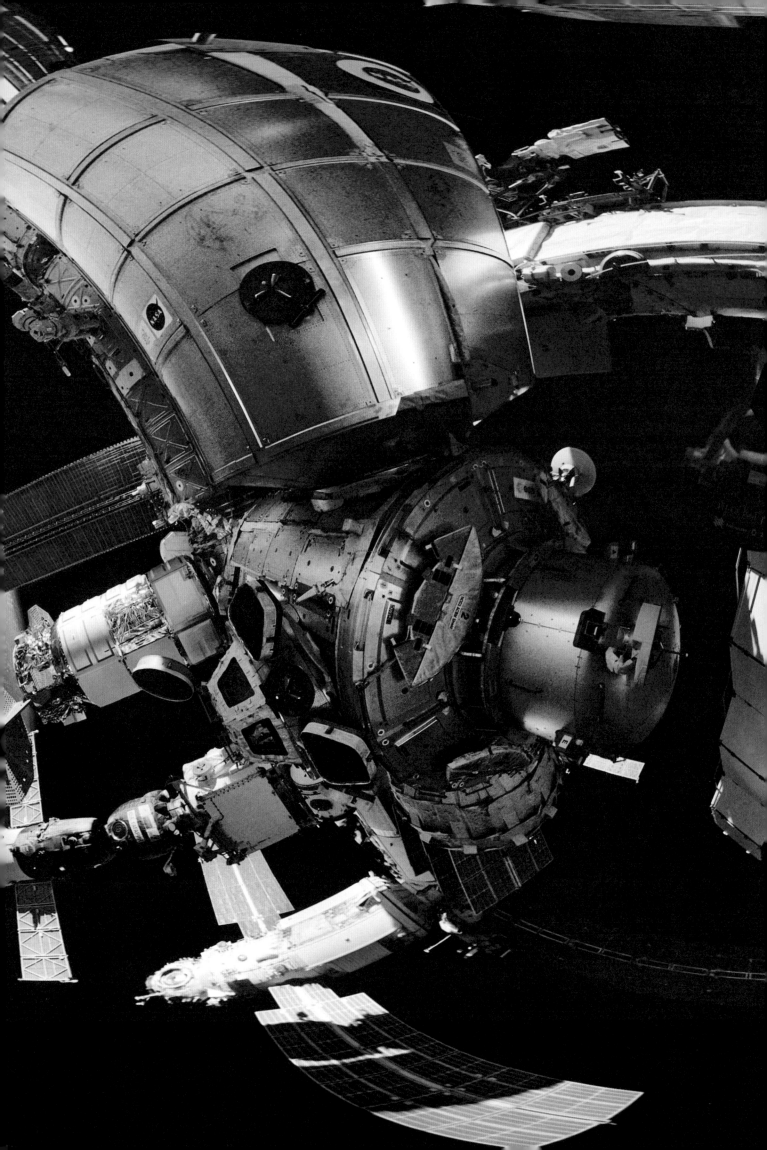

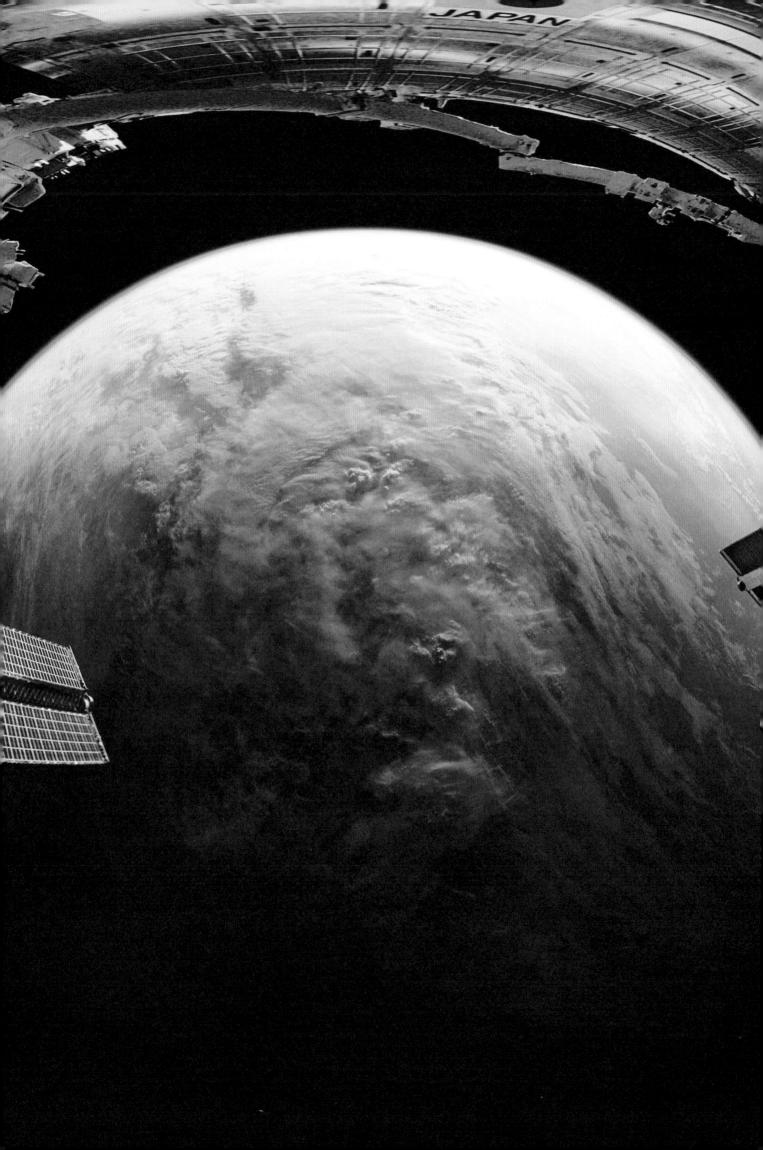

Marie Brassard

Marie Brassard is an author, director and actress. She builds her work on the slopes of our virtual and imagined realities, producing highly innovative pieces of great imagination and maturity that reflect her timeless sense of theatricality and her passionate interest in digital technology.

In 2001, she initiated a solo career, founding her own production company, Infrarouge, and creating her first solo piece, *Jimmy*. This piece was a major turning point in her artistic career, leading to critical acclaim and to continuous touring over many years.

Since then, working in close collaboration with musicians and visual artists, she has created surreal works of theatre that reveal her virtuoso acting skills and highly innovative approach to video, light and sound design. Blending voice and music, and crossing divergent levels of reality, her productions carry the audience into a world in which the lines between private and public or subject and object become blurred—a world in which the relationship between humans and technology becomes as intimate as that between the performer and her audience.

Marie Brassard has lately become more involved with projects related to augmented and virtual reality. She also occasionally works with dance artists and sometimes acts in films. She completed the writing of a film script, titled *The Train*, which she will direct. Production is slated for 2022.

In 2016, she was awarded the Ordre des arts et des lettres du Québec, an honorary distinction highlighting her exceptional contribution to the Quebec artistic community.

Marie Brassard is a singular voice in the theatrical landscape. Her pieces have been presented and warmly received in many countries in the Americas and Europe as well as in Japan and Australia.

Daniel Canty

Daniel Canty is a self-professed "writer, etc." Since the end of the 20th century he has been developing a body of work in which writing lends itself to all manner of metamorphoses: scriptwriting and directing, dramaturgy, creation of books, interfaces, installations, exhibitions, and journeys. His books, for which he often oversees the *mise en livre* (shaping), tend to defy genre categorization. *Sept proses sur la poésie*, on the poetic nature of reality, was published this fall. It follows *La société des grands fonds* (2018), an exploration of the fluid relationships between literature, water, and time, which was a finalist for the Governor General's Literary Awards and the Grand Prix du livre de Montréal. *Mappemonde*, an autofiction essay on the origins of his literary calling, and *VVV*, a geo-poetical atlas of three "transborder odysseys" completed with artist Patrick Beaulieu, were published in 2015. He is also the author of, among other works, the travelogue *Les États-Unis du vent* (2014), the novel *Wigrum* (2011), the serial *Costumes nationaux* (costumesnationaux.com, 2014–2019), and an "auto-science-fiction" series presented in various contemporary art contexts. Daniel travels. He was writer-in-residence at Green College, University of British Columbia, in 2019, and at Passaporta, Brussels, in 2020. He has many projects.

Annabelle Fiset

Annabelle Fiset began her career more than twenty years ago as an advertising art director for accounts including Labatt, the Musée national des beaux-arts du Québec, Les Grands Ballets Canadiens, and the Government of Québec. Looking to connect more closely with the arts & culture milieu, she spent five years with Toast Studio, where she created over thirty poster designs for theatres, art exhibitions, and documentary films. In 2010 Annabelle decided to strike out on her own as a freelance art director. In addition to growing her own client base, she worked with agencies including Sid Lee, Deux Huit Huit, Tuxedo and 45 DEGREES, a division of Cirque du Soleil. During this period her practice encompassed all design disciplines.

She discovered exhibition design in 2015, taking on an art director role with GSM Project in Montreal from 2015 to 2019. Working initially as a freelancer and then full-time, she spent nearly five years on several major exhibition projects, in venues ranging from observation decks to science centers. Notable clients included the Canadian Museum of History, the Burj Khalifa in Dubai, the Cointreau Distillery in France, the Dubai Mall, and the PNB Observation Deck of the Merdeka 188 tower in Kuala Lumpur. In the spring of 2019, Annabelle was named director of the agency's graphic design studio.

Later that year, in December, she joined PHI Studio as its creative director. Her initial assignment was to deliver an exhibition incorporating content from Félix & Paul Studio into a compelling avant-garde immersive experience. *The Infinite* is the largest enterprise that Annabelle has completed so far. The future awaits: as of this writing, she is developing PHI Studio's next major project.

Phoebe Greenberg

Phoebe Greenberg has been a pioneer and innovative cultural force in Montreal for over 20 years. She graduated from L'École Internationale de Théâtre Jacques Lecoq in Paris, a school that emphasizes the body, movement and space as the essence of theatrical performances.

In addition to DHC/ART (now PHI Foundation for Contemporary Art) established in 2007, Greenberg founded PHI Centre in 2012, a multidisciplinary arts organization which offers multiple perspectives of emerging ideas in art and technology. Conceived as a creative ecosystem, PHI Centre prototypes interdisciplinary projects with progressive technologists, musicians, film and VR directors and designers.

Throughout her career, Greenberg has also produced films for such artists as Denis Villeneuve, Godfrey Reggio, and Guy Maddin.

In recent history, Phoebe's attention has been in the realm of contemporary media. The PHI Centre focuses on the exhibition of works along the axis of art and technology, most recently creating installations that travel the world envisioning future generations, storytelling possibilities, and a panoramic perspective of emerging ideas.

Under the direction of Phoebe Greenberg, PHI has produced installations with collaborators such as Félix & Paul Studios, DV and FoST. With her help, PHI has participated in various renowned festivals such as the 76th Biennale of Venice in Italy, Tribeca, and Sundance.

Phoebe Greenberg is the recipient of the order of Quebec and L'ordre des arts et des lettres du Québec.

Ryoji Ikeda

Japan's leading electronic composer and visual artist, Ryoji Ikeda, focuses on the essential characteristics of sound itself and that of visuals as light by means of both mathematical precision and mathematical aesthetics. Ikeda has gained a reputation as one of the few international artists working convincingly across both visual and sonic media. He elaborately orchestrates sound, visuals, materials, physical phenomena, and mathematical notions into immersive live performances and installations. Alongside pure musical activity, Ikeda has been working on long-term projects through live performances, installations, books and CDs.

He performs and exhibits worldwide at spaces such as Museum of Contemporary Art Tokyo, Singapore Art Museum, Ars Electronica Center Linz, Elektra Festival Montreal, Grec and Sonar Festivals Barcelona, Concertgebouw Brugge, The Royal Concertgebouw and Eye Film Museum Amsterdam, Aichi Triennale Nagoya, Palazzo Grassi Venice, Sharjah Biennale, Auckland Triennial, The Whitechapel Gallery London, The Barbican Centre, Festival d'Automne à Paris, La Villette Paris, Centre Pompidou Paris and Shanghai, ACT Center Gwangju (KR), Singapore Art Science Museum, Kunstverein Hannover, Ruhr Triennale, Garage Museum of Contemporary Art Moscow (RU), UCLA Center for the Art of Performance Los Angeles (US), The MET, Crossing the Line Festival New York, as well as Kyoto Experiment (JP), Onassis Cultural Center (Athens, GR), Bi-City Shenzhen Biennale of Urbanism\Architecture (Shenzhen, CN), and Joan Miró Foundation (Barcelona, SP). He has presented solo exhibitions at Park Avenue Armory New York, Museo de Arte Bogotá, Hamburger Bahnhof Berlin, DHC/Art Montreal, Mona Museum Hobart (Tasmania, AU), Telefónica Foundation Madrid, Carriageworks Sydney, HEK Basel (CH), The Vinyl Factory London, Centre Pompidou Paris, and Taipei Fine Arts Museum, among others.

He launched *spectra* as a permanent installation at Mona (Tasmania, AU) in 2018, and *data.scape* at Moriarty Walk, Darling Harbour (Sydney, AU) in 2016. Ikeda's new audiovisual work, *data-verse*, is a commission by Audemars Piguet Contemporary. The first variation of the trilogy was revealed at Venice Biennale 2019: *May You Live in Interesting Times* curated by Ralph Rugoff. In 2020–21, Ikeda presents works at UCCA Beijing (CN) and a major solo exhibition at 180 The Strand London (UK). He is currently working on a permanent work commissioned by Grand Paris for the new subway station Pont de Sèvres (Paris, FR; architect: Henri Dutilleux).

He is the recipient of the Prix Ars Electronica Collide@CERN 2014.

Ryoji Ikeda is represented by Almine Rech Gallery (Brussels, Paris, London, New York, Shanghai) and Taro Nasu Gallery (Tokyo).

Edwin Janzen

Edwin Janzen is a writer, editor, and visual artist living and working in Montreal. With a focus on the history and culture of the Cold War, his art practice is peripatetic and freewheeling, and is animated by the era's exuberant popular culture and modernist utopian visions—on both sides of the Iron Curtain. Janzen works in installation, digital printmaking, video, drawing, artist books, and other media. He completed an MFA at the University of Ottawa in 2010, and holds bachelor's degrees in studio art (Concordia University, 2008) and Byzantine history (University of Manitoba, 1993). Janzen has published in *Canadian Art*, *Border Crossings*, *Espace art actuel*, and other titles, and has written and edited for dozens of individual and institutional clients. He is currently in the grip of a somewhat obsessive fan-writing project focused on *The Wire*, HBO's classic critical drama on the neoliberal American city.

Jeffrey Kluger

Jeffrey Kluger is editor at large for *TIME* magazine and the author or coauthor of twelve books, including *Apollo 13*, *Apollo 8*, and the new novel *Holdout*. He has written more than forty cover stories for *TIME* on topics ranging from space to human behavior to climate to medicine. Along with others at *TIME*, Kluger won an Emmy for the Web series *A Year in Space*. He consulted on and appeared in the Tom Hanks movie *Apollo 13*.

Ariane Koek

Ariane Koek is an acknowledged international expert and pioneer in the field of arts, science and technology, and artists' residencies. Ariane initiated, designed, and directed the acclaimed Arts at CERN program 2009–2015 at the world's largest particle physics laboratory outside Geneva, Switzerland. Today she works worldwide as an independent strategic advisor, creative partner, and consultant on many new high-profile initiatives, such as the new Cavendish Arts Science program at Cambridge University, UK, as well as working with established organizations seeking new cultural directions, such as The Exploratorium, San Francisco, USA and the European Commission's environmental scientific research and policy laboratories known as the Joint Research Centre. She also works extensively as both a curator and writer. She is one of the creative directors of the Official Italian Virtual Pavilion, CityX Venice at the Venice Biennale for Architecture 2021 and the co-curator of *Real Feelings: Emotion and Techology*, first shown at HEK, Basel, Switzerland in 2020 and at MU Hybrid House, Eindhoven, Netherlands in 2021.

Félix Lajeunesse

A visionary creator with a keen eye for detail and sustained emotional focus, Félix Lajeunesse crafts immersive and interactive experiences that are rooted in connection: viewers feel deeply moved by the places and people they see and hear, and find themselves completely involved in the moment. Throughout his career, Félix has fused that sense of immediacy with a spirit of exploration to bring the creative possibilities of immersive entertainment to audiences through a variety of media that forge new frontiers in cinematic storytelling. Since co-founding Felix & Paul Studios in 2013, Félix has directed and co-directed most of the studio's 30 immersive experiences to date. These include the Emmy Award-winning interactive feature *The People's House* with President Barack Obama, the original VR fiction/feature experience *Miyubi* starring Jeff Goldblum, and the *Space Explorers* series in collaboration with NASA. Félix also shares his knowledge and expertise with a bold new generation of creators including Oscar-winning director Roger Ross Williams on *Traveling While Black*, NFB/Clyde Henry Productions on *Gymnasia*, and the team at TIME Studios on the latest season of *Space Explorers* entitled *The ISS Experience*. Whether leading the creative team at Felix & Paul Studios, directing or producing, Félix Lajeunesse continues to push the boundaries of interactive storytelling while charting a new course for presence-based, emotionally powerful artistic entertainment.

Paul Raphaël

An immersive entertainment revolutionary, Paul Raphaël combines creative and technological innovation to design ever-evolving forms of storytelling. The Emmy Award-winning filmmaker, visual artist, director, and studio head is known for his projects' remarkable sense of presence and ingenuity. He's enhanced how viewers consciously and personally connect with an experience, creating incredibly lifelike, emotionally authentic worlds through the technologies of VR, AR, and MR. In a decade-long collaboration with his Felix & Paul Studios co-founder Félix Lajeunesse, he designed the camera technologies that brought the duo's concepts to life. Together they created the first ever cinematic VR experience, *Strangers* with Patrick Watson, the project that launched Felix & Paul Studios in 2013. Since then, Paul has co-directed and overseen the creative direction of the studio's 21 projects, including the Emmy Award-winning interactive feature *The People's House* with President Barack Obama, the original VR fiction-feature experience *Miyubi*, and the documentary series *Space Explorers* in collaboration with NASA. He's brought his expertise to recent co-productions such as Roger Ross Williams' Oscar-winning *Traveling While Black* and NFB/Clyde Henry Productions' *Gymnasia*, and is working with TIME on the latest filming of *Space Explorers* aboard the International Space Station, using Felix & Paul Studios' specialized cameras. Spurring the evolution of storytelling as an interactive experience, Paul works closely with expanded technical teams and creative partners to lead Felix & Paul Studios into an elevated future of immersive entertainment.

Tracy Valcourt

Tracy Valcourt is a PhD candidate (Humanities) at Concordia University in Montreal. Her research interrogates aerial perspectives of landscape and their contribution to the formation of world-views that both represent and support top-down power structures. For the past fifteen years, Tracy has been a frequent contributor to *Border Crossings: A Magazine for the Arts*. In 2018, she co-authored a chapter with Dr. Sebastien Caquard (Concordia) entitled "From Earthrise to Google Earth: The Vanishing of the Vanishing Point" in *Artistic Approaches to Cultural Mapping: Activating Imaginaries and Means of Knowing* (Routledge). Recent publications include essays on Julie Mehretu and Bharti Kehr in a PHI publication accompanying the exhibition *Relations: Painting and Diaspora*, and the introductory essay to the exhibition catalogue for *Domestic Fetishes* by artist Susan Andrews Grace.

TIME Studios

From one of the most globally iconic brands, TIME Studios is an Emmy Award-winning television, film, and immersive studio focusing on the development, production, and distribution of truth-based premium unscripted and scripted premium storytelling that moves the world. With technical innovation and a brand defining visual language that dates back 98 years, TIME Studios aims to impact communities and the world at large with ideas that forge true progress. Combining the industry's leading creators with TIME, one of the most trusted brands that reaches an audience of over 100 million people globally, TIME Studios is uniquely positioned to bring massive audiences to the world's most impactful stories. Recent projects include *Black Gold* (Paramount+), *Big Vape* (Netflix), *John Lewis: Good Trouble* (CNN Films), *Amazing Grace* (Neon), *Right to Offend* (A&E), *Ricky Powell: The Individualist* (Showtime), *Kid of the Year* (Nickelodeon/CBS), *TIME 100* (ABC), the first scripted project for TIME Studios, *Women of the Year* (Amazon) and the Primetime Emmy-nominated project *Space Explorers: The ISS Experience* (distributed in 360-Mobile format through 5G carriers, virtual reality headsets, and in select Domes and planetariums).

THE INFINITE

Created and produced by
Infinity Experience

A joint venture between
Felix & Paul Studios
and PHI Studio

In collaboration with
TIME Studios

ARTISTS

Conception and scenarization
Phoebe Greenberg
Félix Lajeunesse
Paul Raphaël
Marie Brassard

Creative Director
Annabelle Fiset

Guest Artist
(concept and composition)
Ryoji Ikeda

EXECUTIVE LEADERSHIP

Executive Producers
Eric Albert
Stéphane Rituit

Producer
Julie Tremblay

Chief Technology Officer
Pierre Blaizeau

Chief Financial Officer
Marie-Chantal Ménard

INTERACTIVE AND
CINEMATOGRAPHIC VR

Creative and Artistic Directors
Félix Lajeunesse
Paul Raphaël

Head of Experience
Rustle Hill

Experience Producer
Coline Delbaere

Technical Project Managers
Noémie Forestier
Mathieu Désert

Editorial Support
Jimmy Hayes
François Beaupré-Goulet
Simon-Emmanuel Roux
Charles Tranquille

Head of Post-Production
Jacques Levesque

Post-Production Producers
Eléonore Tuvache
Joëlle Boulianne

Cinematographic
Post-Production Manager
Liliane Hudecova

3D Generalist
Kim Fredette
Ran Sieradzki

Unreal Technical Director
Tanya Desjardins de Libero

Unreal Developers
Alex Quevillon
Chris Goossen
David Lapointe
Vincent Bilodeau

Interactive VR Technologist
· **Thomas Azoug**

System Lead Developer
· **Stéphane Goyette**

Lead R&D
· **Florent Cohen**

Lead QA
· **Kevon Romain**

Immersive Audio and Music
Supervision
· **Headspace Studio**

Sound Supervisor
· **Jean-Pascal Beaudoin**

Lead Technical Sound Designer
· **Viktor Phoenix**

Sound Design
· **Mike Ritchie**
· **Jean-Pascal Beaudoin**

Composer
· **Frederic Begin**

Foley
· **Vincent Fliniaux**

VR OPERATIONS

Technology Director
· **Marc-André Nadeau**

VR Operations Coordinator
· **Joël Guerin-Simard**

Monitoring System Developer
· **Thomas Azoug**

Monitoring interface provided by
· **Logient**

Visitor Experience Manager
· **Nancy Hameder**

VR Technicians
· **Jeremy Felker**
· **Jonathan Hardy**
· **Dominic Pagé**
· **Madison Dinelle**
· **Samuel Comtois**

SCENOGRAPHY

Scenographer
· **Laurent Monnier**

Video Artist (Vortex)
· **George Fok**

Computer graphics and programming
(for Ryoji Ikeda):
· **Norimichi Hirakawa, Ryo Shiraki,**
Tomonaga Tokuyama

Light Designer
· **Etienne Boucher**

Production Managers
· **Valérie Gareau**
· **Isabelle Brodeur**

Production Coordinator
· **Laurence Dupont**

Technical Directors
· **Nicolas Jobin**
· **Sylvain Tessier**

Assistant Technical Director
· **Michael Lefebvre**

Sound Technical Director
· **David Simard**

Multimedia Consultant
· **Erick Villeneuve**

UV Station Developer
and Technical Procurement
· **Frédéric Segard**

Construction provided by
· **Scène Éthique**

Thanks to our set
fabrication collaborators
· **Raphael Brien Bannière**
Gréage et Structure Inc
· **Robocut**
· **Sollertia**
· **Studio Artefact**

Technical equipment provided by
· **Ambiofonik**
· **Creative Lab**
· **Espace 3D**
· **LSM**
· **Show Distribution**

Technical integration provided by
· **Élévation**

MARKETING

Marketing Director
· **Scarlett Martinez**
· **Joanne Filion**

Marketing Strategist & Lead
· **Joanne Tremblay**
· **Anil Pereira**
· **Marie-Noëlle Caron**

Content Marketing Manager
· **Claudia Guerra**

Marketing Producer
· **Sarah Rochefort**

Public Relations
· **Myriam Achard**

Public Relations & Marketing
Project Manager
· **Pierre-Olivier Marinier Leseize**

Artistic Director
· **Michel Ouellette**

Communications Agent
· **Andrew Gray**

THE INFINITE
is based on the production Space
Explorers: The ISS Experience

Written & Directed by
· **Félix Lajeunesse and Paul Raphaël**

Produced by
· **Felix & Paul Studios**
in association with TIME Studios

Executive Producers
· **Stéphane Rituit**
· **Jonathan Woods**
· **Mia Tramz**
· **Clàudia Prat**
· **Ian Orefice**
· **Ryan Horrigan**

VR Technology Platform
· **Felix & Paul Studios**

VR Camera Technology
· **Felix & Paul Studios**

VR Camera Technology
· **Felix & Paul Studios**
· **Z-Cam**

ISS Payload Developer
· **Nanoracks**

Produced with the participation of
· **ISS U.S. National Laboratory**
· **NASA**
· **Canadian Space Agency**
· **European Space Agency**
· **Japanese Aerospace Exploration**
Agency
· **ROSCOSMOS State Corporation for**
Space Activities
· **Mohammed Bin Rashid Space**
Centre

VR HARDWARE TECHNOLOGY

Chief Technology Officer
& Creative Partner
· **Sebastian Sylwan**

Director of Technology
· **Pierre Blaizeau**

Head of VR Camera Division
· **Olivier Deschênes-Biron**

Head of Space Technology
· **Stéphane Ruel**

VR Camera Specialists
· **Simon-Benoit Boisvert**
· **Mathieu Gibeault**
· **Martin Gros**

Software Lead Developer
· **Alan Fregtman**

Software Developers
· **Olivier Nadeau Séguin**
· **Philippe Therrien**

Application Developer
· **Kirsty Ellis**

Network and System Specialist
· **Greg Dickie**

Data Manager
· **Guillaume Mailhot-Sabourin**

Technical Imaging Technicians
· **Rosemonde Presset**
· **Georges Rafie**

Camera Senior Systems Designer
· **Howard Burman**

Senior Project Manager
· **Mathieu Désert**

172

LINE PRODUCTION
Sailor Productions

Executive Producer
· **Mathieu Dumont**

Producer / First Assistant Director
· **Sinan Saber**

Production Coordinator
· **Joelle Raymond**

POST-PRODUCTION

Head of Post-Production
· **Jacques Levesque**

Producers
· **Eléonore Tuvache**
· **Joëlle Boulianne**

Production Manager
· **Liliane Hudecova**

Editor
· **Jimmy Hayes**

Assistant Editors
· **François Beaupré Goulet**
· **Charles Tranquille**

Technical Manager
· **Guillaume Mailichier**

Lead Compositor
· **Jérémy Bazin**

Compositors
· **Artiom Kusci**
· **Lex Millena**
· **Charles Tranquille**
· **Joanna Johnson**
· **Matthew Chan**
· **Pratik Kalani**
· **Ryan Kilbane**
· **Jiajia Lim**
· **Colin Dorssers**
· **Sheetal Meshram**

Lead Roto
· **Lucas Pascale-Pallotta**

DI services
· **MELS studios**

Colorists
· **Patrice Fortin**
· **Marc Lussier**

SOUND & MUSIC
Headspace Studio

Sound and Music Supervisor
· **Jean-Pascal Beaudoin**

Editing, Sound Design and Mix
· **Michael Ritchie**
· **Jean-Pascal Beaudoin**

Composer
· **Frederic Begin**

VR SOFTWARE TECHNOLOGY

Head of Core Technologies Group
· **Florent Cohen**

Lead Developer
· **Stéphane Goyette**

Head of Pipeline
· **Hans Payer**

Vision Developers
· **Mostafa Heydari**
· **Sébastien Gemme**

Application Developers
· **David Lapointe**
· **Kirsty Ellis**
· **Jonathan Rodriguez**
· **Rudy Zarrouk**

Core Tech Intern
· **Charles Jobin Fauve**

Developers
· **Vincent Bilodeau**
· **Alex Quevillon**

Project Manager
· **Noémie Forestier**

3D Generalist
· **Kim Fredette**

Unreal Technical Director
· **Tanya Desjardins De Libero**

Head of Interactivity
· **Rustle Hill**

Art Director
· **Ran Sieradzki**

Pipeline Developers
· **Alexis Gervais-Chapleau**
· **Sara Hilmarsdottir**
· **Louise Péquignot**

Senior Researcher
· **Ian Cavén**

Senior Software Engineer
· **Chris Goosen**

System Engineer
· **Andrew Keenan**

Senior Generalist Programmer
· **Éric Desjardins**

Integration Developers
· **Donavan Prieur**

Lead QA
· **Kevon Romain**

Head of IT
· **Jasmin Lévesque**

Systems Administrators
· **Andres Ahumada**
· **Christophe Langlois**

Accounting Manager
· **Julie Migneault**

Analyst and Production Accountant
· **Francis Robitaille**

Corporate Accountant
· **Lysanne Bourgouin**

Accounting Clerk
· **Karine Viens**

Senior Manager, Marketing
Communications
· **Marie-Noëlle Caron**

Marketing Coordinator
· **Marcia Griffith**

Business Development Director
· **Mikael Chagnon**

Business Development Manager
· **Marie-Noëlle Gauthier**

Creative Strategist
· **Simon Emmanuel Roux**

Content & Script Researcher
· **Caroline Lavergne**

Corporate Human Resources Manager
· **Jérémie Héroux Hamelin**

Receptionist/Studios Coordinator
· **Evelyne Morissette**

NASA

JOHNSON SPACE CENTER

ISS Increment Deputy Manager
· **Frank Acevedo**

Strategic Communications Group
· **Gordon Andrews**

Science Communications Integrator
· **Rachel Barry**

Mission Systems Operations
Contract – Voice Services
· **Derrick Bell**

Joint Cargo Certification Team
· **Elizabeth Bauer**

CK3 – Flight Operations
Directorate Payloads
· **Terri Bauer**

ISS Plug-in Plan
· **Tim Bishop**

Lead Increment Scientist
· **Vic Cooley**

OP / Imagery
· **Rebecca Difard**

Public Affairs Specialist
· **Brandi Dean**

OD – Payload Software
Integration Engineer
· **Tony DeLa Cruz**

ISS Avionics
· **Daniel Duncavage**

ISS Joint Station LAN
· **Tremayne Dillard**

OP/MAPI – Joint Cargo
Certification Team
· **Rick Fisher**

EVA Office
· **Dave Foltz**

OC411 – Imagery Working
Group Chair
· **Carlos Fontanot**

Human Factors
Implementation Team
· **Pamela Fournier**

FOD – Crew Office
· **Juan Galvez**

Systems Engineer/
Television Operations
· **Daniel Gates**

Imagery Working Group
· **Chris Getteau**

ISS Payload Topology Lead
· **Craig Gordon**

Increment Deputy Manager
· **Kevin Hames**

Mission Systems Operations
Contract – Voice Services
· **Jamie Hampton**

Public Affairs Specialist
· **Dan Huot**

Crew Earth Observations
· **Amy Jagge**

Mission Systems Operations
Contract – Voice Services Lead
· **Gary Kahn**

Mission Imagery Operations Lead
· **Steve Knarr**

OD – Payload Software
Integration Engineer
· **Darrell Lee**

Increment Deputy /
Payload Manager
· **Lisa Leech**

FOD – Plug-in Port Utilization Officer
· **Michael Lyle**

OX111 – ISS Communications Team
· **Dylan Mathis**

FOD – Crew Office
· **John McBrine**

ISS Plug-in Plan
· **Kevin Moore**

OZ – Research Portfolio Manager
· **Ken Neiss**

FOD – Orbital Communications
Adapter (OCA) Officer
· **Michelle Nowling**

ISS Avionics
· **Don Parrott**

IP/OX – International
Partners Integration
· **Kelle Pido**

ISS Payload Topology Lead
· **Sarah Roach**

OC VV Int. Rep.
· **Katie Rogers**

ISS Research Video Producer
· **Nicole Rose**

SA – Safety Panel Engineer
· **Daniel Mendez**

SA – Safety Panel Engineer
· **Michael G. Sheehan**

Systems Technician –
Television Operations
· **Joseph Simon**

Lead Increment Scientist
· **Jorge Sotomayor**

Systems Technician –
Television Operations
· **Keith Stevens**

ERO Multimedia Supervisor
· **John Stoll**

Mission Systems Operations
Contract – Voice Services
· **Eugene Susco**

OZ – Payload Integration Manager
· **Philip Vourganas**

CK3 – Flight Operations
Directorate Payloads
· **Scott Weinstein**

ISS Avionics
· **Betsy Walker**

OB – Payload Integration
Requirements Engineer
· **Jennifer Wells**

SA – Lead (for DMC)
· **Katie West**

Mission Video
· **Maura White**

Flight Operations
Directorate Payloads
· **Katrina Willoughby**

VR / ROBO
· **Michael Wright**

ISS Program Science Office
· **Diana Garcia**

Joint Cargo Certification Team
· **Carrie Reddy**

NASA Video Producer
· **Mitch Youts**

MARSHALL SPACE
FLIGHT CENTER

Special Operations Controller
· **Nick Kopp**

POIC – Safety
· **Austin Lee**

POIC – Payload Activity
Requirements Coordinator
· **Monica Paceley**

POIC – Payloads Operations Director
· **Christy Robertson**

POIC – Operations Controller
· **Adam Thurmond**

POIC – Safety
· **Bailey Young**

NANORACKS

Operations Controller
· **Andy Bronshteyn**

Avionics Engineer
· **Anna Tierney**

Safety Manager
· **Bob Alexander**

Avionics Technician
· **Bobby Dickerson**

Avionics Engineer
· **Caleb Daugherty**

Mechanical Technician
· **Clint Middleton**

Program Manager
· **Conor Brown**

System Safety Engineer
· **Dana Gomez**

Quality Assurance Manager
· **Dave Elmore**

Systems Verification Engineer
· **David DeLeon**

Avionics Technician
· **Donte Brooks**

Avionics Technician
· **Falanne Jenkins**

Operations Controller
· **Jerry Mathew**

Aerospace Engineer
· **Jordan Lombardo**

Lead Mechanical Designer
· **Joseph Kissling**

Operations Controller
· **Joseph Padish**

Operations Manager
· **Keith Tran**

Thermal Engineer
· **Levi Grinestaff**

Inventory Management
· **Mark Millican**

Project Manager
· **Monikka Mann**

Avionics Technician
· **Romeo Sanchez**

Software Engineer
· **Ryan Sharpe**

Procurement
· **Soum Sarkar**

Director of Engineering
· **Steve Stenzel**

Images of Jerrie Cobb
· **Interview with Jerrie Cobb by
 Paul Soles, September 16, 1963,
 Take 30 CBC
 Source: Archives CBC /
 Radio-Canada**

Footage of Mission – Apollo 11
from the movie *Apollo 11*
· **NEON**
· **Moon Collectors, LLC**

AUTHORS
Marie Brassard
Daniel Canty
Annabelle Fiset
Phoebe Greenberg
Ryoji Ikeda
Edwin Janzen
Jeffrey Kluger
Ariane Koek
Félix Lajeunesse & Paul Raphaël
TIME Studios
Tracy Valcourt

PUBLICATION
PUBLISHER

Hirmer Verlag
Bayerstraße 57–59
80335 Munich, Germany
www.hirmerpublishers.com

Infinity Experiences Inc.
407, rue Saint-Pierre
Montréal, Québec
H2Y 2M3
Canada

CO-EDITORS
Marie Brassard, Phoebe Greenberg

MANAGING EDITOR
Jon Knowles

PROJECT MANAGER
Sarah Rochefort

COPYEDITING
Nathalie de Blois
Claudia Guerra
Oana Avasilichioaei
Luba Markovskaia
Edwin Janzen

TRANSLATION
Michael Gilson
Daniel Canty

PROOFREADING
Mike Pilewski

LEGAL
Stephane Moraille

DISTRIBUTION
Hirmer Publishers

GRAPHIC AND EDITORIAL DESIGN
FEED

PREPRESS PRODUCTION
AND COORDINATION
Rainer Arnold
Hannes Halder

TYPEFACE
Phi and Phi Caption,
designed by Feedtype as part
of Phi's brand identity

PAPER
Tauro Offset 140 g/sqm

COVER
1/0 PMS metallic silver on Peyprint
Shantung with blue foil (KURTZ foil
colorit #902) debossing on the front,
the spine and the back.

LITHOGRAPHY
Reproline Mediateam
Unterföhring, Germany

PRINTING AND BINDING
Printer Trento s.r.l.
Printed in Italy

ISBN
978-3-7774-3767-5

BIBLIOGRAPHIC INFORMATION

Legal deposit, 2022
Bibliothèque et archives nationales
du Québec
Library and Archives Canada

Bibliographic information published
by the Deutsche Nationalbibliothek
The Deutsche Nationalbibliothek
lists this publication in the Deutsche
Nationalbibliografie; detailed
bibliographic data is available on the
Internet at http://www.dnb.de.

4.42675534644508	-2.14120627784902	5.87289250389828	14T06:04:00.000	-3153.520505454300	-5216.126056491270	-3018.114127351190	3.28489869583737	-4.83823027846478
4.78022561209388	-0.10870431885791	5.98682216241148	14T06:08:00.000	-2260.286834582450	-6173.965894534120	-1736.939354351770	4.11357437817195	-3.09468184388080
4.78612689786856	1.93291381716897	5.66400214330495	14T06:12:00.000	-1202.893382372640	-6683.344289358620	-329.263088986522	4.64437153766202	-1.12387175218350
4.44382353677764	3.83399275197529	4.92791364437762	14T06:16:00.000	-58.046198106501	-6706.732744996350	1102.405050887220	4.83778437105545	0.93035766596005
3.77844832537553	5.45553395495240	3.83267064428952	14T06:20:00.000	1091.017557913420	-6242.152782730060	2453.627435523640	4.67925716848276	2.91750330079463
2.83880696164529	6.67952742553240	2.45869979172936	14T06:24:00.000	2160.699147127920	-5323.387504440650	3625.812077820690	4.18035191762713	4.69198624252622
1.69352097810671	7.41756946984585	0.90642969698694	14T06:28:00.000	3073.232137320400	-4017.438162090450	4533.537269914650	3.37775765818855	6.12434732950320
0.42566128965542	7.61672160812687	-0.71127624227090	14T06:32:00.000	3762.380902455450	-2419.462332860540	5110.801467842070	2.33022553932021	7.11079234550302
-0.87302354526343	7.26274242110687	-2.27707472910464	14T06:36:00.000	4178.212291210890	-645.714967277598	5315.738889182570	1.11399339094220	7.58028169696941
-2.10848792903750	6.38122738931528	-3.67725723071647	14T06:40:00.000	4290.637331902640	1174.924307665950	5133.564276900610	-0.18280682008313	7.49924456617902
-3.19108825581267	5.03594485060858	-4.80989902586710	14T06:44:00.000	4091.521633638230	2910.255582818520	4577.585335472940	-1.46641978562363	6.87368486111660
-4.04200557830549	3.32459976559529	-5.59226689521154	14T06:48:00.000	3595.269812131260	4434.245380992800	3688.239865825360	-2.64385608142182	5.74874711650672
-4.59917535085730	1.37204347453591	-5.96712954918700	14T06:52:00.000	2837.851543198850	5636.138546727900	2530.229976167300	-3.62949187224505	4.20591060703845
-4.82213554976719	-0.67897203027604	-5.90736932787730	14T06:56:00.000	1874.258847224590	6426.576909673730	1187.883362918700	-4.35145696513813	2.35752007124045
-4.69515614749006	-2.67869320077881	-5.41805907680325	14T07:00:00.000	774.517099621495	6754.073142374740	-240.996174433792	-4.75714896192977	0.33861386423339
-4.22826214460576	-4.48186751603250	-4.53582228730442	14T07:04:00.000	-381.463065917910	6589.273105066910	-1652.343541665640	-4.81733144641124	-1.70323127179663
-3.45610520459269	-5.95847111656187	-3.32568381617424	14T07:08:00.000	-1509.796966660550	5946.614923801090	-2943.541637911230	-4.52830922695434	-3.61925809316658
-2.43501708180720	-7.00291631522614	-1.87582387719752	14T07:12:00.000	-2528.798092466500	4873.242869070550	-4020.959621047800	-3.91191094532470	-5.27079520661712
-1.23865690199903	-7.54098770848938	-0.29092630052453	14T07:16:00.000	-3364.895403193890	3447.351351000040	-4806.713552119940	-3.01344364756936	-6.53930384749773
0.04725589271108	-7.53445015871913	1.31518995866334	14T07:20:00.000	-3957.853564596840	1772.339680114200	-5244.157209813170	-1.89801113991259	-7.33441462336240
1.33073488727259	-6.98330769198901	2.82722732020461	14T07:24:00.000	-4264.967588878320	-30.676091150300	-5301.782742355960	-0.64572901639074	-7.59963523777240
2.51958658581503	-5.92601001618362	4.13606319578029	14T07:28:00.000	-4264.014396301880	-1831.459987378970	-4975.366363916450	0.65379760221484	-7.31584165646765
3.52769174902782	-4.43739146931321	5.14631057550540	14T07:32:00.000	-3954.823825899240	-3499.820944007460	-4288.277014474830	1.90742596307065	-6.50257690424463
4.28121721276560	-2.62425612263701	5.78339329965833	14T07:36:00.000	-3359.378379289620	-4914.826854127730	-3289.923416676960	3.02475297575152	-5.21708975005745
4.72447050037168	-0.61812094337060	5.99964219987476	14T07:40:00.000	-2520.392578990330	-5973.496070082730	-2052.389734087000	3.92445607779498	-3.55096495732251
4.82435518567192	1.43447003782953	5.77833588345689	14T07:44:00.000	-1498.403877551540	-6598.398465366820	-665.414249802495	4.54029304764795	-1.62437754592348
4.57322072608128	3.38302822252235	5.13535484667975	14T07:48:00.000	-367.489707355107	-6743.567502637120	770.060950646023	4.82648067388819	0.42226166269937
3.98951168250908	5.08491077875300	4.11796934393690	14T07:52:00.000	790.150400711459	-6398.109385542560	2149.338094087400	4.76159164826364	2.43901494971312
3.11611736736819	6.41617523669810	2.80095156015419	14T07:56:00.000	1890.292089690760	-5587.092663645300	3371.768137791200	4.35028855576481	4.27807310155298
2.01683974443495	7.28043840335868	1.28062567992436	14T08:00:00.000	2852.934855489450	-4369.657178524400	4348.233703510120	3.62283644775123	5.80513377421294
0.77161121790209	7.61558330361882	-0.33225710822917	14T08:04:00.000	3608.174942388460	-2834.540240725270	5007.691958770850	2.63253542471799	6.90934365572147
-0.52948044251117	7.39773420010976	-1.92068847484896	14T08:08:00.000	4101.261716366400	-1093.470406468820	5302.288566946230	1.45156086137059	7.51105706735207
-1.79230263732211	6.64260832807864	-3.36944228283965	14T08:12:00.000	4296.504292967520	727.014196578658	5210.730867723990	0.16558646769226	7.56717318854422
-2.92523109828834	5.40474966093469	-4.57309876628164	14T08:16:00.000	4179.783326586330	2494.709271871770	4739.749117120150	-1.13235403670612	7.07382603348695
-3.84583513140039	3.77400029525529	-5.44380033039164	14T08:20:00.000	3759.548174849990	4081.246303385110	3923.610943208200	-2.34830884921364	6.06667305100277
-4.48698093477963	1.86920696613037	-5.91785606263392	14T08:24:00.000	3066.250568096690	5371.353510690930	2821.688840796470	-3.39397633701159	4.61861977031592
-4.80201751617022	-0.17039500243298	-5.96076628416414	14T08:28:00.000	2150.205090784970	6271.268473555530	1514.208647107520	-4.19317528826974	2.83496291592156
-4.78840813378898	-2.19579081853742	-5.57001711134803	14T08:32:00.000	1077.965861617180	6715.663525202830	96.423442999566	-4.68763887772117	0.84591271915951
-4.38933823882430	-4.05960651068867	-4.77503103834437	14T08:36:00.000	-72.550252549064	6672.495715933960	-1328.395837499900	-4.84155916615960	-1.20313259291010
-3.69316685770651	-5.62720002766999	-3.63459618881061	14T08:40:00.000	-1217.821719091920	6145.338200126950	-2656.605614888000	-4.64433519643941	-3.16270210567830
-2.73084635661446	-6.78627943770910	-2.23199778267850	14T08:44:00.000	-2274.887639508870	5172.9681175118250	-3791.831832571340	-4.11113086278077	-4.89074901031628
-1.57194474866481	-7.45436893103116	-0.66869245206174	14T08:48:00.000	-3167.380286426120	3826.315204196240	-4651.956788360960	-3.28132666075544	-6.26298106678063
-0.29959325710973	-7.58400305916808	0.94293830392433	14T08:52:00.000	-3830.978310776590	2203.121170541880	-5174.943895269300	-2.21524268958764	-7.18150936416786

4071.725074928050	-3103.977434447420	-4479.846379061810	1.58460570450607	-6.74749545745061	3.24087278099672	14T12:04:00.000	-4306.423934783600	-498.420930889818	-5
3548.641024386020	-4591.430335672030	-3548.862914613880	2.74823943697322	-5.57229475924327	4.47035736139189	14T12:08:00.000	-4242.805760672140	-2274.572019402290	-4
2768.399954001650	-5746.115939199490	-2359.985485210320	3.71445623729273	-3.99106965663057	5.37671890323188	14T12:12:00.000	-3872.393920943950	-3886.225631488080	-4
1787.218446702210	-6483.696795624780	-999.333804093524	4.41236009418748	-2.11751522184996	5.89282943503697	14T12:16:00.000	-3221.569620863930	-5216.426480762030	-2
-676.138175300406	-6749.995943353610	434.152205305117	4.79017200756635	-0.08779246036785	5.97975466043126	14T12:20:00.000	-2337.088900609050	-6168.235235347710	-1
484.125846182682	-6525.230480971170	1835.952524728870	4.81963189439131	1.94948985003664	5.63033564272993	14T12:24:00.000	-1282.857462286150	-6671.957448690060	
1609.157163974730	-5825.615955769120	3103.761661422620	4.49836899403862	3.84493818975925	4.87004739689443	14T12:28:00.000	-135.343739653428	-6690.485845999240	
2617.113292379570	-4702.155727579720	4145.113011274070	3.85004064509167	5.45990941845715	3.75485282310463	14T12:32:00.000	1022.024890310550	-6222.193785506810	2
3434.766758106830	-3236.769928352150	4884.198142182750	2.92226219238181	6.67699305292757	2.36665143137101	14T12:36:00.000	2105.036445596550	-5301.139318175180	3
4002.818481152610	-1536.157101526680	5267.344490654870	1.78272831982890	7.40828972461249	0.80684020863150	14T12:40:00.000	3034.952039952380	-3994.493948805680	4
4280.128897536190	276.039609961760	5266.819063518120	0.51416060801968	7.60127552719904	-0.81111797722236	14T12:44:00.000	3744.266655282060	-2397.468134328990	5
4246.634023875840	2068.191367068030	4882.759212428330	-0.79158954250806	7.24229023271409	-2.36983111995066	14T12:48:00.000	4181.570702841820	-626.260786774465	5
3904.761396392460	3710.154742171310	4143.121601016470	-2.04002188220247	6.35728857644438	-3.75617956265733	14T12:52:00.000	4315.209799688920	1190.428006564650	5
3279.284564941340	5082.641673964960	3101.710182127280	-3.14054148605137	5.01031395263854	-4.86922115008099	14T12:56:00.000	4135.511694736890	2920.676515037240	3
2415.588994424840	6085.901780115610	1834.332022377550	-4.01302372429072	3.29920364713447	-5.62767329023127	14T13:00:00.000	3655.490828953000	4438.816782789510	3
1376.422855509770	6647.068385146600	433.311683969464	-4.59385682755885	1.34879926503908	-5.97608420966650	14T13:04:00.000	2909.955787093590	5634.536511458170	1
237.309049610738	6725.571379721650	-999.281763756760	-4.84088107053956	-0.69830043753261	-5.88925481676310	14T13:08:00.000	1953.038063796030	6420.953648229620	1
-919.029109159003	6316.116749732130	-2359.192729207750	-4.73664016025823	-2.69264653065493	-5.37425992609323	14T13:12:00.000	854.273066251198	6741.047219342560	
2008.782442869110	5448.948536084570	-3547.679494941770	-4.28953832011614	-4.48941628981003	-4.46962328857439	14T13:16:00.000	-306.508001101438	6571.876284204120	
2953.177658105230	4187.423689486480	-4478.710055841600	-3.53279731246534	-5.95917076702708	-3.24197662201675	14T13:20:00.000	-1445.082553992100	5926.207059543120	
3684.118061394640	2623.195643966180	-5085.092657882810	-2.52156454011343	-6.99686358322774	-1.78067503362190	14T13:24:00.000	-2479.035931256250	4851.399263548830	
4148.968002739690	869.490676803000	-5323.153448551560	-1.32874145662125	-7.52874259530528	-0.19115237662377	14T13:28:00.000	-3333.725527415860	3425.728210784780	
4314.201039499430	-947.002460407872	-5175.712767073380	-0.03973705827404	-7.51692303107006	1.41249665977763	14T13:32:00.000	-3947.572413047060	1752.550223506190	-
4167.722807349460	-2695.054777988760	-4653.256808579950	1.25322926927125	-6.96167642271072	2.91509399435631	14T13:36:00.000	-4276.357324213450	-47.186590668099	-
3719.783486333850	-4248.133593998450	-3793.273051505180	2.45722836738637	-5.90172901872318	4.20810145517307	14T13:40:00.000	-4296.274415046760	-1843.505742311360	-
3002.383371036210	-5493.430513179380	-2657.736769623620	3.48500405720022	-4.41217864326101	5.19721525937584	14T13:44:00.000	-4005.618964902650	-3506.537203385730	-
2067.144462946370	-6340.098958417990	-1328.835272021820	4.26134401976302	-2.59994616707952	5.80942362099085	14T13:48:00.000	-3425.008253878930	-4915.706030844170	-
-981.702234620459	-6726.058405085850	96.881387065020	4.72888512879918	-0.59639616077566	5.99885525217654	14T13:52:00.000	-2596.076320562680	-5968.425581197380	-
175.153082261416	-6622.769494248040	1515.516981220110	4.85269987209611	1.45202689505307	5.75067012864380	14T13:56:00.000	-1578.634184325540	-6587.702390304220	
1319.273028191900	-6037.535075350920	2823.541729880170	4.62338798745643	3.39509727052703	5.08277077812107	14T14:00:00.000	-446.429384454499	-6727.992619403140	
2367.408907742760	-5012.980558205670	3925.526762514910	4.05777764402168	5.09057622720529	4.04428053471630	14T14:04:00.000	718.242011524424	-6378.762948980330	
3243.370163455870	-3623.823866590520	4741.197837637310	3.19743826259450	6.41492355903661	2.71152478659511	14T14:08:00.000	1830.643625342790	-5565.356698053330	
3883.591370522210	-1971.265573333450	5211.283399199060	2.10530327139706	7.27231383803945	1.18204137950159	14T14:12:00.000	2809.878990037840	-4347.088529665140	
4241.694910370090	-175.500217124890	5301.729625049710	0.86076387242191	7.60114511364502	-0.43284644282374	14T14:16:00.000	3584.843278069670	-2812.771250733570	
4291.761583207110	1633.013087480000	5006.067555130530	-0.44607488582978	7.37792701139242	-2.01592789969924	14T14:20:00.000	4099.356558809850	-1074.070244828640	
4030.170012386520	3322.936305404700	4345.849237570500	-1.72060432426245	6.61889859552563	-3.45229864572513	14T14:24:00.000	4316.159973004730	742.644189178279	
3475.870353990030	4771.515851969810	3369.105467692780	-2.87043711195430	5.37894684997308	-4.63750527023169	14T14:28:00.000	4219.560439352170	2505.432102209230	
2669.068460184690	5873.477400535100	2146.925179467840	-3.81191987553990	3.74804771372586	-5.48505336733592	14T14:32:00.000	3816.550391706040	4086.280298633380	
1668.363762344990	6548.758731746970	768.331078048344	-4.47640177356769	1.84508191858516	-5.93295318685262	14T14:36:00.000	3136.341188563880	5370.332699970000	
546.486686437752	6748.455537256300	-666.230137027406	-4.81555637471311	-0.19082474867292	-5.94865599559740	14T14:40:00.000	2228.307055597880	6264.273389008230	
-615.067580932026	6458.428963037910	-2052.322763531660	-4.80513105563668	-2.21096747924531	-5.53166459348334	14T14:44:00.000	1158.427342389110	6703.228267986020	
1732.060804813980	5700.239805442760	-3289.243505868200	-4.44661386268756	-4.06843434140541	-4.71333324272074	14T14:48:00.000	4.447615522384	6655.574778893080	-
2723.682288740150	4529.387845581350	-4287.390678271680	-3.76686471410270	-5.62907166272330	-3.55415713162357	14T14:52:00.000	-1149.869504755590	6125.226298913340	